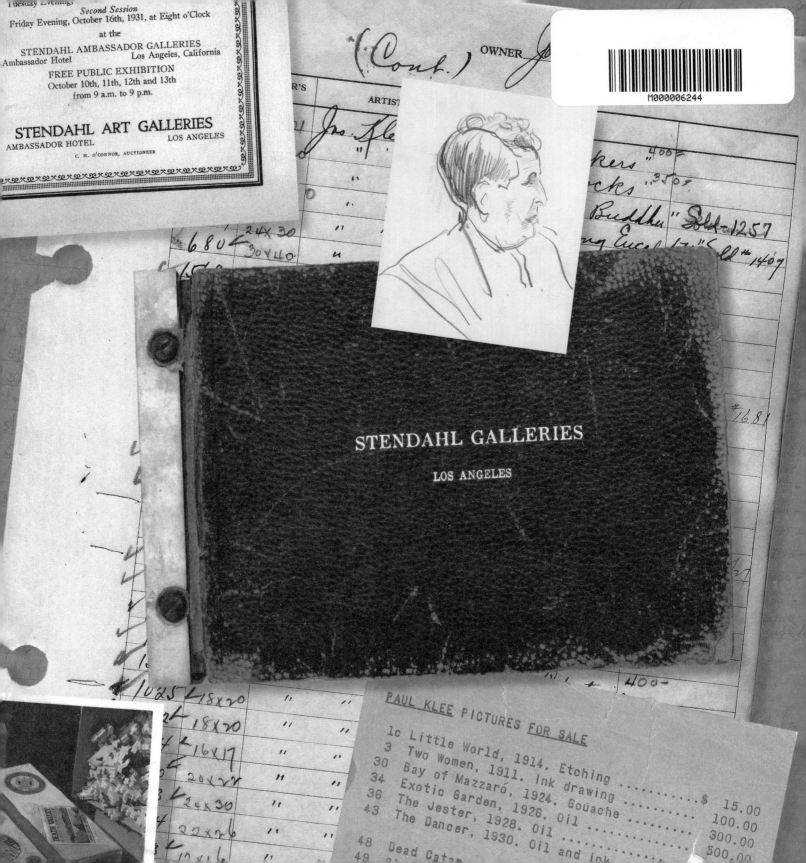

Tuesday Evening,
Second Session
Friday Evening, October 16th, 1931, at Eight o'Clock
at the
STENDAHL AMBASSADOR GALLERIES
Ambassador Hotel Los Angeles, California
FREE PUBLIC EXHIBITION
October 10th, 11th, 12th and 13th
from 9 a.m. to 9 p.m.

STENDAHL ART GALLERIES
AMBASSADOR HOTEL LOS ANGELES
C. H. O'CONNOR, AUCTIONEER

M000006244

STENDAHL GALLERIES
LOS ANGELES

PAUL KLEE PICTURES FOR SALE

1c	Little World, 1914. Etching			
3	Two Women, 1911. Ink drawing	$	15.00
30	Bay of Mazzaró, 1924. Gouache			
34	Exotic Garden, 1926. Oil		100.00
36	The Jester, 1928. Oil		300.00
43	The Dancer, 1930. Oil and ink		500.00
48	Dead Cat			
49				

EXHIBITIONIST

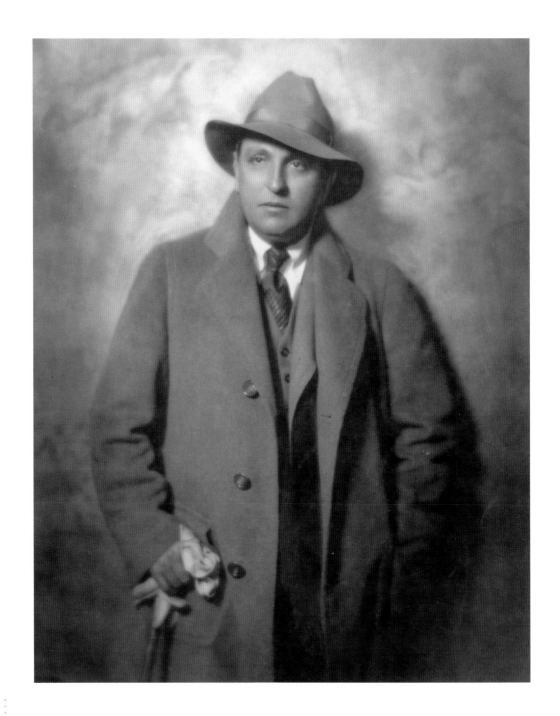

Earl L. Stendahl by George Hurrell, *Grand Seigneur* of the Hollywood portrait, 1928.

EXHIBITIONIST

Earl Stendahl, Art Dealer as Impresario

APRIL DAMMANN

Design by Jamison Spittler

ANGEL CITY PRESS

Exhibitionist: Earl Stendahl, Art Dealer as Impresario

by April Dammann

Copyright © 2011 by April Dammann

Designed by Jamison Spittler of Jamison Design, Nevada City, California

Cover design by Amy Inouye of Future Studio, Los Angeles

ISBN-13: 978-1-883318-86-4

ANGEL CITY PRESS

2118 Wilshire Blvd. #880

Santa Monica, California 90403

310.395.9982

www.angelcitypress.com

LIBRARY OF CONGRESS CATALOGING-IN-PUBLICATION DATA

Dammann, April.
 Exhibitionist : Earl Stendahl : Art Dealer as Impresario / by April Dammann.
 pages cm
 Includes bibliographical references and index.
 ISBN 978-1-883318-86-4 (hardcover : alk. paper)
 1. Art dealers—United States—Biography. I. Stendahl, Earl (Earl Leopold), 1888-1966. II. Title.
 N8660.S69D36 2011
 709.2–dc22
 [B]
 2010054452

Printed in China

Opposite: Portrait of young Ron Dammann by Nicolai Fechin, 1948.

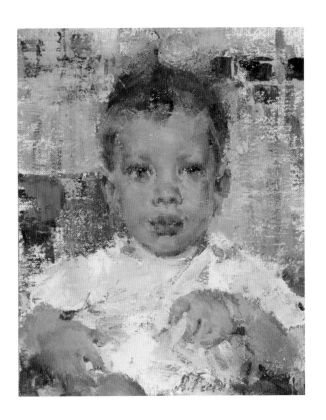

For my husband, Ron Dammann,

a Stendahl heir by birth and by spirit.

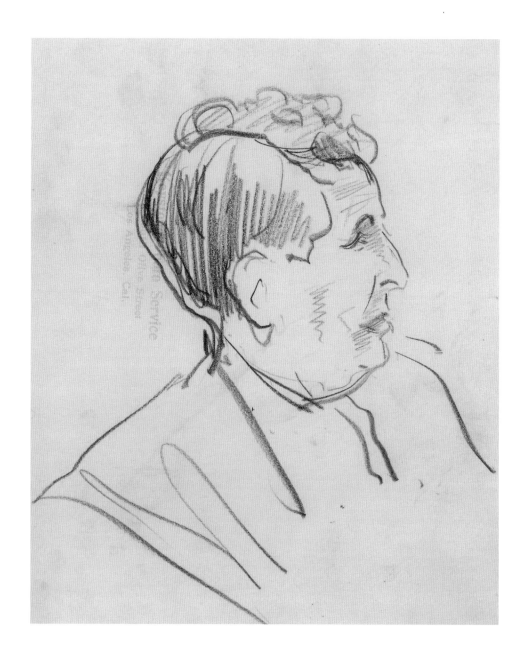

This drawing of Earl Stendahl is thought to be by Nicolai Fechin, perhaps in lieu of a thank-you note to his dealer. The sketch appears on the back of the original photograph, shown on page 71, of an artist's banquet hosted by Stendahl and honoring Fechin.

CONTENTS

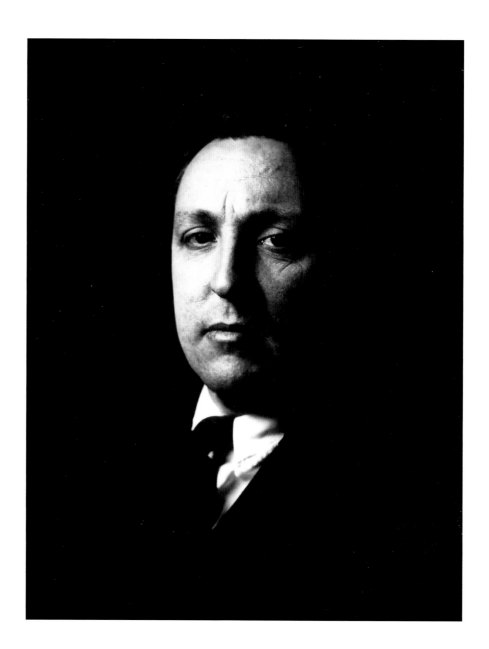

The young exhibitionist, Earl Stendahl.

If one were creating a fantastic fictional character whose physiognomy, actions and dialogue fit the romantic vision of an art dealer, one would fantasize Earl Stendahl, the primary subject of this book. But this story is not fiction, it is fact, fully researched and documented and presented to the reader as an illumination of a time and place which until now was almost lost to history.

When I was asked to write a brief foreword for *Exhibitionist: Earl Stendahl, Art Dealer as Impresario* I was pleased, because the request suggested that the author recognized that my generation (the generation of Monday Night Art Walks on La Cienega Boulevard, UCLA Extension classes in art history, the Pasadena Art Museum in the old Chinese Pavilion and the founding of the Los Angeles County Museum of Art) had worked hard to establish Los Angeles as a fledgling cultural community.

Now, some fifty years later, I can assert with a degree of confidence that our city and its cultural institutions have moved beyond their adolescence to a solid level of maturity. What allows me to say that is not the magnificent completion of the Museum of Contemporary Art, the UCLA Hammer Museum, The Getty Center, Disney Hall, or the Broad Contemporary Art Museum, but rather the simple fact that Angelinos have matured to a point where they can now look back on their past and take pleasure in and give credit to some of those early heroic figures who, against all odds, set the stage for this happy condition.

The author of this book, April Dammann, a granddaughter-in-law of Earl Stendahl, had access to his extensive notes, letters, documents, photo files, and oral history, which she used to trace a three-generation dynasty of art dealers who constitute her extended family. It all began with Earl Stendahl's arrival in Southern California in 1909.

This is a rich and wondrous tale allowing the reader to run the full gauntlet of emotions with

The seasoned exhibitionist, Earl Stendahl.

Stendahl and his clan as he strives to make a living selling art in a city endowed with no cultural consciousness while surrounded by the shallow glamour of the infantile film community. Dammann makes it clear that Stendahl's ambitions were purely pragmatic and that, upon his arrival, his knowledge of art was limited. But his enthusiasm inspired a host of collectors to become involved, first in California landscape painting, later in avant-garde European Modernism, and finally in Pre-Columbian art—a field in which Stendahl is internationally recognized for his pioneering efforts.

During the early years, to stay alive, Stendahl developed a number of educational innovations that are still used by museums and galleries to draw audiences, including promotional capers such as showing Pablo Picasso's *Guernica* in his commercial gallery space shortly after the painting was completed. A national tour of *Guernica* and sixty-three related Picasso paintings and drawings, organized in support of the Spanish Republic, actually began at the Stendahl Gallery and then went on to the San Francisco Museum of Art, the Chicago Arts Club, and ended in the Picasso retrospective at the Museum of Modern Art in New York. Criticism at all of the showings was repulsive, including the

Los Angeles Examiner's declaration that Picasso's masterwork was "cuckoo art."

The admission fee at Stendahl's was two dollars and fifty cents and twenty-five cents for students. They raised only two hundred and fifty dollars for the Spanish war orphans, but the venture made *Guernica* the most talked about painting of its time and brought Hollywood luminaries such as Edward G. Robinson, Bette Davis, George Cukor, Dashiell Hammett, and Anna May Wong into the art world and into Stendahl's sphere of influence.

Stendahl's interaction with clients, especially Walter and Louise Arensberg, is fascinating. They were neighbors and lifelong friends, and Stendahl helped them build what still remains today as one of the most magnificent collections of twentieth-century Modernism ever assembled—a collection that would reside in a Los Angeles museum, had not the Los Angeles County Art Museum and UCLA turned it down.

Dammann's detailed accounts of the humanistic relationship between Stendahl and his artists can be looked upon as exemplary. He provided money, studio space, dinners with his family and even wrote them notes of affection to keep them going.

While reading *Exhibitionist* I couldn't help but think of Calvin Tomkins's celebrated book *Living*

Well is the Best Revenge that introduced its readers to a pair of relatively unknown personalities, Sara and Gerald Murphy. Their story, told with wit and wisdom, broadened our awareness of what it meant to be alive among the great writers and artists of early twentieth-century Modernism. The Stendahl story is different, less sophisticated perhaps, but the message is similar. It takes these unique, supportive individuals with their charm and charisma to propel the primary figures and movements to their acclaim.

This is essentially a Los Angeles story but also one which can be appreciated by a national and international readership. Stendahl's life is a case study of a brash young Californian (American) seeking his spot on the world stage.

Have a good read.

—Henry T. Hopkins,
Professor Emeritus, Art, UCLA

[Note: Dr. Hopkins wrote this Foreword in December 2008, less than a year before he passed away in September 2009.]

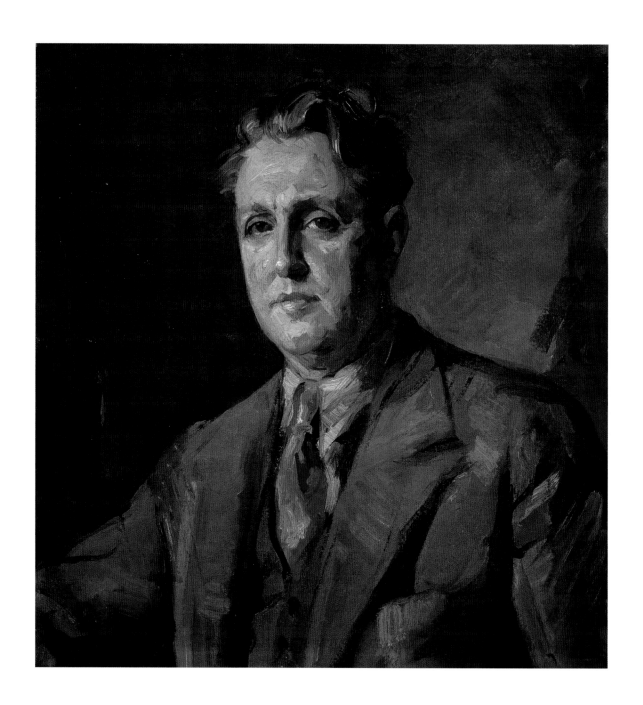

Earl Stendahl, portrait in oil by Fritz Werner, 1932.

The two-house complex where I live on a little avenue in the Hollywood Hills has been home to the Stendahl Galleries since 1940. My husband's grandfather, Earl L. Stendahl, was lured to the neighborhood by art collector Walter Arensberg, who, with Stendahl's help, amassed what was described in a 1949 Chicago Art Institute catalog as "the most discriminating single group of twentieth-century paintings and sculpture in existence." That our home (the former Arensberg estate) has so long been associated with the finest examples of modern and ancient art has been a source of pride for the Stendahls and Dammanns. The houses themselves are architectural jewels, with additions by Richard Neutra, Gregory Ain, Lloyd Wright, and John Lautner. The Arensberg house was the setting for historically important salons, welcoming Los Angeles's pioneers of Modernism in art and architecture, as well as writers, musicians, academicians and personalities from the film industry. In early 2011, the home was designated by the City of Los Angeles as a Historic-Cultural Monument worthy of preservation.

"If these walls could talk" knocked around as a family mantra for many years. A professional writer, I harbored a desire to one day chronicle the colorful story of Earl Stendahl's influence on the art history of Southern California dating from 1911, when young Stendahl first began selling paintings. Over the years, the business has been alternatively or simultaneously called, Stendahl Gallery or Galleries, Stendahl Ambassador Galleries, Stendahl Art Galleries, Earl Stendahl Gallery, and Stendahl-Hatfield Galleries, named for Stendahl's short partnership with dealer Dalzell Hatfield. As long as clients could find him, the nuances of the appellation were apparently not an issue.

Earl and his son, Alfred (1915-2010), and their partner Joseph Dammann, Earl's son-in-law, saved or donated to the Smithsonian Archives of American Art, seemingly every exhibition catalog since the beginning of the Stendahl Art Galleries, along with never-published photographs, personal and gallery correspondence, advertisements, lease agreements, invitations, newspaper articles, customs declarations, and inventory price lists. Given the abundance and richness of the source material, failing to write this book would have bordered on irresponsible. But the project was not set into motion until the chance discovery of a long-neglected portrait in oil, which harbored a secret.

Some years ago I was rummaging through canvases stored in our basement. From dusty stacks, I pulled out a painting of Grandpa Earl in a fine old frame. I liked it immediately and planned to hang it in a place of honor over the fireplace in the main gallery. My husband Ron Dammann (who represents the third generation to run Stendahl Galleries) noted that the work was unsigned and undated but probably commissioned in the 1930s and done by a good portrait painter of that era. Up on the wall went Grandpa.

One day, when Los Angeles art dealer George Stern came by the gallery on business, Ron asked him if he had an idea of who the portrait's painter might be. Examining the back of the picture, he and Ron found the artist's name hidden behind the stretcher bars: "Werner 1932." One small mystery solved. Austrian painter Fritz Werner had been represented by Stendahl. Then, a startling find: a label which had been scribbled over in blue pencil read *"Rising Mists,"* the title of a Monet-like landscape painting by premier California impressionist Guy Rose. Stendahl, who was Rose's dealer in the 1920s, had exhibited a painting by that title at the Guy Rose Memorial sale at his Ambassador Hotel gallery in 1926. It was reproduced in the sale catalog.

To further excite Ron, George, and me, an official Guy Rose estate stamp was affixed to the back of the Grandpa picture. *And* the canvas's measurements matched *Rising Mists* exactly. Could there be a painting by Rose *under* the portrait of Stendahl? Why would someone paint over a valuable work of art? Earl Stendahl was eccentric, yes. Unpredictable, often. But he was first and foremost an astute businessman and a lover of fine art. With all due respect, a new mantra emerged: "If it's a Guy Rose, Grandpa goes!"

In a painstaking process that took more than two years, Santa Barbara conservator Scott M. Haskins removed the image of Stendahl and uncovered the strikingly beautiful *Rising Mists* by Guy Rose. A similar impressionistic painting, sold privately by Ron and George, had recently brought eight hundred thousand dollars at auction. Grandpa would have been astounded (and undoubtedly amused) at today's prices; much of the correspondence I researched for this book concerns the dollars and cents of buying, selling, and promoting art. For the record, the portrait of Earl Stendahl survives as a convincing digital photographic reproduction, mounted in the original frame. It hangs once again in the main gallery.

Did we get our answers? Not entirely. We still do not know what led to the over-painting. One theory: Depression-era economics might have dictated a

quick solution to debt. Perhaps Fritz Werner owed Stendahl a favor or a payment, and the portrait settled the books. Even in tough times, it's doubtful that the price of a fresh canvas was the cause of recycling a painting. But, knowing Stendahl's flair for the dramatic, it is possible that his replacing a Guy Rose work with his own face was an act of defiance for some perceived injustice. Dealers and artists do have a long history of quarrels over their partnerships, and Stendahl was involved in some doozies. But he had a reputation for fair dealing throughout his career.

A year after the Guy Rose Memorial Exhibition, *Rising Mists* was listed in Stendahl's inventory as still available for fifteen hundred dollars. It carried insurance worth three hundred dollars, as long as the painting was "contained in the reinforced concrete building known as the 'Ambassador Hotel' and in that portion designated as Stendahl Galleries," — from the *Policy in the name of Ethel Rose.* End of story? Not quite. There is, apparently, yet *another* image under *Rising Mists.* Like the mysterious painting, this book is a layered portrait of a man. It is an attempt to look deeply into an important life.

I had the privilege of knowing Earl Stendahl as "Grandpa," while still in my teens; my experience of him and his influence goes far beyond the few years I shared time with the Stendahls at family dinners and on outings to football games, art openings, and favorite restaurants. I came of age in this family, listening to tales of long-ago deals and relationships. Ron recalls, "When Grandpa was in a jovial mood, we all knew he had made a good sale. Inappropriate outbursts or insults usually meant a Pre-Columbian pot had failed to find a home." After one well-celebrated New Year's Eve, Ron and I were asked to drive the Stendahls home from a party at Uncle Al's house. We gladly obliged. After helping the couple into their home, Grandpa took Ron aside and said, "Don't let that one get away." I think he was pointing at me.

I viewed Ron's mother, Eleanor, as the self-appointed keeper of Stendahl-Dammann memories. She relished the role of repeating stories, and it impressed me that the details remained constant, time after time, as if she knew that personal histories could be lost without such a commitment. Her father deserved it. She's gone now, so the storytelling falls to me.

I remember Earl Stendahl. But only now do I appreciate how remarkable he was and what a wonderful story his is.

—April Dammann
Hollywood, California, 2011

Views of St. Croix Falls, Wis.

High School
Normal School
Residence
Business Block
General Electric Power House
Church
Bank

St. Croix Falls, Wisconsin.

1 SALESMAN

Most stories that begin with a

hopeful kid leaving a tiny town

In 1909, a restless twenty-one-year-old candy maker looked

in Wisconsin for a career in

at a map of the United States to determine which city was

Hollywood involve a naïve young

as far away from Menomonie as he could possibly get. His

woman. Starlet stories, with

outstretched arm laid a determined finger on San Diego,

depressing endings. Not this one.

California. "I'd heard there was gold in them thar hills," he

later told radio interviewer Prudence Penny after he had

established himself in Los Angeles. For the kid from nowhere, "gold" meant the thrill of opportunity and the chance to make his mark. But, as big as his dreams were, it is certain that founding one of the pioneering and most influential American art galleries of the twentieth century was not among them.

.

Earl Leopold Stendahl was larger than his small town. Menomonie originated as an Indian village, overlooking picturesque Lake Menomin. A stroll through the modern midwestern city (population 15,000) reveals remnants of the time of Stendahl's late-nineteenth-century youth. Main Street has been designated a national Downtown Historic District with restored Victorian-era buildings. Stendahl was born there on December 11, 1888, to a family of confectioners. The John Steendahls (who, yes, spelled their name with two e's; in 1918, Earl

was the first to drop the second e) were part of a largely Norwegian immigrant population who lived and worked alongside their Swedish neighbors. Stendahl's future wife, Enid Isaacson, was the daughter of a prominent Swedish druggist in nearby St. Croix Falls. Earl and Enid met as teenagers at the Stout Institute (now the University of Wisconsin-Stout) where the predominant non-academic training for males was in "sloyd"—the Swedish system of specialized tools and materials for woodcarving. According to Stendahl's only son, Alfred, his father excelled in woodworking and anything that required manual dexterity. Young Earl played the violin and the clarinet in local bands with his family—all musicians. He managed two small orchestras and dabbled in painting, too. But his creative pursuits were limited by the necessities of The Monte, the family bakery and sweet shop business. The seven Steendahl children were involved with their parents, taking turns at the soda fountain and the candy counters and rising before dawn to man the ovens.

Though short in stature, Earl Stendahl played football and ran track in high school before, he claimed, he was expelled (for offenses unknown).

1 The Stout School, Menomonie, 1913.

2 Baker Earl, right.

3 The Monte was billed as "The Place with Telephone Tables." Customers could order right from their tables, or call the operator to connect to friends in the city for one minute. Long distance was an extra charge. All this in 1909. The Monte offered fifty-three soda and sundae flavors, as well as an array of baked goods and candy, all made in the family factory. The motto was "Good eating and good thoughts make life worth living."

DIRECTIONS
for using Phones

First look over Menu carefully and
find the numbers of the dishes desired.
Then take down the receiver and when
the operator asks for order, give her the
numbers. If you want to talk to parties
in the city, tell the operator to connect
you with central.

Eat your Sunday dinner
HERE
Tables will be reserved

The Monte will have a
special sale of one of its
products every Saturday.
Starting at 10:30 a. m.
WAIT FOR IT

Use
Our Table
Telephones to
Talk to Your
Friends

One Minute Limit

Good eating and good thoughts
make life worth living.

The Monte
EARL STEENDAHL

Menomonie, Wis.
U. S. A.

THE PLACE WITH THE
TELEPHONE TABLES

3

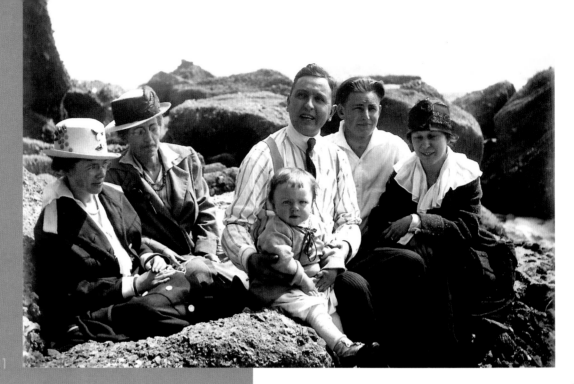

1

2

3

He was good at peddling Steendahl sweets at the local county fairs. A story confirmed by newspaper accounts is that Stendahl invented the ice cream cone, although he is one of many to make that claim. On a hot afternoon at the fair, the ice cream vendor next door ran out of cups. Waffle-maker Stendahl curled fresh-off-the-iron batter into a cone and watched folks line up for the handy new treat. The young man began to understand that with some ingenuity and a little chutzpah, he might find ways to open doors far from Menomonie. From an early age, Stendahl seemed to be on a faster track than others: a short-timer counting the days until he could earn enough to marry Enid and make his escape.

In the spring of 1909, with his twenty-year-old bride Enid by his side, Stendahl kissed his parents, sisters, and brothers goodbye and boarded a train bound for San Diego. That trip marked the beginning of a lifetime of travel to the corners of the world, but Stendahl once told an interviewer, "I can't find a place I'd rather live, work, or die in than California." Quite a contrast to the way he summed up his hometown: "Menomonie is an Indian word for *dead broke.*"

The young couple were on their own, far from family and everything they had known in Wisconsin. Enid was hoping her parents' talk of moving to Southern California was more than an effort to comfort her. In fact, within a few years Mr. and Mrs. Alfred Isaacson settled into an English Tudor in Hancock Park, one of the oldest neighborhoods in Los Angeles, developed by the oil barons of the Hancock family and home to some of the area's most prominent residents, including the Huntingtons and Crockers and Dohenys.

4

Alfred Isaacson, a builder, as well as a postmaster and druggist in his Wisconsin days, expanded the home to include a larger dining area, among other improvements. He and Sophie anticipated that in a short time, the Steendahls would move north to live with them. Just such a plan was developing for Enid and Earl.

In San Diego, after a period of selling Velie automobiles, White Motor Company trucks, and check-protector machines (Stendahl approached art client Charlie Chaplin with one of these, years later), the impresario-in-the-making decided to fall back on something he was very good at: running

1 A picnic on Ventura Road.

2 The Isaacson home.

3 Car salesman Earl Steendahl, before he dropped the second *e*.

4 An outing at Tioga Pass with the in-laws.

a restaurant. But unlike the random approach he had taken in choosing San Diego as a destination (point and shoot), this time he and his wife carefully researched the most likely place for success in the restaurant business: Main Street, downtown Los Angeles.

In 1913—the same year the Los Angeles County Museum of History, Science, and Art opened—the Steendahls moved in with Enid's parents and put all their hopes and money into the Black Cat Café, a cozy establishment that served up breakfast, lunch, and dinner, and, of course, tantalizing desserts. While Stendahl oversaw the kitchen and the front of the small restaurant, he fretted over the frequent turnover of the young staff. He was surprised at the substandard work ethic demonstrated by the Californians in his employ, compared with the responsible siblings and others who had helped run The Monte back home. Stendahl expected everyone to be as committed as he was, but he discovered that his idealistic "one for all, and all for one!" didn't resonate with the busboys and waiters at the Black Cat Café.

To add further pressure, Stendahl was receiving almost daily letters from his brothers in Menomonie, reporting how brother Egbert was running The Monte into the ground by assuming too much debt and letting Earl's high standards slide. It was a sad day when brother Sam wrote to Earl, "Mother and Father are unable to continue the biz." Earl and his father-in-law had both invested heavily to try and rescue the restaurant. Egbert eventually took full responsibility for the demise of the once-thriving Monte. Following a less-than-successful stint selling musical instruments, Egbert wrote Earl asking for help—"in case I have any trouble with the banker"—in his plan to convert an eighty-acre farm in Montana to cash "for the purpose of helping our parents."

The senior Steendahls had moved to California, living on a small fruit farm near Palo Alto. Egbert owed them money and wished to smooth things over with the family. Poor Egbert seemed to muck up everything he touched. He wrote to Earl, "My heart goes out to you all for the burdens I have placed on you, but I know that all things work for good for those who love God." Egbert's faith didn't prevent his eventual confinement in a mental institution in Pomona, California, where he lived out his days.

Sam, who moved with brother Victor to their parents' California farm, committed suicide years later. Earl's son Al didn't recall ever being told about how the tragedy of his uncle's death came about. But the Steendahl boys were a proud and hard-working bunch, and vulnerable to taking their failures too much to heart. Earl Stendahl's resolve *not* to fail was born out of the same family dynamic that couldn't

save some of the others. "We're Norwegians," said Earl, as if that summed it all up.

Keeping the Black Cat going was all consuming, but Stendahl made time for other creative outlets. He invented a kiddy-cart train. "I think he had the contraption patented," said Al. Stendahl also dreamed up a "fountain ashtray" with a moat of water surrounding the center to decrease fire danger in hotel lobbies. His father grew dates, inspiring Stendahl to build a date-pitter that was supposed to be an improvement over what was currently on the market. There is no record of Stendahl earning money from his inventions, but he had a "better mousetrap" mentality all his life. In business, it meant he was continually trying to improve service and profits. Add a salesman's sensibility, and the young man was primed to match the right product with the right customer base.

Back at the café, a few art dealers were coming in for lunch. Stendahl enjoyed their animated conversations and engaged them in discussions about local artists. He, too, was a painter, and had an appreciation for quality pictures. Stendahl had sold works of art stamped with a "Steendahl" sticker in San Diego as early as 1911. Could there be something to this art game? In a marketing scheme that is not unusual for restaurants today, Stendahl asked his dealer customers to display some of their paintings on his walls. He even helped set prices. A few sold. Stendahl thought, "This is easy. There is money to be made in this pursuit." He approached the art peddlers who had started bragging to others about their profits from the Black Cat Café; Stendahl asked to take more pieces to sell outside the lunch spot. According to Al, "As he'd done in San Diego, Dad went out and stuck his foot in a few doors and sold some paintings, and that's how he got into the art business."

Stendahl's timing could not have been better. The opening of the Panama Canal in 1914 brought the rest of the world to the West Coast in dramatic fashion. Booming Los Angeles was moving quickly away from its provincial reputation toward a "city of the future!" as it was promoted by the chamber of commerce. What that future would hold artistically was yet to be determined. Certainly Modernism—of which Stendahl would become a pioneering proponent—did not take root in California without great resistance. But while still at the Black Cat Café, Earl Stendahl was beginning to imagine his own future as a painting salesman.

In 1917, a job opened up downtown at the Wilshire Boulevard interior design firm of Cannell and Chaffin. Earl and Enid now had a two-year-old

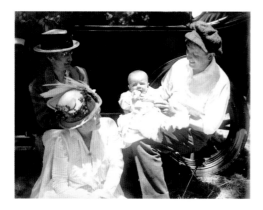

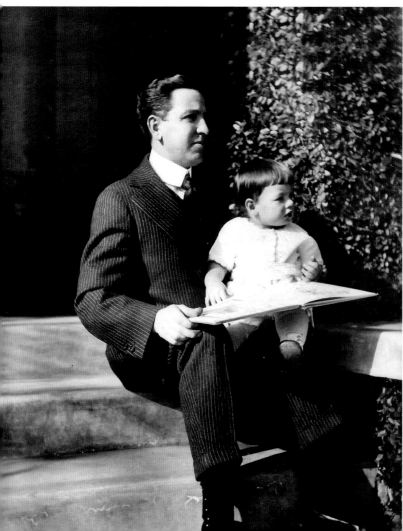

son, Alfred Earl, and wanted to move to a place of their own. Armed with letters of recommendation from a car dealer, a cigar seller, a banker, and a baker in Menomonie, twenty-nine-year-old Stendahl convinced the elegant proprietors that he was a bona fide dealer in paintings of Los Angeles artists. The match was fortuitous: while other sellers of art dealt almost exclusively in works from New York and Europe, Cannell and Chaffin was interested in showing emerging local painters.

Stendahl bought a new suit for his job as a sales associate. His already astute eye began to develop further through his exposure to the finest antique furnishings and decorative arts of the eighteenth century and to the lovely landscape paintings of the California *plein air* school. Stendahl was also impressed by a clientele of well-to-do people, many of whom might stop by the showroom following a visit to the Los Angeles County Museum of History, Science, and Art. One afternoon Messrs. Cannell and Chaffin alerted the staff to the imminent arrival of a very important client. All must be perfect: ties straightened, hair pomaded, shoes mirrored. When Mr. William Randolph Hearst arrived, Stendahl observed firsthand that there were people in the

world who could buy anything they wanted, without regard to the cost. Perhaps he thought to himself presciently, "One day that man will be my client."

Within a year, Stendahl was managing the Cannell and Chaffin Gallery. But his quick rise was interrupted by a call to duty: In July of 1918, Vice President/Counsel Henry W. O'Melveny of the Los Angeles Trust & Savings Bank wrote to the commanding officer of the Central Training School for Officer Candidates in Louisville, Kentucky, saying, "Mr. Stendahl is a man of business experience and of versatility and in my judgment is well adapted to the military profession." Yes—if they wanted dreamers and schemers. Stendahl had applied for admission to officer training in the Field Artillery Division after having satisfactorily completed the six-week course in military science and tactics at the University of Southern California. But the war soon ended, and Stendahl's leadership training was never put to the test. At least not on the battlefield.

Around this time the young husband, father, and businessman dropped the second e from his last name to be known thereafter as Earl L. *Stendahl*. He

3

was forging an identity, the same way Los Angeles was. If he was fortunate to hitch his future to the city's star at a fortuitous time in its young history, he was wise about choosing a place for his first gallery. If he was to be an ambassador for art, his location had to reflect his class and good taste.

1　New parents, Enid and Earl.

2　Earl and Al.

3　Soldier Earl saw no action in World War I.

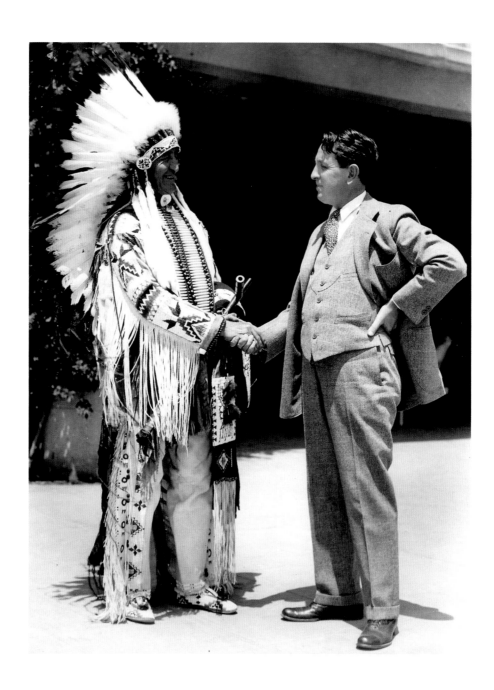

Stendahl greets a real Indian chief, regaled in beadwork and feathers, which Earl recognized as valuable examples of ethnic art. Today the intricately crafted work is highly collectible.

Chapter 2 AMBASSADOR

The Ambassador Hotel opened on

Wilshire Boulevard to great fanfare

for well-heeled sun-seekers. The Ambassador was billed

on New Year's Day of 1921.

as "The Great Hotel that Seems Like Home," that is, if your

Soon a popular destination for

home had thirty-plus shops, eighteen holes of miniature

visitors from the East, it offered a

golf, horseback riding, bowling, tennis or tango lessons,

dizzying assortment of indoor and

a movie theater (talkies only), tea dances, plunges in the

outdoor activities

pool, social chess, and encounters with "authentic Indians."

The management team decided to offer something else to

1

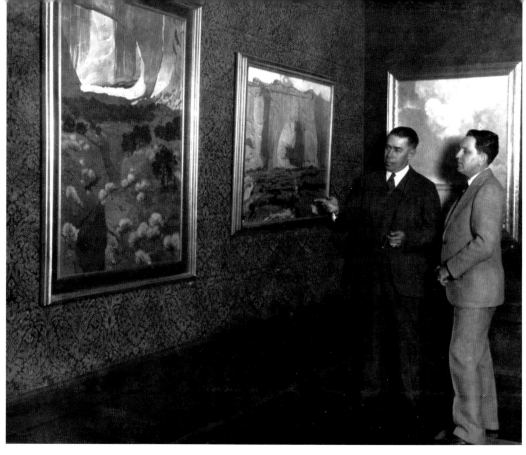

2

the hotel's high-society guests: fine art. A lease agreement gave Earl L. Stendahl space on the main and lower levels to install Stendahl Art Galleries. The fit was ideal, because Stendahl specialized in the premier California landscape painters of the day. The hotel hoped to impress out-of-towners with not just the beauty of its fair state, but with the way Southern California's particular charms could be captured on canvas by the likes of Edgar Payne, William Wendt, George Gardner Symons, and Guy Rose.

In mid-town Los Angeles on Wilshire, the boulevard of dreams, the young art dealer was poised to greet winter vacationers who had money and taste. These connoisseurs traveled west to experience firsthand what they had heard about Southern California's azure skies, golden hills, misty ocean, and pastel light. The climate and the landscape that lured his hoped-for clients also assured Stendahl of a steady supply of product: Why wouldn't artists bring their palettes to such an impressionistic paradise? And bring them, they did.

Stendahl probably never knew that the opening of his new gallery was in jeopardy, due to the

Ambassador's cost overruns, just months before the planned debut. Disaster was averted, thanks to a lawyer who stepped in to provide leadership and get things under control. Henry O'Melveny was the same man who had written a letter of recommendation to Stendahl's army training school years earlier. O'Melveny, an avid art collector, probably was instrumental in the decision to include an art gallery in the stylish shopping arcade in the Ambassador.

As soon as one month after the hotel's splashy opening, its Program of Events listed art lectures in the Stendahl Art Galleries in its weekly schedule. These continued for years and were conducted by the currently exhibiting artist, be it William Wendt, Nicolai Fechin, Joseph Kleitsch, or other stars in Stendahl's expanding constellation. When classes of students attended, sometimes Stendahl did the honors himself. He had not studied art in high school or college, but from his earliest commercial dealings in painting and sculpture, he promoted art education.

In a 1925 letter to Post-Impressionist painter Armin Hansen, Stendahl wrote, "We feel if the children grow up through the grades in the presence of these prints, year after year, by the time they graduate, they will have a fairly good knowledge of who is who in the art world. I think we will get results immediately." Yes, results, as in *sales*. An informed public is a buying public. Stendahl never apologized for emphasizing both the intellectual and the dollar value of art appreciation.

3

In June of 1925, the gallery hosted an exhibition of the work of "The Spanish Master" Federico Beltrán-Masses in the Ambassador's Grand Fiesta Ballroom. Stendahl sent letters to all of the local public and private high schools alerting the principals to the show of Spanish paintings at the Ambassador. He sent similar letters to art editors at the *Los Angeles Times* and other

1 Federico Beltrán-Masses honored, in front of *La Maja Maldita*, painted by the artist in 1918. He gained American fame for his portrait of Rudolph Valentino.

2 Stendahl with James Swinnerton and his desert landscapes, which are still in demand, today. Swinnerton gained fame as the "Canyon Kiddies" cartoonist for *Good Housekeeping* magazine and for painting backgrounds for Warner Bros. cartoons.

3 Federico Beltrán-Masses at the Ambassador.

newspapers with this mission: to encourage students of all ages interested in art to view his show and to attend a series of informal talks in the Stendahl Galleries given by the proprietor three nights a week. "These art talks will be so conducted that students may easily take notes. Mr. Stendahl will use in these addresses paintings by the world's greatest masters." Not surprisingly, Stendahl was up to more than just educating students. He was, at the same time, trying to raise ten thousand dollars to use as purchase prize money for the coming International Pan-American Exhibition of paintings planned for November of 1926 in Exposition Park. The Beltrán-Masses show could attract considerable interest and funds.

To that end, a program at the Ambassador featured a Spanish theme of art, music, and dance, co-hosted by Spanish painter Francesc Cugat. It is too bad that the artist's brother, the famed Xavier Cugat, didn't show up with his band to put the crowd in a buying mood. The opening party was billed as the "Most Brilliant Event in the International Artists Club's History in a gorgeous setting." The invitation copy boasted "the greatest collection of master paintings ever brought to the West" in an exhibition that would be "long remembered in the art annals of Los Angeles and the Southwest." This and other breathless pronouncements had the unmistakable Stendahl stamp. He understood the value of professional publicity (and spent plenty for it), but he couldn't resist injecting his own brand of hyperbole into every show.

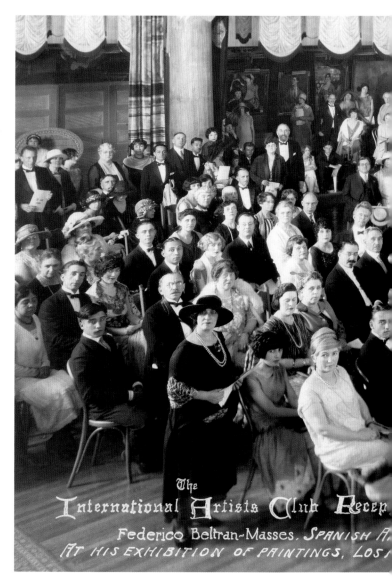

The International Artists Club Recep
Federico Beltran-Masses, SPANISH A
AT HIS EXHIBITION OF PAINTINGS, LOS

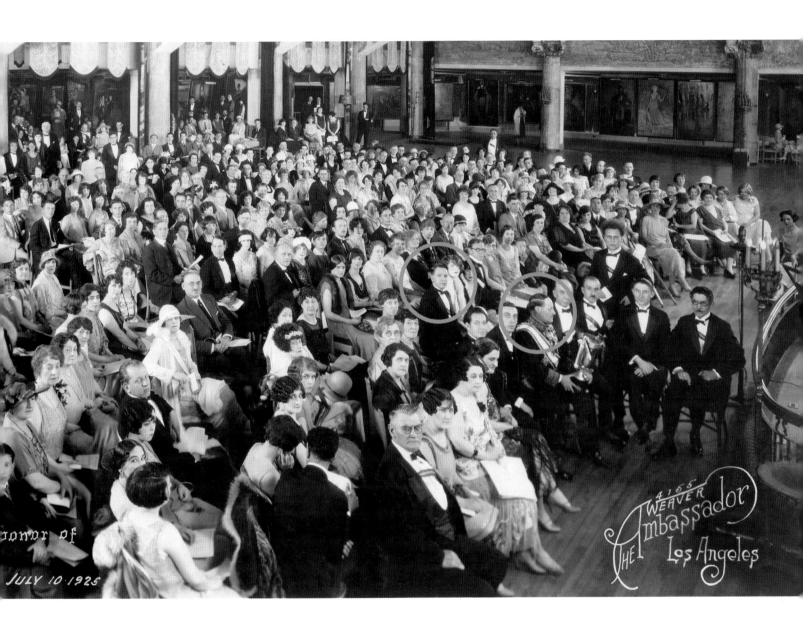

The International Artists Club Reception in honor of Beltrán-Masses, in the front row. Stendahl is in the second row.
July 10, 1925.

Stendahl happily took credit for the success of the Beltrán-Masses exhibit and all the accompanying fanfare. He strongly encouraged the hotel director to co-sponsor other shows, courtesy of Stendahl Galleries, which could obtain the talents and services of Spanish, Mexican, German, French, and Italian artists—all poised to exhibit at the Ambassador in the coming season. Stendahl saw an obvious publicity opportunity for both the hotel and the gallery and declared that these co-sponsored events would become the most popular entertainment in the community.

That would have been a tall order, because Los Angeles in the 1920s displayed a kind of Gold Rush mentality, with plenty to see, do and exploit. Growing in sophistication, with a population approaching two million, the City of Angels was a boomtown that enjoyed economic rewards from real estate, oil, agriculture and from its ultimate industry: the movie business. Why shouldn't the art game claim a piece of so delicious a pie?

The earliest Los Angeles dealers like Stendahl, Alexander Cowie, John F. Kanst, Jake Zeitlin, and Dalzell Hatfield benefited from the hugely successful Panama-Pacific International Exposition in San Francisco in 1915, where thousands were exposed to important works of fine art. The West Coast was becoming a true art center, with its own identity apart from the established meccas of Paris, Chicago, and New York. Historians lament that the desirable aspects of life in Southern California—the very ones that drew hordes of immigrants to the region in the early twentieth century—were ultimately ruined by too many people seeking opportunity and good weather. As his son Al recalled, Earl experienced Los Angeles in only a positive light. As an active participant in the city's burgeoning cultural life, Stendahl gained an enlightened perspective. He liked what he saw and experienced.

When Sid Grauman, an impresario in his own right, planned the opening of his much-anticipated Chinese Theatre on Hollywood Boulevard in May of 1927, Stendahl was not about to be left out of such a spectacular premiere. He offered the services of Beltrán-Masses and another portrait artist he handled, Howard Chandler Christy, to immortalize on canvas the screen stars Grauman handpicked for his Motion Picture Hall of Fame. Stendahl must have found a kindred spirit in Grauman, who considered himself a patron of the arts and who marketed his projects with similar gusto. Grauman claimed his Hall of Fame would attract art lovers and movie fans from all over the world and that the Grauman's Chinese Theatre complex would be "one of the showplaces of the Western Hemisphere." The Chinese was

declared an Historic-Cultural Monument in 1968, but Grauman didn't live to see the honor.

Actress Norma Talmadge was chosen as the inaugural subject for Christy to paint in life-size; she had turned the first spade of dirt at the groundbreaking in 1926 and was a favorite of Grauman's. She supposedly walked across a slab of wet cement in the forecourt, inadvertently inspiring the famous handprints and footprints there.

More prestigious work was on the way for Christy. "I believe I have pictured the soul, as well as the person of Mr. Hearst," he said, at the unveiling of his large portrait of William Randolph Hearst. The occasion was the opening of a Christy show at Stendahl's that included an invitation to make appointments with the famous portrait painter for personal commissions. Stendahl considered the show a great success, as did the critics who particularly liked Christy's *Portrait of a Publisher.*

In the years that Stendahl operated his gallery in the Ambassador—1921 to 1932—he averaged ten shows a year, a staggering schedule. Since many of the exhibits featured more than one artist in two large spaces, one can only imagine the busy-ness of doing business at such a pace. But Stendahl thrived under challenging circumstances. Al described his father as never idle. "He worked Sundays, always." Al called Earl "a carnival man" who took pride in concocting publicity campaigns. The Ambassador, as a prestigious magnet for vacationers with a yen

to take home a lovely souvenir, was a perfect fit for Stendahl's vision of promoting art and artists.

A stack of exhibition catalogues from this era names the crème de la crème of California Impressionists working at the time. Stendahl referred to these women and men as "worthwhile painters," an understatement, given Stendahl's enthusiasm for his artists and his propensity for *overstatement.* His voice is more typical in the text from an ad he wrote for the *Los Angeles Evening Express,* in December of 1930: "...Buying paintings from peddlers or private sources because they are cheap is dangerous."

The group of "Worth-While Painters" listed was incredibly impressive, and Stendahl had a personal, often affectionate, relationship with each of them. In correspondence, William Ritschel begins, "Dear Old Earl, You are a peach!" followed by a drawing of a little peach and three exclamation points; Cornelis Botke signs, "Corney;" William Wendt is "Billy;" Elmer Schofield: "Scho." There were nicknames applied to Stendahl, too: He was "Stennie" to William Randolph Hearst after many dealings on Wilshire Boulevard and at the Marion Davies estates, and "Earl-the-Pearl" in certain collegial circles. Such was the familiarity enjoyed among partners-in-art.

Episcopal Chair made c. 1780, by San Juan Capistrano Indians for JUNIPERO SERRA, Apostle and Founder of California. Now mine. Duke of Alba at right.

*Happy New Year 1925—
Let's Make it!*

Chas. F. Lummis

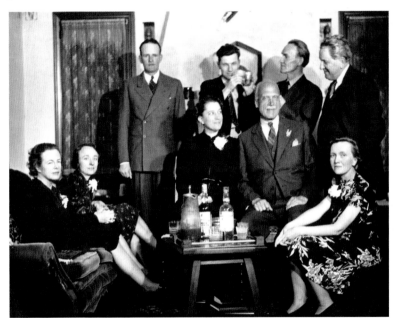

1 An advertisement for "Worth-While Painters."

2 *Cottonwoods Along the Mojave* **by John Frost.**

3 To the Stendahls from Charles Fletcher Lummis, author, reporter, defender of Indian rights and collector. Note the Duke of Alba, descendant of the sixteenth century's "butcher of Flanders," who embodied Spanish imperialism at its worst.

4 Earl Stendahl, at far right, with Enid, far left, and artists Alexander Archipenko, standing, second from left; Nicolai Fechin, standing, second from right; Elmer Schofield, in front of Fechin; and Delfina Bateman, Stendahl's longtime secretary and accountant.

A postcard mailing for a 1930 show reads, "The Finest Exhibition of American Landscape Art Ever Shown in the West. Famous Artists Represented in This Important Collection: George Inness, Thomas Moran, William Keith, Henry Ranger, Charles M. Dewey, Birge Harrison, Charles Davis, Howard Pyle, Elliott Daingerfield, Gardner Symons, Leonard Ochtman, Carlton Wiggins, Ben Foster, Edward W. Redfield, William Ritschel, and Albert Groll."

Perhaps the most comprehensive statement submitted by Stendahl to local art critics is a piece he titled, "Of Interest to Art Lovers." It went like this:

The Stendahl Art Galleries in the Ambassador Hotel are always on the look-out for paintings to exhibit that will be most interesting to the general public, as well as connoisseurs and collectors. This year, probably more so than previous ones, their calendar is filled with fine exhibitions of the foremost artists of America, and they have succeeded in obtaining various types of work, in order to show non-partiality to any certain school.

William Wendt, who is the Dean of California landscape painters, just closed a very successful exhibition, which was on March 21 to April 9. This was Mr. Wendt's farewell exhibition before leaving for Europe, where he will remain for a year—not to paint, but to rest from forty years of strenuous hard work.

Following this exhibit comes the show of desert paintings by Albert Groll, National Academician, who has gained an enviable reputation in New York as the very first man who painted the Arizona desert. In this collection he is also showing waxed drawings done in Sicily; the entire last gallery is devoted to the drawings.

In the downstairs art gallery, also owned by Earl Stendahl, there is a combined show by Jessie Arms Botke and her husband Cornelis Botke. His paintings have the brilliancy and vigor of the modern Impressionist School, with none of the eccentricities common to many of our artists. Mr. and Mrs. Botke have decided to make Los Angeles their permanent home and are indeed a great asset to our art colony here.

Mr. Stendahl has induced Leon Gordon, the great portrait painter of New York, to come to Los Angeles to do several important commissions. He arrived in Los Angeles this week and is delighted with it.

Stendahl was particularly devoted to seascape specialist William Ritschel, N.A., and one of Stendahl's ads proclaimed,

**PROPORTION ACHIEVED /
GLAMOUR REVEALED /
LIGHT DIFFUSED / COLOR INFUSED
Through Hanging
of Appropriate Paintings**

1 William Ritschel, N.A.

2 Eastern painter Albert L. Groll, N.A., 1925.

3 Leon Gordon, portrait painter.

To think that such appealing benefits could derive from putting a picture of a listing ship on the wall. In fact, at the time of his one-man show at Stendahl's, Ritschel (1864-1949) was considered to be America's greatest marine painter by art critic and painter Arthur Millier and others. Any superlatives that Stendahl used to describe the works of art that he was touting were usually justified, not just a sales pitch.

Among Stendahl's most popular exhibitions at the Ambassador were those devoted to landscape painter Edgar Alwin Payne (1882-1947). Stendahl developed a close relationship with Payne and considered him to be a kindred spirit. The two were contemporaries, both had left home early, arriving in California by 1911, and, artistically, each was self-taught. Of course, even though Stendahl demonstrated real talent with watercolor and oils, he didn't compare his efforts to those of one of the foremost *plein air* painters of the time.

Payne lived and painted in Laguna Beach before moving to Los Angeles to be closer to his dealer. He and wife Elsie traveled the world, always returning to California, where the mountains and lakes of Mono County beckoned. Al said of the artist, "You see an Edgar Payne, and you know you're on the eastern slopes of the Sierras."

Stendahl and Payne had a prosperous partnership. Multiple pages in the Stendahl Galleries Inventory ledger attest to the dozens of Payne pictures that were exhibited and sold during their long association. And, unlike other dealers and critics, Stendahl recognized Elsie's artistic talent, encouraging her toward a successful career in her own right.

Stendahl's relationships with his artists weren't limited to the gallery. In the preface to Ruth Westphal's book, *Plein Air Painters of California—The Southland*,

2000 - Sardine Fleet
1800 - Cypress on 17 Mile Drive

Paintings

450 1 - Morning Surf
200 2 - Moored, South Sea Islands
650 3 - To the Horse Fair
1000 4 - La Claire de Lune
3500 5 - In the Golden Days of Columbus
2000 6 - A Grey Morning, California Coast
1500 7 - Katwyk, Strand Scene, Holland
1500 8 - Monarchs of the Seas (Monterey)
750 9 - Shell Digger (Holland)
1200 10 - At Day Break, Capri
1500 11 - Tahiti Idyll
12 - Moonlit Surf

Paintings

2500 21 - Morning After a Storm
2500 22 - Wind Swept Cypresses - Monterey
2500 23 - Evening Tide
2500 24 - Morning Hour
2500 25 - Fish Wives (Gossiping)
2000 26 - Waiting for the Boats
2000 27 - Purple Tide
2000 28 - Point Lobos - Monterey
2000 29 - Life in Tahiti
1500 30 - Primitive Landscape, Tahiti
1200 31 - Girl from Bali
4000 32 - In the Glorious Days of Venice
1500 33 - Moonlight Tahiti
Port of Romantic Spain

Al referred to the galleries his father set up in hotels in Pasadena and San Diego:

> My father serviced these salons in a Roamer touring car which we used in the summer to both visit and transport such artists as Payne, Wendt, Frost, and Symons to the High Sierras or to drive up the coast to see Ritschel, Hansen, and Gilbert. Sundays and weekends, when not involved with hanging a new exhibition, we usually visited studios in Laguna Beach, Palm Springs, or Santa Barbara. I vividly remember these men in their spacious studios filled with finished and unfinished canvases and walls hung with mementos of their travels.

2

Stendahl's daughter Eleanor (1923-2000) also spoke fondly of the artists her father represented and of the way her family's business was such a part of their home life. Even though Stendahl's dedication to his galleries kept him away much of the time, when he would call Enid at the dinner hour to say "I'm bringing Payne home with me," the kids knew they were in for a treat. They looked forward to the artist's stories of sailing ships and cowboys. Whether receiving last-minute dinner guests was always a treat for Enid is slightly more complicated.

Her children recalled their mother serving up now-legendary meals to Stendahl's "waifs," as the family called them: hungry artists, art critics, collectors, curators, friends. Most of the Stendahls' guests were not, by any means, down-and-outers. But anyone who showed up around the dinner hour, invited or not, was warmly received. Enid accepted her role without complaint—at least in front of the children. Earl had everybody convinced that their home possessed *la salle à manger de la porte ouverte*—the dining room of the open door. Enid probably would have liked a *porte fermée* policy from time to time, but she grew in her homemaking and hostess roles, recognizing the richness to which she was exposing her children around their table.

1 Stendahl's inventory of Ritschell paintings and their prices.

2 The Stendahl bungalow at 342 North Bronson Avenue, Los Angeles.

The Stendahl Gallery at the Ambassador was often the scene of a banquet honoring an important patron or artist. In May of 1922, as Edgar Payne was preparing to embark on a two-year painting trip to Europe with Elsie, Stendahl sent him off with a formal dinner. Al pointed out, in looking at the group photo from the event (with identifications scribbled on the back), that the attendees were mostly other artists (Alson Clark, Hanson Puthuff, Jack Smith, John Rich, and Edouard Vysekal, among others.) Also pictured are special guests Dr. William A. Bryan, director of the Los Angeles County Art Museum, Bishop Johnson, Stendahl's father-in-law, *Los Angeles Times* art critics Antony Anderson and Fred Hogue, magazine editor Rob Wagner, and certain travel agents, art patrons, a producer for Zane Grey Pictures named Ben Hampton, and one so-called "adventurer" known as Captain Osborn. Note that the banquet was being held in the gallery space where Stendahl was giving Charles Russell (1864-1926) his first important exhibition. The paintings seen behind the participants are early Charlie Russells, backing up the stiff-looking group with a bit of western action. Stendahl stands out in the middle of the picture as the only gentleman not in formal wear (nor even a dark suit) to honor Payne. Al said his father couldn't afford a tuxedo at the time, but Earl's sartorial statement seems deliberate. In any case, the send-off was a big success. Payne's travels abroad were productive; he sent a group of paintings

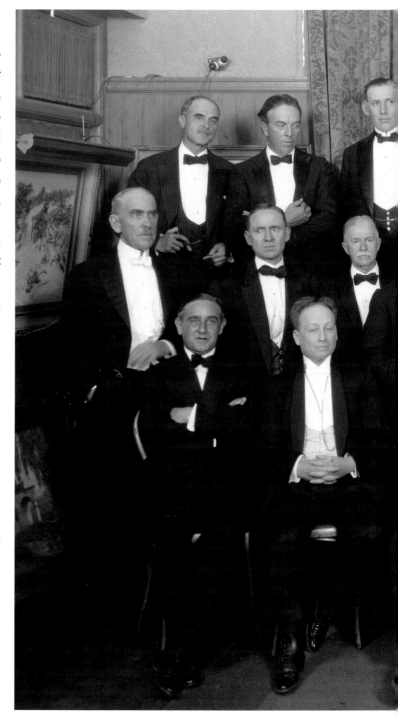

Edgar Payne Banquet, 1922. Stendahl is circled.

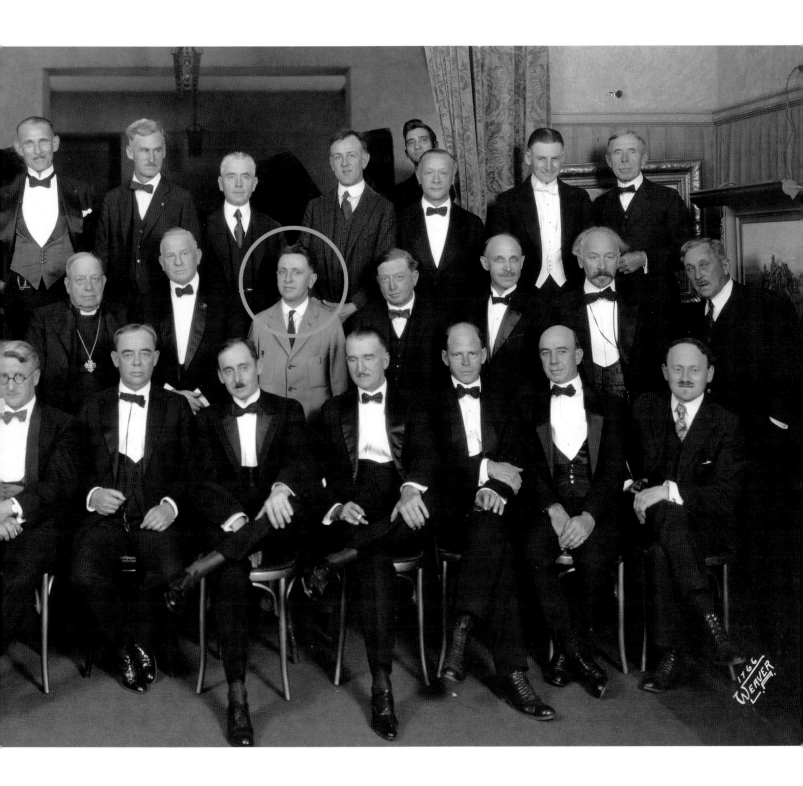

1

2

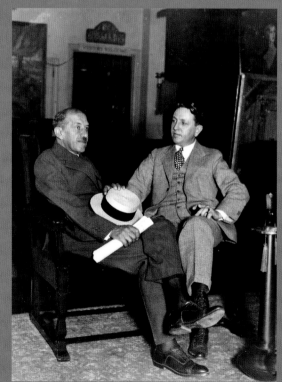

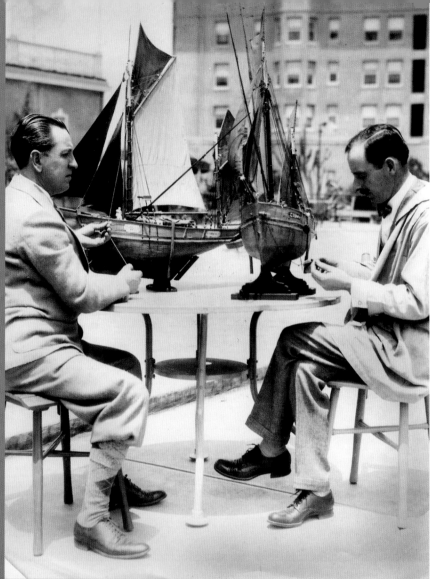

3

home to Los Angeles for Stendahl to exhibit, and the show was well received by both critics and collectors.

For all his success with the California landscape painters and their pleasing subject matter, Stendahl could not ignore his conviction that the trickle of Post-Impressionist and avant-garde art coming in from Europe would soon become a steady stream. Hadn't the New York Armory Show of 1913 and the Panama-Pacific International Exposition of 1915 in San Francisco demonstrated that modern art, as disturbing and misunderstood as it was to some, was here to stay? Stendahl surmised correctly, as historic hindsight reveals, that none of the difficulties of 1930 to 1931 eclipsed the necessity of recognizing that new artists and new forms were an advancing tide upon West Coast shores. Earl Stendahl decided to dive in. He was going to be the avant-garde of the avant-garde, or go down trying.

Stendahl hired Sonia Wolfson (1903-1997) for multiple roles at the gallery, particularly to promote his more controversial exhibitions. Wolfson, who went on to a long career as a publicist for Twentieth Century-Fox, was designated secretary on much of the Stendahl Gallery correspondence in the 1930s.

She was well known at the time as a writer of art criticism for *The Art Digest* and other local publications. Wolfson liked the hands-on experience of working at a top gallery, and Earl paid her a fair part-time wage. Conflict of interest comes to mind, but there is no evidence that anyone was concerned about Wolfson's close association with Stendahl at the time she was covering the local art scene. *Los Angeles Times* publisher Harry Chandler accused (one hopes with humor) *Times* feature writer Fred Hogue of being a relative of the Stendahls, so positive were his reviews, and so close was his relationship with Earl and Enid.

From Sonia Wolfson: "I expect Mr. Stendahl will be crucified promptly and publicly after the opening of the Marc Chagall exhibition next Monday. It's probably the wildest thing that ever happened to Los Angeles." Wolfson was appealing to Marjorie Driscoll of the *Los Angeles Examiner*, hoping to entice the editorial writer to come with a photographer to preview one of the last Stendahl shows at the Ambassador and his first significant foray into abstract art: a crucible in his career.

The success or failure of this solo exhibition, the first in a series by modern French masters, would largely determine the level of enthusiasm that Stendahl could muster for the new direction he was pursuing. Not that he had any doubts about the artistic merits of the works he had recently seen in Paris. Stendahl

1　One of Charles Russell's "Cowboy and Indians" themed oils.

2　Stendahl with *L.A. Times* art critic, Antony Anderson, early 1920s. Note Earl's ubiquitous cigar.

3　Stendahl assists Payne, who constructed ship models for accuracy in his marine paintings.

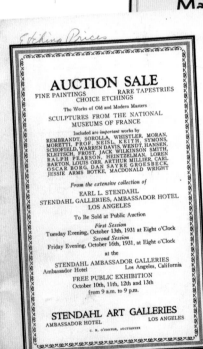

Allen's Clipping Press Bureau
LOS ANGELES.
SAN FRANCISCO.
PORTLAND, ORE.
CLIPPING FROM

LOS ANGELES, CALIF.—
SATURDAY NIGHT—$45
OCTOBER 10, 1931

AUCTION

OPENING a new GALLERY on Wilshire Boulevard, I need money. I am offering my nationally famous private collection of

Masters' Paintings
...ure, Tapestries
...d Etchings

...cted Public Auction.

...great artists whose master-
...ever before been seen in
...art, will appear—Rem-
..., Wendt, Frost, Symons,
...eitsch, Sorella, Loren
...Hansen, and other classic
...sters.

...d school of art is repre-
...e Rennaissance to the
...sts. Among the tapes-
...the finest and best
...UVAIS in existence

...st Session:
...tober 13, 8 P. M.
...sion, $1.00
...d Session:
...ober 16, 8 P. M.

STENDAHL ART GALLERIES

AMBASSADOR HOTEL
LOS ANGELES

C. H. O'CONNOR, AUCTIONEER

AUCTION SALE
FINE PAINTINGS RARE TAPESTRIES
 CHOICE ETCHINGS
The Works of Old and Modern Masters
SCULPTURES FROM THE NATIONAL
MUSEUMS OF FRANCE

Included are *important* works by
REMBRANDT, SOROLLA, WHISTLER, MORAN,
MORETTI, PROF. NEISL, KEITH, SYMONS,
SCHOFIELD, WARREN DAVIS, WENDT, HANSEN,
KLEITSCH, FROST, JACK WILKINSON SMITH,
RALPH PEARSON, HEINTZELMAN, LOREN
BARTON, LOUIS ORR, ARTHUR MILLIER, CARL
OSCAR BORG, DAN SAYRE GROESBECK,
JESSIE ARMS BOTKE, MACDONALD WRIGHT

From the extensive collection of
EARL L. STENDAHL
STENDAHL GALLERIES, AMBASSADOR HOTEL
LOS ANGELES

To Be Sold at Public Auction

First Session
Tuesday Evening, October 13th, 1931 at Eight o'Clock
Second Session
Friday Evening, October 16th, 1931, at Eight o'Clock
at the
STENDAHL AMBASSADOR GALLERIES
Ambassador Hotel Los Angeles, California
FREE PUBLIC EXHIBITION
October 10th, 11th, 12th and 13th
from 9 a.m. to 9 p.m.

STENDAHL ART GALLERIES
AMBASSADOR HOTEL LOS ANGELES

C. H. O'CONNOR, AUCTIONEER

was excited about the opportunity to show painting that contrasted with the traditionalism of academic art associated with his gallery. Although he would continue to exhibit California's scene painters and impressionists well into the Thirties, those shows increasingly gave way to the experimenters of the abstract schools.

Stendahl recognized real mastery in Chagall's whimsical distortions and his way with color. But Wolfson was right about how the artist's show would be received by most of the public and the press. When it opened on December 15, 1930, "I was told that his work was decorative," wrote Dr. George A. Berson in a published analysis on Chagall, after viewing the exhibition. "The only thing I would let that man decorate would be the walls of an institution whose inmates were all pronounced Mongolian idiots." Berson went on to call Chagall's paintings senselessly ugly, unskillful, and the work of a spiteful, foolish child. *Rob Wagner's Script* had a bit more fun with its coverage of the show. "Are the Modernists Spoofing the Public?" begins with:

> Earl Stendahl has barricaded himself within the little room back of his Ambassador Art Gallery. Through a peephole he watches the faces of those who come in. If they are over forty-five years old, he hides under the stairs; if they are of the younger generation, he comes out beaming like an apple pie.

Stendahl is then complimented for being the high priest of the academicians who dares to show the new heebie-jeebie school of painting. Unlike dour Berson, who has nothing but derision for the Chagall canvasses, the *Script* writer sums up by encouraging one and all to drop by Stendahl's for either an aesthetic thrill or a good laugh. Is it all a giant spoof? "No!... Yes!... No!... Crash! Then Earl calls the ambulance."

Showman that he was, Stendahl decided to build upon the maxim, "There is no *bad* publicity." Following the Chagall exhibition, he mounted one-man shows for the French masters Giorgio de Chirico, Georges Rouault, Raoul Dufy, and Maurice Utrillo. There was no shortage of coverage, extending to the *Christian Science Monitor* and the magazine *Progressive Arizona*, where Sonia Wolfson closed her long article by extolling Stendahl's "courageous deed" in bringing Chagall's work to the West Coast.

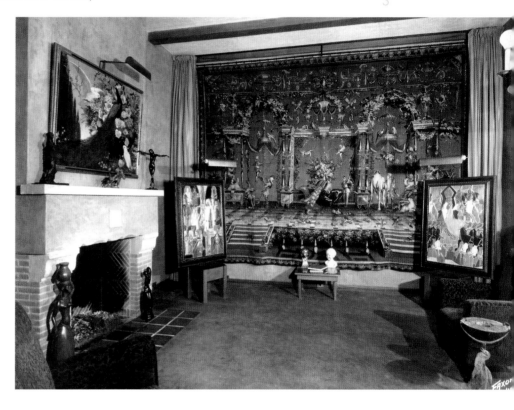

Stendahl closed out his years at the Ambassador in October of 1931 with a highly publicized auction sale, put on with the impresario's characteristic panache. Admission to each of the two sessions of the sale was one dollar; the thirty-six-page catalog

1 Cover of Auction Sale catalog, 1931.

2 Newspaper advertisements announcing auction to help fund new gallery on Wilshire Boulevard, 1931.

3 Beauvais tapestry on exhibit among works by Karoly Fulop and Jessie Arms Botke.

cost fifty cents. For absentees, a mail-order bid could be submitted: "Our Miss Sonia Wolfson will represent you, just as if you were present yourself, securing the items at the lowest possible price."

The auction sale catalog's inside cover contains a quote from the then-current issue of *The Art Digest*. No name is attached to the short piece called "The Best Investment":

> Wars may come and go, industrial crises may cripple the economic world, stocks and bonds may crumple in value, a nation's currency may depreciate or become worthless, but beautiful and recognized works of art are unperishable, and their value fluctuates, but little.

Can there be any doubt that the writer is our own Earl Stendahl? The sale featured "Fine Paintings, Rare Tapestries, Choice Etchings, the Works of Old and Modern Masters and Sculptures from the National Museums of France." Contributing artists are listed, including, Rembrandt, Whistler, Moran, Symons, Schofield, Wendt, Hansen, Kleitsch, Payne, Frost, Smith, Barton, Millier, Borg, Groesbeck, J.

Botke, and Wright. William Wendt was represented by eighteen canvases; Edgar Payne by a staggering eighty-five. The conditions of the sale stated "Terms cash," with a cash deposit of twenty-five percent, required, if requested.

The most valuable *objet d'art* up for auction at the closeout sale was a magnificent seventeenth-century Beauvais tapestry from one of the palaces of the Princess de Faucigny of Cystria. The photo caption declared, "Mr. Stendahl acquired the tapestry direct from the Princess." No one knows what the dealer hoped to get for such a rare piece in 1931, but the catalog stated that a similar one sold in Paris for more than one hundred thousand dollars. Stendahl's Beauvais showed up on his gallery wall sometime later as the centerpiece of another exhibition. William Randolph Hearst turned it down for fifty thousand dollars, and Stendahl subsequently let it go for twelve hundred dollars at Parke-Bernet in New York. "It was a marvelous thing," Al recalled.

The back cover of the Stendahl Auction Sale catalog promoted "The New Stendahl Art Gallery Now Open at 3006 Wilshire Boulevard, one block east of Bullocks Wilshire." For some time, while still at the Ambassador, Stendahl had talked about creating a new private art gallery that would equal or surpass the best galleries in the country. To his great credit, Stendahl did not pull back or cut

Slopes at Lee Vining by Edgar Payne.

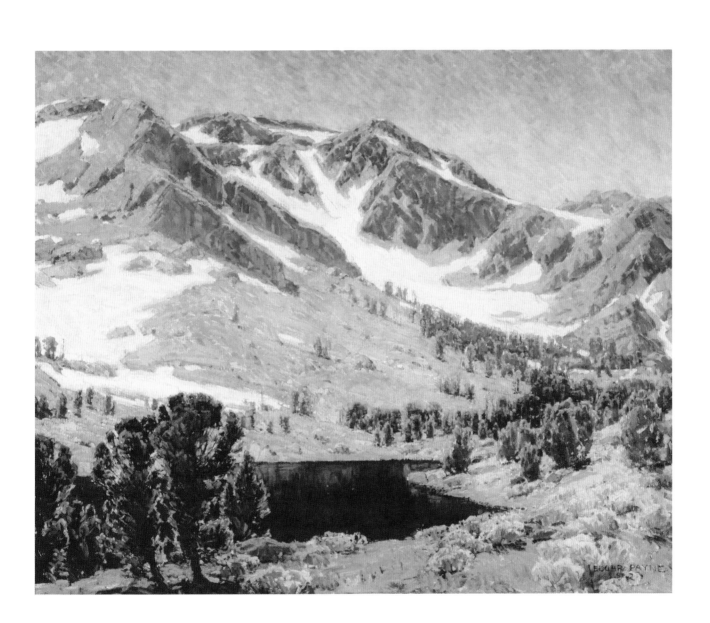

corners, when he made plans to lease ten thousand square feet of space in the Clark Building, a handsome French provincial just down the street from the popular department store.

Stendahl would continue to show paintings and sculpture at his Ambassador Galleries for a few more months, before finally bidding. Once settled in at the much larger space, he realized that he had stayed at the Ambassador six months longer than he should have. He told a Parisian dealer friend, "God knows I am in desperate need of help," when the Ambassador Hotel Operating Company demanded back rent of twenty-five hundred dollars within a short period of time.

Stendahl turned to the currency he counted on throughout his career. He offered as a security holding nine Edgar Payne paintings, valued at fifty-three hundred dollars. A. Frank, vice-president and general manager of the hotel, didn't feel that the paintings were of sufficient value to cover Stendahl's twenty-five-hundred-dollar debt. What an insult, especially after a successful ten-year relationship.

And not just to Stendahl; Edgar Payne must have been equally piqued.

Stendahl finally reached an agreement with Frank by adding more collateral to the Payne cache: all the paintings hanging in Mrs. Frank's bedroom. Unlike her husband, Mrs. Frank valued Payne's work and had covered her walls with canvasses that still belonged to Stendahl. If that transaction strained Stendahl and Payne's relationship, Payne also worried that Stendahl's move from the Ambassador might curtail his own income stream. Payne accepted an offer by the Ilsley Gallery, which took over Stendahl's lease. In better economic times the transition might have been smoother for Payne and his dealer. Only a few years earlier, the two men had entered into an investment partnership in the St. Paul Hotel, using eight of Payne's pictures as collateral.

But things were different after 1929. The Great Depression was on the land. Now Americans could barely pay for heat, water, and light, let alone fine art. Payne felt a need to continue showing his work at the Ambassador. Stendahl saw the wisdom in accommodating artists for whom other opportunities opened up and was inclined to try to keep them happy.

"It is impossible for me, during these days, to sell enough to satisfy any one artist, and from reports I

hear all over the country, it is the same with all other dealers," Stendahl wrote to painter Jessie Botke (wife of artist Cornelis Botke). Payne and Ilsley began hustling Jessie for her works, prompting Botke to write Earl:

> Just had a wire from this Mr. Ilsley who has taken over the Ambassador gallery—how come you never said anything about it???? Payne seems to be in partnership with him. They are coming out tomorrow and want some of my paintings and C's prints. I don't know what to do about it, only we have to do business soon or quit. Gosh. Yours, Jessie.

Gosh, indeed. Stendahl wrote back:

> You must be your own judge. It is alright with me to give them what paintings you desire, but I still think it would be well to keep me supplied with some of your best, as you have been connected to my gallery for so long. I doubt whether any gallery will put the interest back of your work that I have, and I think it would be bad policy to kill that interest.

The polite tone of the correspondence probably covers much stronger emotions. Business was done largely on a handshake, with dealers investing time and money and building their reputations on their artists. Raiding another gallery's assets was wrong, and Stendahl must have lost sleep on many a night, questioning his own practices when it came to maintaining control over his artists. He was certainly no Svengali. But he expected a level of mutual respect, where partners could count on one another.

Botke remained loyal; Payne did not. Stendahl knew there were other painters waiting for the chance to sign on with Stendahl Galleries. On the last day at the Ambassador, it is easy to imagine the dealer lighting a cigar as he dons his fedora and strides purposefully up Wilshire Boulevard to his future.

Stendahl with George Gardner Symons (left) and Elmer Schofield (right) at the Ambassador.

Chapter 3 ARTIST'S CHAMPION

In 1931, Earl Stendahl could

not have considered the bold move of

of art" he called himself, with no false modesty. He needed

his galleries to the large, expensive

more product than ever to sell, and he had an uncanny

Wilshire Boulevard building without

talent for finding it. Stendahl represented or sold the works

his conviction that artists would

of the most important painters of the first half of the twentieth

follow him there. Stendahl was,

century. That is a large claim, but it is confirmed by the artist

above all, a salesman. A "peddler"

files at the Smithsonian Institution that were compiled from the

Stendahl Art Gallery papers: more than seven hundred artists

paid Stendahl his one-third sales commission over fifty-five years.

As a matter of practicality, a dealer could not serve every one of his artists equally. According to Al, a common problem in the field was that each artist's ego required plenty of attention from his dealer. An annual exhibition was expected; frequent solo or group shows were desired. Anything less could be a deal breaker. In fact, a number of Stendahl's artists, including Jack Wilkinson Smith and Hanson Puthuff, did break away in 1923 to form the Biltmore Salon at the Biltmore Hotel in downtown Los Angeles. Alexander Cowie was hired to run the operation, and it became successful, especially with its Western landscape emphasis, but its mission to put Stendahl out of business failed, if that was, as Al claimed, indeed a goal.

Was there enough material to go around? Though perceived to be provincial, Los Angeles's art-buying public (whether locals, visitors, or transplants) was developing sophistication, but was it enough to stimulate a significant market? A look at the increasing number of museums, galleries, art schools, and clubs of the day suggests the answer is "yes."

About the same time that Stendahl arrived in California, the Municipal Arts Commission of Los Angeles was formed. The Los Angeles County Museum of History, Science, and Art followed, and in 1918 the Otis Art Institute opened. A Fine Arts League and women's social clubs, such as the Ebell (still an active organization), also promoted art appreciation. The Chouinard School of Art, like Otis, began training the next generation of painters, sculptors and muralists, many of whom would find their way to one of Stendahl's galleries.

STENDAHL GALLERIES

LOS ANGELES

Stendahl was a team player when it served his purposes. He relied on institutions that could be counted on for quality and dependability, such as the California Art Club (which celebrated its centennial in 2009). The Club supported radical experimentation in Impressionism by artists such as George Gardner Symons and Elmer Schofield of the Eastern Landscape School. These men, both National Academicians, came west to conquer a promising new frontier, where California's particular light and air, the mountains, the deserts, and the beaches cast their spell.

Stendahl gave a show in 1932 called Fifty Members of the California Art Club with prices printed in the announcement. Those charges seem quaint, compared with contemporary valuations of fine works of art, but the value of art is capricious, even mysterious. Earl Stendahl understood the uncertainties involved and thrived on them. He played in a high-stakes game, with anyone welcome at the table, as long as he or she brought a firm handshake and a wad of cash. Add an authentic appreciation for fine art, and Stendahl was truly in his element. Los Angeles, with its pioneering spirit and patina of make-believe, provided the enterprising dealer exactly the right place to take his chances with little-known artists. He approached his business with creativity, even offering an installment plan (this means of payment became popular after World War I, but was rarely applied to the purchase of art). Author Irving Stone recalled Stendahl telling him that collecting art was a *necessity* and should be treated like a utility: "When you pay those monthly bills, send me a small check, as well."

In 1932, as Stendahl was trying to establish the Wilshire Boulevard building, he turned to various promotional gimmicks to stimulate business and champion his artists. An idea put forth by artist Jessie Botke struck Stendahl as a good one. *The Art Digest* had publicized a successful show in Chicago, billed as The One Hundred Dollar Sale, in which the artists offered any picture for one hundred dollars. According to Botke, out of thirty-six works, thirty-four were sold.

Those odds had "Stendahl" written all over them. He decided to put on a One Hundred Dollar Sale in Los Angeles. It just might break the spell, offered Botke, referring to the tough economic times and lackluster sales. Botke suggested a couple of promotional phrases for her friend Earl to try: "The Stendahl Galleries to the rescue of the artists," or "Artists must live."

Stendahl moved ahead with plans for the "strictly a bargain" show to go up in mid-summer, a good

Leather album, one of dozens, many dedicated to an individual artist's work.

time for experimentation. He invited participation from Botke (hoping for one of her popular white peacock pictures) and her husband Cornelis, Alson Clark, John Frost, Armin Hansen, Paul Lauritz, Edgar Payne, Jack Wilkinson Smith, Orrin White, and more. Heavy hitters, all. In an astute, but dishonest, ploy, Stendahl told each artist that the *others* were sending fairly good-sized paintings. Given the rivalry and egos involved, this all but guaranteed some impressive works of art. Sure enough, in they came. (One can only marvel at the prices some of the pictures that sold for a hundred dollars at Stendahl's that summer would have brought privately or at auction today.)

In the early years at 3006 Wilshire, Stendahl strove mightily to keep old customers and cultivate new ones. For all the heft of a Kandinsky, a Matisse, or a Calder, Stendahl also maintained allegiance to local painters. An artist in Southern California could still be one of the best in the world in Stendahl's eyes, or perhaps, merely in his words. The impresario in him was always chasing the first, the best, the most significant, or the unusual in the promotion of his artists; he called this "propaganda." Superlatives worked for him because he sought out only those men and women who were producing the finest art.

The fact that Stendahl recognized such talent, time after time, testifies to his connoisseurship and to his instinct for what was good and what would sell.

STENDAHL'S STANDOUTS

The big picture of Earl Stendahl's influence in Los Angeles and beyond, at a time when California was forging its unique identity as a center for the development of art and artists, can be illustrated by the relationship between Stendahl and four true standouts from his stable: Guy Rose, Joseph Kleitsch, William Wendt, and Nicolai Fechin. By birth, an American, a Hungarian, a German, and a Russian. These men found inspiration in the American West, and their dealer devoted all of his resources to finding audiences for their remarkable artistic output.

Guy Rose (1867-1925)

In the 1920s, if a young dealer in early California landscape paintings wanted to align himself with a true master of a genre, that artist was Guy Rose. Born in California's San Gabriel Valley, Rose was the son of a wealthy senator with large land holdings. He studied art in Paris, and he lived in Giverny for many years where he befriended and painted with Claude Monet. Upon his return to California in 1914, French Impressionism influenced Rose's beautiful canvases, and Stendahl recognized in the taciturn gentleman a unique interpreter of countrysides and coastal regions. Rose rightly gained a reputation as the most important of the California Impressionist painters.

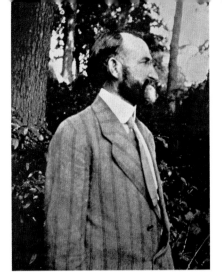

Catalogue

of the

Guy Rose Memorial

at the

Stendahl Art Galleries
Ambassador Hotel
Los Angeles, California

With an Appreciation of the Artist
by PEYTON BOSWELL
and a Sketch of His Life
by ANTHONY ANDERSON

February 16 to March 14, 1926

Guy Rose showed works in several Los Angeles galleries, but his closest and most productive association was at Stendahl's, where he was among the first artists to exhibit at the Ambassador Hotel gallery in 1921. There were other Stendahl shows, including a one-man exhibit of some sixty-five paintings. Sadly, Rose was afflicted by lead poisoning from tainted paints and could no longer work after being paralyzed by a stroke in 1922. Stendahl was crushed (both personally and professionally) by Rose's illness and had a hard time dealing with the injustice of a great talent being extinguished. The same year, Stendahl wrote a short biography of the artist in a book he published, *Guy Rose*, featuring illustrations of the artist's work from the large exhibition of October 1922. In Stendahl's words:

Meanwhile, we have much of his finest achievement with the brush on exhibition and on sale at the Stendahl Galleries in the Ambassador, and Los Angeles art lovers will not let it pass to other cities. It is part of the life work of one of our most gifted sons, and it should remain in Los Angeles.

1 This photographic portrait of Guy Rose, one of the few in existence, appeared opposite a tribute to the artist by Peyton Boswell, who wrote, "His paintings, once neglected, will become the prized possessions of collectors, and some day, through gifts and bequests, there should be "Guy Rose rooms" in the museums of Los Angeles, San Francisco and San Diego."

2 After the death of Guy Rose, Stendahl mounted an extensive memorial show in honor of the master California Impressionist.

In subsequent years, Rose's works have found placement all over the world. As much as Stendahl adhered to the "keep it at home" philosophy of appreciating local art, he must have understood that an artist of Rose's caliber could not, and should not, be contained.

In early 1926, after Rose's death, Stendahl and the artist's widow, Ethel—herself a trained painter— catalogued the remaining paintings in Rose's *oeuvre* for display at Stendahl's Guy Rose Memorial Exhibition. Stendahl wrote, "This is the first great memorial exhibition of a native California artist who has gained international fame and who is now classed among the immortals in the realm of art."

Many paintings sold at Rose's Memorial Exhibition, but in subsequent years there were disagreements between Ethel and Stendahl, regarding his handling of the estate. Even so, the two remained friends until Ethel's death in 1946.

Joseph Kleitsch (1882-1931)

"Ten masters of the caliber of Joseph Kleitsch, properly supported, can give to Los Angeles an art renaissance that will live for centuries," wrote, Fred Hogue, an editorial writer for the *Los Angeles Times*. "Neglect them, and the fate of Sodom will be our own—not through fire descending from heaven, but from the rust of materialism, of mediocrity, that works slower but equally sure." Hogue was not alone in the biblical proportions of his admiration for the Hungarian painter. Reviewing a May 1928 Kleitsch show at Stendahl's, he echoed the voices of many others who praised Kleitsch's work. "Why do I find in these canvases a harmony that I miss when I look upon the landscapes themselves? It is because the creation of the master possesses an intangible something lacking in nature itself."

In the same piece, Hogue described Kleitsch (then forty-two years old) nesting like a bird in his studio space, high under the eaves of the Ambassador Hotel, where the artist worked and supplied paintings to Stendahl. The two had traveled in Europe together (and would again in 1929), immersing themselves in the best that the museums, restaurants, and French countryside had to offer. By all reports, Kleitsch painted exuberantly in France and was never happier.

But his life in Laguna Beach gave him the subject matter for some of his most masterful work. Stendahl considered Kleitsch a paradigmatic figure among the

1 *Rising Mists*, Carmel, 1918-1919, by Guy Rose. This is the image that was discovered underneath the portrait of Earl Stendahl shown on page 12. The whole story is in the preface.

2 Joseph Kleitsch, Paris, 1926.

plein air painters of Southern California. The restless, immensely likable artist became known for the bold colors of his palette and for a joyful, vigorous artistic expression from the time he was a young portrait painter of note.

Stendahl gave Kleitsch his first one-man show in 1922, in keeping with his history of offering emerging artists their first solo or California exhibitions. Other Kleitsch exhibitions were received with equal enthusiasm. Antony Anderson teased his readers: "When Earl Stendahl told me, with a confidential air, that a surprise awaited me at his gallery in the Ambassador, I wondered a little—though only a little, because his gallery, since its very inception, has always been a place of delightful surprises." What Anderson discovered at Stendahl's Kleitsch show in June of 1923 was a display of some seventy-one paintings of astonishing beauty and quality. A gypsy soul was gaining the notoriety he deserved.

A "Temporary Agreement" survives in the Stendahl Archive, written in longhand, and dated March 16, 1922, naming Earl Stendahl as Mr. and Mrs. Joe Kleitsch's exclusive agent for the territory of Los Angeles County and vicinity for the sale of paintings produced by Joe Kleitsch. It was agreed that Stendahl would receive a fifty-per-cent commission on all sales and that Joe's wife Edna Kleitsch would earn fifteen percent on any sales she consummated outside the gallery. Of special note is the way the simple document began: "Mr. Alfred Isaacson transfers his Velie car to Mrs. Edna Gregg Kleitsch for the consideration of six hundred dollars." Isaacson was Stendahl's father-in-law. The deal was that the first six hundred dollars taken in on a Kleitsch painting would be turned over to Isaacson, the next six hundred dollars to Stendahl. Edna got her wheels, and the steady sales of Kleitsch pictures made everyone happy until the economic downturn that followed the booming 1920s.

Letters between Stendahl, Joe, and Edna revealed relationships that started strictly in the business arena but evolved to a level of intimacy. From Stendahl to Joe, who was away painting in Spain: "You ought to get down and do a little work every day, no matter how small or large the canvas, for after all, it is the quantity of work that helps you acquire quality, and after all, it is the fine quality in the painting that sells it." Later, in 1926, Stendahl prodded, "All I can say, Joe, is to finish up enough stuff for a big exhibition. I don't care what you do or how much, just plant yourself and paint." In a note to Edna the same year, Stendahl bragged that the king of England had complimented him on his gallery.

Edna was duly impressed. And she was flattered when Stendahl wrote that he thought her son was a fine boy and had the makings of a great man. Such kind words extended to the father when Stendahl called Joe "much better than the average man," trying to reassure Edna, when doubts emerged about Kleitsch's fidelity. Far from home in Europe, Kleitsch was sending back portraits of beautiful young women. Edna may have been justified in seeking comfort from a family man whom she trusted. Stendahl was up to the task—probably as much out of a desire to keep things calm and profitable, as out of sincere affection for the couple.

Stendahl found himself in the middle of other Kleitsch domestic crises, some involving illness and, increasingly, money. Letters, like the gorgeous canvases, kept coming. Poor Edna had three nervous breakdowns and begged Stendahl from her hospital bed in Ohio for money recently made on a Kleitsch painting. By return mail Stendahl sent condolences, along with three hundred dollars minus his commission. The dealer was operating on several fronts. He had recently opened new exhibition spaces in other premier Southern California hotels: the Maryland, the Huntington, and the Vista del Arroyo in Pasadena and the Hotel del Coronado near San Diego.

1 Business license to expand Stendahl Galleries, 1923.

2 At one point, there were several Stendahl Gallery locations. (Note the misspelling of Hotel Del Coronado on this sign).

For a short time in the mid-1920s, Stendahl partnered with dealer Dalzell Hatfield at the Ambassador. They remained associates and friends for many

years after the official partnership ended, with each continuing in his own space. A Stendahl-Hatfield Galleries catalog for an early-1925 exhibition called Joseph Kleitsch and His Work announced on its cover, "If you accept art, it must be part of your daily lives. You will have it with you in your sorrow, as in your joy.

It shall be shared by the gentle and simple, learned and unlearned and be as a language all can understand."

The inventory ledger shows six pages of Kleitsch paintings exhibited by Stendahl over the time of their fruitful association—hundreds of works. Most were marked "sold," and many that were "returned" sold privately or at auction much later. Unfortunately, after the 1929 stock market crash, disappointments over diminished sales and debts seem to have doomed the Stendahl-Kleitsch relationship. Only two years later, Kleitsch died of a heart attack at age forty-six. Stendahl, then a man of forty-two, outlived many of his volatile, temperamental, and stressed-out artists.

Since their business relationship had soured, Stendahl did not sponsor a memorial exhibition for Kleitsch as he had done so successfully following Guy Rose's death in 1926.

While he was art critic at the *Los Angeles Times*, Arthur Millier wrote a popular column called The Art Thrill of the Week, often mentioning Stendahl and his shows.

In an August 10, 1941, piece, the subject was support of the arts: how art cannot flourish without patrons. Stendahl was quoted: "It takes just one man or woman with guts, some taste, enthusiasm and dough. Especially the guts." He was talking about clients and collectors. But he himself took a bold approach to the business of art. Perhaps that was the elemental quality that gave Stendahl an advantage over many other dealers whose galleries closed within two years. Stendahl was no avatar of advanced consciousness

or mythical intuition. He had guts. He thought nothing of telephoning William Randolph Hearst or Nelson Rockefeller or, apparently, George V to interest them in a work of art. He believed in his artists and took risks to promote them. Joseph Kleitsch had needed careful handling, and it didn't end well with him. But Stendahl took his losses with equanimity, because his product (the artist) was worth the trouble.

William Wendt (1865-1946)

The *Los Angeles Times* writer Fred Hogue declared that a Kleitsch landscape actually improved upon nature, but Millier wrote that William Wendt never felt he knew as much as nature. There was humility, as well as poetry, in the Wendt landscapes that captured the California light in such a way that earned him the reputation of dean of the Southern California artists.

Superlatives and awards followed William Wendt, A.N.A., from the time he was a student at the Chicago Art Institute, making him an artist with great appeal for Stendahl. With studios in Laguna Beach and Los Angeles, Wendt was soon considered an adopted, native son. A twenty-five-year association developed, documented by a trove of mostly hand-written letters between Stendahl and Wendt. In short order, "Mr. Stendahl" and "Mr. Wendt" became "Earl" and "Billy." (It took Stendahl a while to correct his "Dear Billie" to "Dear Billy" in those letters.)

To Mr. and Mrs. Earl Stendahl with sincere regards.
William Wendt.

1 *The Village (Laguna)* by Joseph Kleitsch, 1922.

2 Frontispiece of the book Stendahl published, *William Wendt and his Work*, 1926.

WILLIAM WENDT
And His Work

With Articles by:

ANTONY ANDERSON
Art Critic of the West

FRED S. HOGUE
Chief Editorial Writer L. A. Times

ALMA MAY COOK
Art Writer L. A. Evening Express

ARTHUR MILLIER
Art Critic Los Angeles Times

STENDAHL ART GALLERIES
The Ambassador Hotel
Los Angeles, California
1926

In the spring of 1926, Stendahl wrote the following publicity blurb for *William Wendt and His Work*:

> It is with great pride that we offer this exhibition by William Wendt, A.N.A. For many years he has been working for just such a showing. The number and quality of his many canvases show us a Wendt little known, even to his intimate friends. We think and firmly believe that no exhibition in the past, or even in the future, will leave as profound an impression on this community as the present one. Wendt has given us California as she really is, and his work will live to be the most enduring record of our beloved state.

Wendt was a man of deep faith who found spiritual inspiration in the Southern California countryside. Millier, upon viewing William Wendt and His Work, felt "lifted up, made to rejoice, strengthened, comforted." But it is doubtful that the dealer's relationship with Wendt ever touched upon religion. Stendahl's grandson Ron Dammann has no recollection of Earl or Enid ever attending church, having a Bible by their bedside, or ever speaking of their Lutheran heritage. But Stendahl respected whatever muse stirred an artist and could plainly see the magnificent results. His approach was ecumenical in its outreach: come one, come all, whatever your beliefs or background. Gaze upon these canvases. Commune with nature, as interpreted by a trained and inspired eye. Feast on the brush strokes, the color. Put something down and send a little every month.

The correspondence between Stendahl and Wendt over many years documents the development of an increasingly personal dealer-artist relationship. In the 1920s, the language in the letters reflected the colloquialism of the time: "I will try and make this a corking good show and feel that a lot of things will be turned," Stendahl wrote Wendt before a 1922 exhibit at the Ambassador. Over time, the two correspondents express joy, pain, frustration; they occasionally bragged, gently chastised, and, when necessary, forgave.

Stendahl was usually the first non-family member to hear good news from the much-older Wendt (in 1922 they were thirty-four and fifty-seven, respectively). "I doubt Mrs. Wendt has acquainted you with the news of my good fortune in Chicago, that of receiving the Mrs. Keith Spaulding prize of one thousand dollars for my picture, *I Lifted Mine Eyes Unto the Hills.*" Stendahl was delighted. Recognition for one of his artists meant good publicity and increased sales. Wendt was already well established, but the young dealer looked for every angle to promote his top *plein air* painters.

The dealer-artist dance sometimes involved stepping on toes or reminding each other who was leading whom. In December of 1923, after complimenting Wendt on how wonderful his pictures looked in the private room at the Maryland Hotel space, Stendahl reminded his client of their business arrangement:

2

We note what you say about having sent a picture to the Biltmore for exhibition. You are the only one of the western artists whose pictures we handle who is exhibiting pictures there. We wish to cooperate with the Biltmore Gallery in every way possible, in order to further the sales of the western artists' pictures, but we must insist upon the exclusive handling of these pictures. Would like to talk this over with you the next time you are in the city. Yours very truly.

1 Title page of the book, *William Wendt and his Work,* 1926.

2 William Wendt oil, untitled.

A strictly business letter was typical of Stendahl's approach, but it wasn't meant to be off-putting. It might be answered by one filled with the intimate details of loss or illness. In one, Wendt complained of a recurrence of shingles and lamented, "All my good intentions come to naught, as usual." In another, he signed off with "Oh hell, hell, hell," having just told Earl that it is four in the morning and for the third night in a row he is unable to sleep, even after taking ten tablets. "Of course I cannot work—not even out of doors."

Stendahl responded paternally in a way that belied his youth:

> I see now that I will have to come down [to Laguna] and take complete charge and put on this show in a very worthwhile way, while you are out on the desert communing with nature. There is only one thing I want you to do and only one, and that is not to think of the show or of your pictures at all. Don't worry about how many paintings are going to be sold. I want you to forget about paintings in every way. I will take care of this end of it to your credit, and when the final wind-up comes, I am sure the results will make you a very happy and healthy man. Now Bill, cut out all this damn fretting, and go out with Chamberlain or Griffith and

give not a thought to painting or anything but your health, and when you get back, we will all go out and get drunk. I am going to come down the end of this week or sooner with several cars to pick up everything you have that we are going to show. Forget about the reception and banquet, we will pull that stunt later, when you are in a better condition.

Stendahl received a letter from Wendt's physician three years later (1929), telling the dealer that Wendt was having increased attacks of angina pectoris and was instructed to avoid excitement and any physical strain. The doctor declared it distinctly inadvisable for Wendt to attend an upcoming exhibition of his paintings and the opening reception at Stendahl's, because such activities would be too exciting and strenuous for the artist. Why Wendt felt he needed

1 Wendt writes Stendahl, adding a sketch of a painting for an exhibition, 1938.

2 William Wendt exhibition at Stendahl Galleries, 1931.

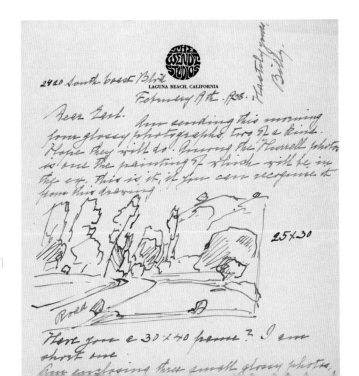

1

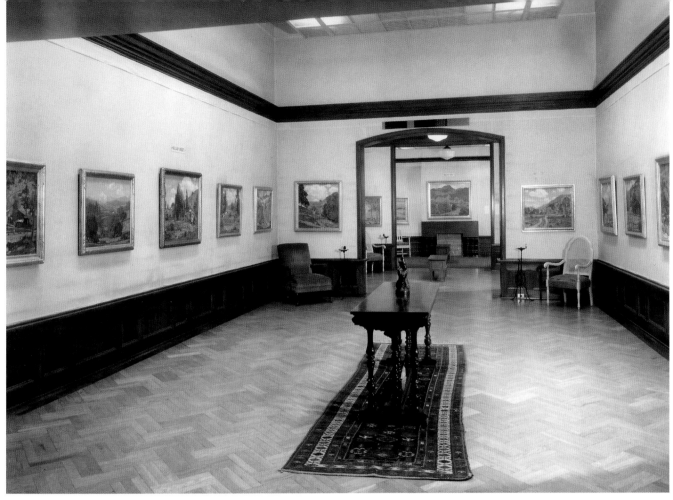

the proof of a note from his doctor is unknown; there is no evidence that Stendahl was ever anything but sympathetic to the ills of anyone close to him. During the years that the dealer was producing the famous Stendahl chocolates at his Wilshire Boulevard gallery, boxes of candy were fairly flying out the doors to any and all who showed the least need for comforting. Wendt did make it to the opening of a March 1931 show, which the *South Coast News* of Laguna Beach called one of the most brilliant gatherings in the history of art in Southern California. It was also one of Stendahl's most successful.

In 1937, Wendt was partially paralyzed by a stroke. But a year later, when Wendt's health had improved, Stendahl reported to him that the fertilizer king of Covina, California, (whose identity remains a mystery) was interested in the painting *Gently Evening Bendeth.* "This man has never bought a picture in his life. Doesn't know values at all," said Stendahl. Wendt responded, "Letter just received. Fertilizer King. Sh--."

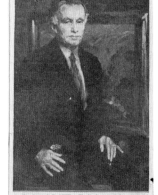

Here is a portrait of William Wendt whose reputation as an artist has shone steadily for more than 40 years in California. Now in his 77th year, his paintings are on exhibition in Los Angeles in a retrospective show. This portrait of the artist is by Fritz Werner.

-1939- Christmas Greetings to Earl and Enid from Billy and Julia.

By the 1940s, Wendt was experiencing more sick than well days. His handwriting grew increasingly shaky. Reading the letters between him and Stendahl during this time feels like an invasion of their privacy. One is witness to the deterioration of an artistic genius. There is an undiminished mutual affection and friendship made more necessary, perhaps, during a period of worldwide instability. Europe was at war. Stendahl returned from a buying trip in Mexico where he had run out of money. "It is sure a hell of a condition I came back to." Wendt responded, "I really have missed you. Of all the wonders you are *the wonder* of wonders. I have seen you while enjoying your hospitality during my exhibitions at the gallery—pretty boy by evening. Next morning the proverbial lark couldn't sing any more cheerfully than you, though it beat you on rising. Here you are, heck, out of money, the same old optimist as always. Your optimism is the saving grace that carries you through, I believe. Wish I had some of it."

Stendahl sent Billy one thousand to two thousand dollars a year for about eight years—the rest of Wendt's life. "Be of good cheer and God bless you for all the fine things you have done for me and

1 Christmas greetings to Earl and Enid from Billy and Julia. Hurrell signed the photo, 1939.

2 A 1942 portrait of William Wendt, at age 77, by Fritz Werner, who also painted the portrait of Stendahl over Guy Rose's *Rising Mist*.

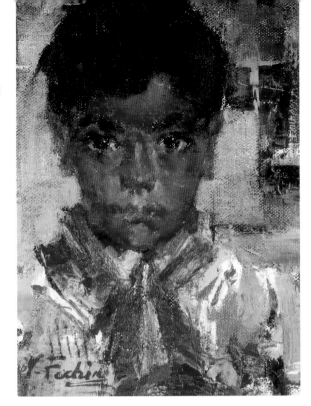

the good guidance you have made me follow. With deepest of love, Earl."

Nicolai Fechin (1881-1955)

One artist stood out from the first time Stendahl looked at a small portrait in oil, bursting with brilliant color, deft in its draftsmanship, and expressing both raw beauty and power. The little Mexican boy with haunting eyes who made such an impression, was the work of Nicolai Fechin, a Russian painter transplanted for health reasons to Taos, New Mexico, following a bout with tuberculosis in New York.

In 1927, Fechin was featured in Stendahl's *Quarterly Review,* sent to gallery clients and prospective clients, "with the idea that you are interested in the great art movement now taking place here in the West." The pamphlet had a circulation of five thousand copies. "Don't flick the pages of the *Review* and then throw it aside for bulkier magazines. Study it. Enjoy it. There's treasure here." The purpose of the publication was to alert its readers to exhibitions at Stendahl's and elsewhere, and to provide information about art happenings of interest to "art lovers and connoisseurs."

Arthur Millier contributed a piece to the *Review,* writing that Fechin's virtuosity compared to the masters Rubens, Titian, and Velasquez. The critic attributed Fechin's artistic depth to his roots, saying, "No Russian, whatever his faults, lives and works on the surface." It is interesting that Millier referred to "surface" pejo-

ratively, because it is the surface of Fechin's canvases that brought so much attention and acclaim. He painted with a palette-knife technique that left dollops of jewel-like colors, each startling to the eye. Stendahl considered himself "an amateur sketcher" but had aspirations of becoming a good painter.

3 *Jose Lisandes Renandes* by Nicolai Fechin, circa 1935.

4 Nicolai Fechin.

In Fechin's Taos studio, Stendahl tried his hand at applying paint the way the master did, and was the first to admit he never achieved anything close to the effect he so admired in Fechin's work.

Stendahl found enchantment in the Fechin portraits and easel paintings. "Your things are the kind of paintings I love to deal in, and I know we will be very successful in handling them. If it is possible to get your things together for a show, we would make quite a thing of it. You have a host of friends here, and they will all put in a good word for you and do a lot of boosting."

Stendahl dedicated himself to expanding the artist's reputation in Los Angeles, building upon good notices from New York and New Mexico. Critics and collectors responded enthusiastically to the Fechin exhibition in April of 1928 at the Ambassador. But the opening was threatened the day before, when the paintings hadn't arrived. Wealthy collector John Burnham loaned his private

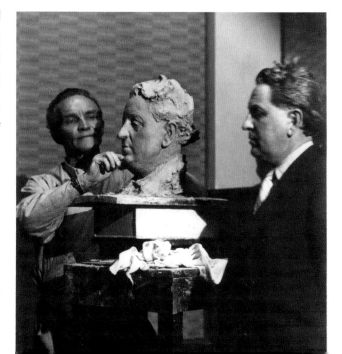

plane so Stendahl could fly to Palm Springs where Fechin was working. "I denuded his studio of paintings and within two hours was back in town. I guess it was the very first complete art exhibition delivered by plane," Stendahl told radio interviewer Prudence Penny in 1931.

Stendahl went on to tell the radio audience that his reputation as "The Flying Art Dealer" came about "for both love and expediency. I've since flown all over Europe, to Mexico, and frequently fly to New York for a single day to buy some special picture coming on the market. This last trip, I flew to New York, stopping off at Taos to see Fechin and Leon Gaspard, the two Russian artists living there. In London, or rather Chelsea, I stopped off to see Dean Cornwell's murals for the public library here [Los Angeles]. Then flew to Paris. It's great fun, flying, and darn economical business, as well."

1 Fechin in his studio, Taos, New Mexico. Note the door, hand-carved by Fechin: Stendahl bought it along with another, then installed both in his Hollywood home in 1954.

2 Fechin captures Stendahl in clay.

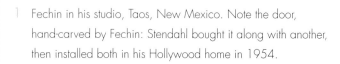

2

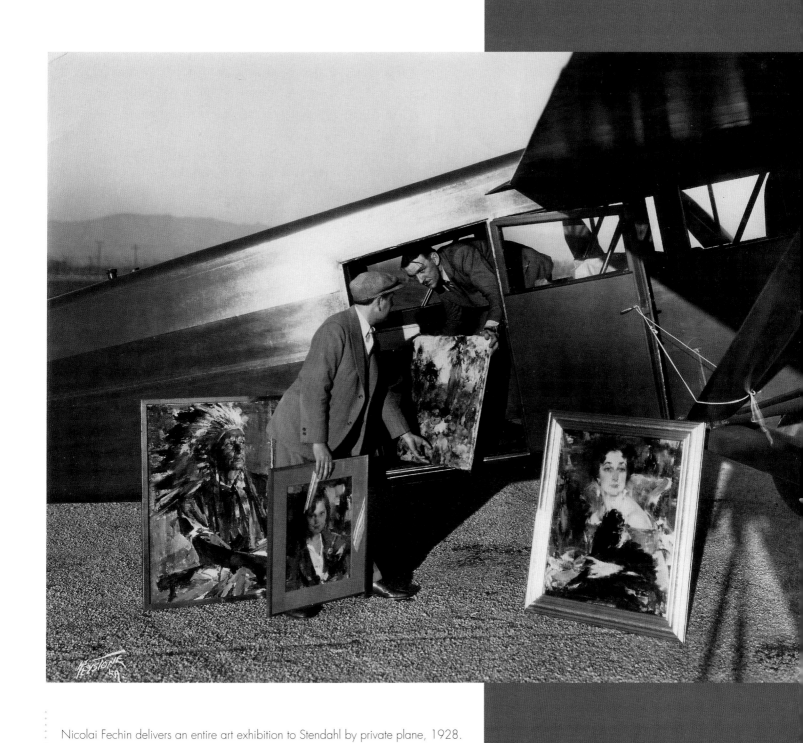

Nicolai Fechin delivers an entire art exhibition to Stendahl by private plane, 1928.

In the interview, Stendahl took some credit for the strenuous activity required to further Southern California's hard-earned dominance over San Francisco as the art center of the Pacific Coast. Fechin was an example, he explained, of making a worthwhile investment in an important artist.

Fechin was honored by Stendahl at an artists' banquet, in conjunction with Fechin's solo show at the Ambassador, in February 1930. The dinner was attended by most of Stendahl's artists—truly a Who's Who of the best painters producing art at the time.

Eleanor Stendahl Dammann Howell recalled that, although many artists shared family meals on Bronson Avenue and in the Hollywood Hills, Fechin was one of the few her father spoke of often, apart from business. She didn't understand until her teenage years that the Stendahls' livelihood depended on Papa's dealings with his artists. Didn't every kid pass the dinner rolls to Karoly Fulop or Julia Wendt or Millard Sheets? The Fechins were a colorful bunch, and Eleanor, just slightly younger than their daughter Eya, enjoyed hearing stories of colorful Kazan, Nicolai's Russian home village. She never forgot talk of Fechin's reputation as the "Tartar Painter."

Eleanor took her sons to see Eya at the Fechin house and studio in Taos, a place that was hand-crafted by Fechin in a mélange of Pueblo and Russian styles. When Eleanor became a grand-mother, she encouraged visits by the next generation

1 Portrait of Eleanor Stendahl Dammann, by Nicolai Fechin.

2 Fechin and Stendahl in the Ambassador cactus garden.

3 Stendahl's Artists' Banquet at the Ambassador, honoring Fechin, 1930.

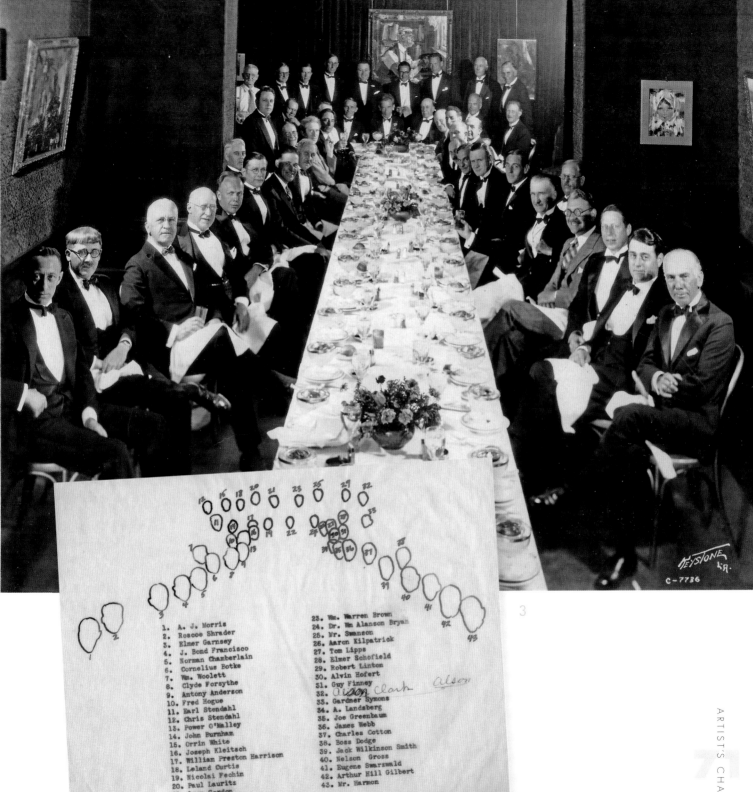

1. A. J. Morris
2. Roscoe Shrader
3. Elmer Garnsey
4. J. Bond Francisco
5. Norman Chamberlain
6. Cornelius Botke
7. Wm. Woolett
8. Clyde Forsythe
9. Antony Anderson
10. Fred Hogue
11. Earl Stendahl
12. Chris Stendahl
13. Power O'Malley
14. John Burnham
15. Orrin White
16. Joseph Kleitsch
17. William Preston Harrison
18. Leland Curtis
19. Nicolai Fechin
20. Paul Lauritz
21. Leon Gordon
22. James Montgomery Flagg

23. Wm. Warren Brown
24. Dr. Wm Alanson Bryan
25. Mr. Swanson
26. Aaron Kilpatrick
27. Tom Lipps
28. Elmer Schofield
29. Robert Linton
30. Alvin Hofert
31. Guy Finney
32. Olson Clark Olson
33. Gardner Symons
34. A. Landsberg
35. Joe Greenbaum
36. James Webb
37. Charles Cotton
38. Boss Dodge
39. Jack Wilkinson Smith
40. Nelson Gross
41. Eugene Swarzwald
42. Arthur Hill Gilbert
43. Mr. Harmon

3

to the non-profit Fechin Institute, founded in 1981 to honor the artist's life and work.

Fechin established a studio at the Stendahl Art Galleries on Wilshire Boulevard, where Stendahl provided certain comforts, including a samovar for the man from Kazan to make Russian tea. Stendahl had bragged to Nicolai and his wife, Alexandra, that the new gallery was one of the most beautiful in existence and that they would surely be thrilled to see it. Sure enough, when Fechin first entered the Wilshire Boulevard building, he said, according to Stendahl, "My, a cathedral!"

A vigorous letter-writing campaign brought in commissions for portraits, which kept the artist busy, in addition to the classes he began to conduct in the Stendahl Galleries outdoor patio.

"So far the enrollment has far exceeded our expectations," Stendahl wrote to Ukrainian-born artist Alexander Archipenko, hoping to entice him to teach drawing, sculpture, and painting, in conjunction with his upcoming show at Stendahl's. Many artists agreed to shepherd the courses, and for years some journalists referred to Stendahl's art school, with one using the term "outlaw" art school, so innovative was the instruction coming out of 3006 Wilshire Boulevard.

Thomas M. Beggs, while chairman of the Pomona College Art Department in 1934, contacted Stendahl, asking him to "send the dope" on Fechin's classes to a promising art student, who was deeply interested

in undertaking the work. The young man was John C. (Jack) Burroughs of Malibu Road, Pacific Palisades. "Just tell him when to show up, and he'll be there," said Beggs. Jack Burroughs was the twenty-year-old son of *Tarzan* author Edgar Rice Burroughs. Three years after studying at Stendahl's with Fechin, Jack was given the chance to illustrate his father's book, *The Oakdale Affair and the Rider.* Edgar was reportedly so proud of his son's work that he assigned him as illustrator for all his subsequent books during his lifetime.

Alexander Archipenko, who knew Fechin well, saw that his comrade's classes were bringing in more money than sales of pictures: about twenty-five hundred dollars for six weeks. Archipenko was offered studio space at Stendahl's for the run of his art course, should he agree to teach. It would be a coup to land him. The fiery artist was among the most aesthetically inventive sculptors of the twentieth century. He mixed media in startling ways and made a big splash on the Paris art scene at a very young age. Stendahl was drawn to Archipenko's modern approach and Cubist tendencies. He knew that Archipenko already had a reputation as a teacher in New York. When the artist said "yes" to teaching

classes, Stendahl opened a bottle of vodka and shared it with Fechin.

Fechin told others about a note Stendahl showed him from Archipenko regarding Archipenko's upcoming show at the gallery. There were two specific requests: submit publicity to only the most important newspapers in Los Angeles and serve no refreshments at the opening, as "it only tends to create the wrong atmosphere for the appreciation of modern art. Don't you agree with me?"

It is highly unlikely that Stendahl believed a "wrong atmosphere" could come from plenty of canapés and cocktails. There is no record of any compromise that might have been reached, or how much fun was or was *not* had by all at Archipenko's opening party.

Champion that he was of the artists he represented, Stendahl could not do all he wanted for them. He struggled mightily in the 1930s. "Every gallery will promise sales on things they don't have. I have done that many times myself." The dealer could be surprisingly candid about his business practices, as in a letter to Alexandra Fechin. "We have done everything humanly possible to make sales, but there just haven't been any." Luckily, Fechin's work had caught the eye of actress Lillian Gish. He painted a large oil portrait of her (very large at forty-nine by forty-five inches) in 1925 called *Lillian Gish as Romola*, which hung in the Art Institute of Chicago.

In late 1936, Stendahl concocted a plan to exploit Fechin's relationship with the star. A little publicity with Hollywood flair might generate new sales. Stendahl contacted Gish in Beverly Hills, telling her it would please Nicolai Fechin very much if she would extend him the privilege of doing a drawing of her head to be reproduced in a planned book about the artist. The drawing would appear next to a color image of *Romola*. "Although I have not seen the portrait Mr. Fechin did of you, reports received from artists pronounce it one of the finest produced in

Ukrainian artist Alexander Archipenko.

1

1 *Lillian Gish as Romala* by Nicolai Fechin, 1925.

2 *Tonita* by Nicolai Fechin.

this country." When Gish came to Fechin's studio at Stendahl Galleries for a sitting, Stendahl made sure the local press knew about his glamorous visitor.

One of the last works Stendahl sold of Fechin's, before the artist died, was a portrait in oil called *Tonita*. Viewers are moved by the Indian girl with a lap full of crimson roses so voluptuously vibrant that they could only have been painted by Nicolai Fechin.

COEQUALS: THE FEMALE ARTISTS

Throughout his long career, Stendahl was particularly drawn to the female in art. A study of his personal collection from the 1930s through the 1960s reveals an abundance of women as subjects on canvas, in stone, and in Pre-Columbian clay. Stendahl's affinity for the feminine in art was complimented by his enthusiasm for the female painters he represented. Millier called them "Earl's Girls," a term Stendahl liked. Some of the most talented were married to famous artists: Julia Wendt, Elsie Payne, Ethel Rose, Edna Kleitsch, Jessie Botke. It is a fact that divorces occurred over artistic jealousies when certain wives were relegated, unjustly, to their husbands' shadows. And, as we have seen with Edna and Joe Kleitsch, Stendahl sometimes found himself in the middle of domestic dramas, acting as a reluctant referee.

Stendahl was particularly respectful of the output of his female artists because he recognized that their motivations and their commitment to the artistic calling were different from the men's. It might be a stretch to call Stendahl a feminist, but there is no denying he was sensitive to how the women had to rearrange their lives—sometimes drastically—to make art. He worked with talented women who, faced with the pressures of marriage, children, and their "place" in society, resisted suppressing their creativity. He considered the world better for their bravery and declared so by putting the best among them in the spotlight. Stendahl didn't charge less for women's paintings, as some other dealers did, dealers who believed that painting as well as a man was the goal of any female artist and accomplishing that was a rare feat. Stendahl's approach was as

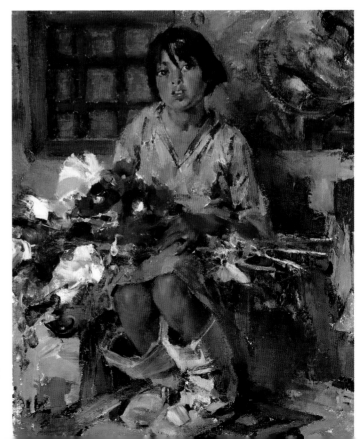

uncomplicated as it was smart: recognize quality wherever it occurs and support it. Even up against the most sought-after male painters of the day, there was nothing second-class about Earl's Girls, except perhaps the sexist moniker itself.

Stendahl agreed to put on the inaugural exhibition of Group of Six, made up of a half-dozen West Coast women painters, who felt they could garner more attention by pooling their considerable talents. They deliberately chose a name that had no suggestion of femininity. Their work in watercolor, oil, and lithography won high praise and was deemed by critic Alma May Cook to be better than many showings of male artists at Stendahl's. The six were: Marian Curtis, Eula Long,

Dorr Rothwell, Martha Simpson, Bernice Singer, and Denny Winters. Determined that the women he represented should be showcased, Stendahl rarely said "no" to a request from the sometimes-demanding females. One was wise not to thwart the likes of Ethel Rose, Edna Reindel, Bessie Lasky, Jessie Botke, Julia Bracken Wendt, Marion Gross, or Emmy Lou Packard.

Julia Bracken Wendt (1871-1942)

Julia Bracken Wendt was a well-regarded and successful sculptor, who is said to have been the inspiration behind the work of her more-famous husband, William Wendt. Stendahl enjoyed a personal and professional relationship with them both, visiting Julia often in her Arroyo Seco studio. He admired her for the monumental pieces she created, unusual work for a woman. Her artistry can still be seen in Los Angeles at the Ebell Club and at the Los Angeles County Museum of Natural History, where her large, classical sculpture for the rotunda was hidden away for decades, before being resurrected in 1980 in a place of honor. Apparently, after Julia died, her draped goddesses clashed with the move toward Modernism in art. While her style was still in

1 Marion Gross catalog cover and inside cover.

2 Bessie Lasky.

favor, Stendahl helped her earn the commission for a bas-relief on the Hollywood High School Memorial Auditorium (now its library.)

Ethel Rose (1871-1946)

In 1935, Arthur Millier touted Ethel Rose, Guy Rose's widow, as the number-one discovery of the art season. But she wasn't new to Stendahl, who had been encouraging her artistic leanings from the time he began representing her husband. He put on the first show of Rose's decorative paintings done in tempera that were, according to Millier, astonishing and delightful in their loving detail. A few years later, Ethel Rose exhibited again at Stendahl's, this time in A Special and Important Exhibition of Small Exquisite Water Colors. It didn't matter to Stendahl that the artist had not had any formal art training until late in her career. He knew from his own experience as a painter that studying was only a part of what it took to make good art. He liked Rose, and he liked her work enough to invest time and money in the pursuit of sales for her.

Rose confided to Stendahl that her husband's lead poisoning affected not only his vision, but his hands, which became so crippled that he could no longer hold a paintbrush. As an artist herself, she agonized over his suffering. Whether or not her husband's illness had an impact on her own artistic output is unknown.

But she relied heavily on Stendahl for support in the years following Guy Rose's stroke in 1922.

Rose and Stendahl's relationship could not help but be complicated by the death of Guy and their subsequent financial dealings in trying to sell off his paintings. Though affection remained, it wasn't an easy partnership. Stendahl would have preferred to be her art dealer, without the added responsibility of managing her deceased husband's estate.

Rose's fashion illustrations were featured in *Vogue* and other national magazines until her death on Christmas Day, 1946.

Bessie Ginsburg Lasky (1888-1972)

Another female painter whose work sold well at Stendahl's was Bessie Lasky, wife of Hollywood movie producer and mogul, Jesse L. Lasky. Stendahl especially liked Bessie's California mission paintings. Through her, he found new clients in actors Adolph Menjou, Jean Harlow, and Mary Pickford, who, for a time, was a producing partner with Jesse Lasky. Stendahl was never overly enamored of the "film colony," as he referred to it, but took every opportunity to reach out to potential, moneyed clients. The Laskys lived on Tower Road in Beverly Hills; Stendahl was only too happy to meet their neighbors.

Emmy Lou Packard (1914-1998)

In July 1941, Diego Rivera asked Stendahl to show the works of his protégée, Emmy Lou Packard, a young painter, print-maker, and muralist, who had lived with Frida Kahlo and Rivera in Mexico. It was a tribute to Stendahl that Rivera chose his gallery for Packard's new series of paintings and drawings, because it's likely that Jake Zeitlin, A. Cowie, D. Hatfield or a number of others would have gladly taken her on. Rivera heaped euphoric praise upon the twenty-six-year-old's work and regarded her not just as a prodigy, but as a member of his family.

Stendahl enlisted Rivera to write the introduction for the Packard show catalogue, as he had done for Kandinsky's seventieth-birthday exhibition at Stendahl's. Poetic and heart-felt, Rivera's essay reads like a love letter to artistic talent, to Mexican-American heritage, and to the promise of youth.

1

1 Diego Rivera and his protégée Emmy Lou Packard

2 *Self-Portrait in a Jungle* by Emmy Lou Packard.

3 Original, signed letter: Diego Rivera sends Stendahl an introduction to Emmy Lou Packard and her show.

In November, 1928, an American woman came to see me [...]
me the paintings her daughter had done. At that time I was painting
the Secretariat of Education murals, in Mexico City, where this child
had been living for two years. Her name was Emmy Lou Packard, the
excellent painter of today, [...] great character, [...] the paintings of

I was [...]
tones, and the [...]
Mexican life th[...]
 She w[...]
a French gothic[...]
had been born [...]
and shy, brigh[...]
country in whic[...]
ponded with th[...]
produced them.[...]
two centuries [...] [...]uego.
hybridization [...] [...]he
tinent. Born [...]
is the true t[...]
home is the l[...]
 Tod[...]
entire year [...]
plant appeare[...]
for her. Sh[...] [...]t.
mixed with b[...]
from the ori[...] [...]r-
bright cours[...] [...]e same
fertil Ameri[...] [...]s
The America[...]
portions ap[...] [...]the
velous pla[...] [...]of
as it was t[...]
in the draw[...] [...]n and
the humid [...] [...]sed
South; hig[...]
yellows, b[...] [...]al
Mexico. [...] [...]o
Mexican, [...] [...]raw-
in plastic[...] [...]en

language [...] [...]precia-
handles b[...]
ing, the [...] [...]d love
years ago[...] [...]grown

tion bef[...]
receive [...] [...]st
with whic[...]
ourselves - grown from two [...]
united with twenty centuries of a marvelo[...]
now beginning to become again a living reality.

Diego Rivera

Edna Reindel (1900-1990)

Some of Stendahl's artists stand out as straddling genres and styles. An example is much-honored Edna Reindel, a New York painter who moved to Los Angeles in the 1930s. Her adaptable output was appreciated by both conservatives and Modernists. One watercolor was called *Republicans Are Not Always Ungrateful*. Reindel was one of few women who sought and was awarded mural commissions. Stendahl's interest in her work centered on still-life studies, flowers and scenes of Martha's Vineyard in New England.

.

If ever Earl Stendahl met his match, with respect to a persuasive female personality, devotion to artists, pioneering spirit, and sheer vitality, it was in the person of Madame Galka E. Scheyer. She was not herself an artist, but a German-born art collector and dealer who championed modern art. She was dedicated to bringing to the American consciousness major figures of Europe's avant-garde, much as Stendahl had done as early as 1929. Scheyer was best known for founding and relentlessly promoting the Blue Four collective of artists, Wassily Kandinsky, Paul Klee, Lyonel Feininger, and Alexei Jawlensky. Her 1926 California shows in Oakland and Los Angeles were groundbreaking enterprises that opened to both enthusiasm and revulsion. Stendahl was watching, as Scheyer drove home her point: Abstract art was here to stay. And her four artists, her "kings," were among the most important practitioners of the day.

2.

1 Galka Scheyer beams as Mary Pickford admires her portrait, thought to be by Beltrán-Masses.

2 Artist Edna Reindel at work on her self-portrait, 1942.

Unsurprisingly, Stendahl signed on to show the Blue Four but didn't realize, at first, the consequences of doing business with the abrasive Galka Scheyer. At times, she was a girl Earl could do without.

"She was a feisty little thing," remembered Earl's son, Al. Difficult, uncompromising, salty of speech. Stendahl and Scheyer fought over details of the Jawlensky and Kandinsky shows on Wilshire Boulevard. Al recalled an all-nighter, where Chris Stendahl was helping Scheyer and Earl hang paintings for an opening the next day. Struggling with one canvas, Scheyer asked Stendahl, "How high should I hang it?" to which he replied, "Tit high, little lady. Hang it tit high."

After Scheyer died, Stendahl was determined to see her important collection remain intact, preferably in Southern California. Scheyer had envisioned UCLA as its repository. That was not to be. Instead, thanks to Stendahl's intervention, more than five hundred pieces from Galka Scheyer's artists, and hundreds of documents, were donated to the Pasadena Art Museum, where they now reside in the Norton Simon Museum of Art. Stendahl's friendship with Scheyer had been enhanced through their mutual affection for Diego Rivera, who was a strong advocate for female artists.

Stendahl's reputation for supporting women's creativity got a big boost during his sponsorship of the Junior Leagues of America annual exhibitions of arts and interests. He gave over all the rooms of his galleries to the works of prize-winning members of the Junior Leagues from all over the country—122 chapters, some twenty thousand members strong. These were juried shows that displayed arts and crafts in so many categories that it is difficult to visualize that everything fit into the Wilshire Boulevard building: sculpture, oils, watercolors, drawings, prints, lithography, photography, books and portfolios, ceramics, miniatures, woven and embroidered fabrics, metal work, knitting, puppets and marionettes, baby clothes, rugs, and costume designs, to name a few. Many of the Leaguers, known more for volunteerism and social pursuits, were fine artists, and the judges weren't amateurs, either: For the 1937 exhibit, no-less-noteworthy authorities than artists Stanton Macdonald-Wright and Barse Miller, and critic Arthur Millier were impaneled to hand out the ribbons.

Stendahl was in his element hosting the Junior League shows. True to form, he concocted a program of concomitant classes offered in arts and crafts,

needlework, Christmas card-making, theater arts, and scenery design—all to further exploit the talents of the energetic young women he was getting to know. Al remembered his mother signing up for theater arts; she had nurtured a dream in her Wisconsin youth of acting on the stage. She did make it to Hollywood but never crossed the footlights from audience member to performer. It may be that Enid enrolled in classes during the Los Angeles convention of Junior Leagues more to keep an eye on Earl than to hone her thespian skills. Stendahl spent a great deal of time in the company of women. Whether or not Enid doubted her husband's loyalty to her, she did worry that he might not always behave in a gentlemanly manner around the female artists. She heard the "tit high" story, along with everybody else.

Whatever his image or mood on any given day, Stendahl never wavered from his commitment to the artists—be they male or female—nor did he put himself above them. He was comfortable as a middleman between those who made art and those who bought it. If pushed to favor one constituency over the other, Stendahl would choose the artists. He was their champion, and they responded.

Bessie Lasky was photographed by *Vanity Fair* photographer Walter Frederick Seely.

The Stendahl candy kitchen.

Chapter 4 CANDY KID

No matter how hard he tried,

Earl Stendahl could not sugar-

turning the top floor of his new gallery into a candy kitchen

coat the Great Depression. When

wasn't obvious (or even conceivable) to anyone but the

art tumbled quickly to the bottom

former confectioner from Wisconsin. Just as opening the

of most people's must-have lists,

Black Cat Café in downtown Los Angeles relied upon

Stendahl faced a decade of daily

Stendahl's former experience in the restaurant busi-

rigors to stay afloat. The idea of

ness, the soon-to-be-famous Stendahl Chocolates evolved

from his early success in the family candy business.

By 1931, the café on Main Street must have seemed a distant memory. Stendahl closed it several years before preparing for his first gallery at the Ambassador in 1921. But he carried with him the experience of turning out good food and sought-after sweets.

Stendahl was dubbed the "Candy Kid" by author and screenwriter-director Rupert Hughes, Howard Hughes's uncle. Did the nickname bother Stendahl? Not at all. Where another businessman might take umbrage at the suggestion of unsophistication, Stendahl made no pretense of the fact that he was good at a number of things, one of which was making candy. In fact, he liked the attention of someone as well regarded as Rupert Hughes. When radio interviewer Prudence Penny teased Stendahl about being called the Candy Kid, Stendahl laughed it off with, "One man sent in an order for twelve hundred pounds, thereby *forcing* me into the business, so here I am—a dignified art dealer, being interviewed as the Candy Kid!"

If only there could have been an abundance of such lightheartedness during the humbling 1930s. Certainly, Stendahl's optimistic nature helped carry him through and set an example for his wife, children, and employees. But reality could only be finessed so far. One might assume that the segment of the buying public that could afford fine art collecting would be less affected than other parts of society. But Stendahl, along with the rest of the Southern California art community, discovered that almost no one escaped the upheaval. Even film-industry clients, who had previously accepted Stendahl's terms, now moaned and haggled over prices.

The move to 3006 Wilshire Boulevard had been a leap more of faith than practicality. But Stendahl was not one to cling to a comfort zone. The Ambassador, for all it had offered the dealer, was yesterday's news. Still, would patrons who followed him to the new building be receptive to pictures on the walls that critics were calling "wild"? Stendahl's enthusiasm for Chagall and the other renegades was genuine. But he realized that it wasn't enough for *him* to like the new wave. He had to convince a buying public. He smartly aligned himself with the Art Students League, the Painters and Sculptors Club and a small number of art schools and galleries that were also taking bold steps to define the avant-garde in Los Angeles. A growing community of European émigrés was settling in Hollywood and enriching its artistic and social landscape. Stendahl's home became a salon for gatherings of artists, collectors, and critics, just as the third-floor kitchen of his new gallery became

the place to lay out meals for artists-in-residence and their patrons. At the time Stendahl closed up shop at the Ambassador, the press questioned whether anyone else could fill the void in those spaces. Would the new occupants offer the same kind of hospitality? The studio lunches and private office chats with famous artists? Stendahl liked that there was a perception out there that his style of promoting art and artists would be missed at the Ambassador. Since he wasn't a man to leave things to chance or to rest on past reputation, he decided to create even more impressive experiences for his customers at his new gallery and, sometimes, elsewhere.

"Los Angeles has at last an art gallery adequate to its needs and in what a worthy setting!" The *Los Angeles Times* and other papers had nothing but superlatives to bestow upon Stendahl's new emporium for fine art. It was, by all reports, an institution impeccably planned, from lighting to specially made wall fabric woven in New York to cabinetry, curtained recesses for the most valuable paintings, exterior staircases, outdoor sculpture bases and niches—all artistically pleasing and functionally appropriate.

A formal invitation-only reception was held on Tuesday, September 29, 1931, honoring internationally known muralist Dean Cornwell in his first one-man show on the West Coast. A Beverly Hills columnist called the fancy-dress party "as brilliant a gathering as we've ever seen in this sartorially scrambled town" (a label that could describe Los Angeles today).

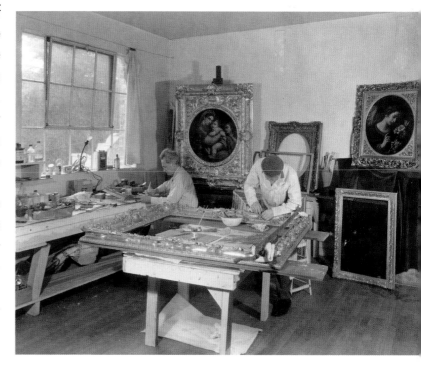

Earl Stendahl was a ringmaster of, in his words, "a four-ring circus" at the New Stendahl Galleries. And, in fact, the outdoor Sculpture Court was covered with a canvas tent that Stendahl preferred to

Frame-making studio at Wilshire gallery. Vic Stendahl and Swiss restorer Joseph Sutter (in beret) at work.

1

3

1 Opening night, the new Stendahl Galleries, 1931. The architecture firm of Morgan, Walls, and Clements was hired to implement Stendahl's vision, although Stendahl did much of the "architecting" himself, according to Al. Partner Stiles O. Clements had studied at the Ecole des Beaux Arts in Paris and was prominent in the Art Deco movement of the 1920s, particularly along Los Angeles's Miracle Mile. The famous El Capitan, Mayan, and Wiltern theaters were designed by the firms, as well as the Richfield Oil Tower, which was demolished in 1969, just three years after Clements and Earl Stendahl both died.

2 Print Room, Stendahl Galleries, Wilshire Boulevard.

3 Vestibule, Stendahl Galleries, Wilshire Boulevard.

call a pillared pergola. Sonia Wolfson invited Alma Whitaker of the *Los Angeles Times* to come and preview the "magnificent" Cornwell exhibition in the new galleries that she said would attract world-famous artists. She defended her over-the-"big top" solicitation: "these adjectives are not merely Barnum & Bailey wind."

The beautifully designed spaces included an Old Masters Gallery, the Modern Room, Print Room, Tapestry Gallery, Lecture Hall, Fountain Garden, and studios for painters and sculptors. The portrait painter's studio had been planned with particular attention to the artist's comfort and aesthetic sensibility. Stendahl provided a model stand, dressing room, balcony, fireplace, even a Frigidaire to save trips up or downstairs for refreshments.

In the middle of the new gallery's opening-night party, when a photo opportunity for the artist presented itself, Stendahl searched room by room for Cornwell, but the artist could not be found. Cousin Chris discovered Cornwell on the third floor, leading a group of the

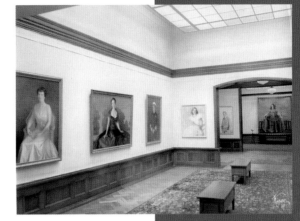

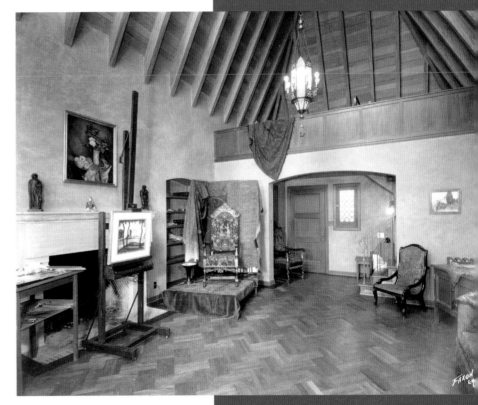

1 Modern Room, with works by Russian portrait painter Glev Ilyan, 1936.

2 Upstairs Portrait Painter's Studio, Stendahl Galleries, Wilshire Boulevard.

gowned-and-tuxedoed on a tour of Stendahl's candy kitchen and handing out chocolate samples.

The Beverly Hills reviewer called the formal affair a high compliment to Wisconsin-bred Stendahl—the Candy Kid who became one of the most famous art dealers in America. "Earl has raised his candy making to a high art," the reviewer said, followed by comparing (one hopes facetiously) the color and texture of the candies to the quality of the paintings on display. There is no question that the chocolates were world-class. Indeed, a magazine ad for the Cornwell show included mention of "Stendahl's Chocolate DeLuxe Candy, made daily in spotless kitchens. Order early for Thanksgiving and Christmas."

Downstairs there was plenty to enjoy, too. Guests who glided over oak parquet and mahogany floors were treated to a display of life studies for the four large murals Cornwell had just completed for the rotunda of the downtown Los Angeles Public Central Library. The ambitious project, which earned the artist fifty thousand dollars in prize money, took five years. Each painted panel depicted successive eras in California history.

The Beverly Hills review closed with an observation that turned out to be as prescient as it was sardonic: "Those who don't go to see these famous pictures are the kind of people who would beat little children, suck eggs, or vote for wax figures of movie stars on Hollywood Boulevard." In 1966…a museum filled with wax figures with famous faces turned up.

Much has been made of the Stendahl Chocolates that were later paired with boxed puzzles of fine art prints, giving customers a double treat. Stendahl knew he was onto something unique and prized by the artists, other dealers, and collector-clients. Thank-you letters to Stendahl acknowledged the highly anticipated treats that would arrive at Christmastime. But the Candy Kid was, to a certain extent, putting on a brave face for the public. The candy factory at 3006 Wilshire Boulevard was not a nostalgic holdover from his youth, nor a sideline hobby that he could take or leave. The hard fact was that art sales dipped precariously during the Depression years, and Stendahl relied on his

1 Dean Cornwell and Stendahl.

2 Cornwell's exhibition, featuring studies for the L.A. Public Library rotunda murals.
The studies are seen at the rear of the gallery, under the window.

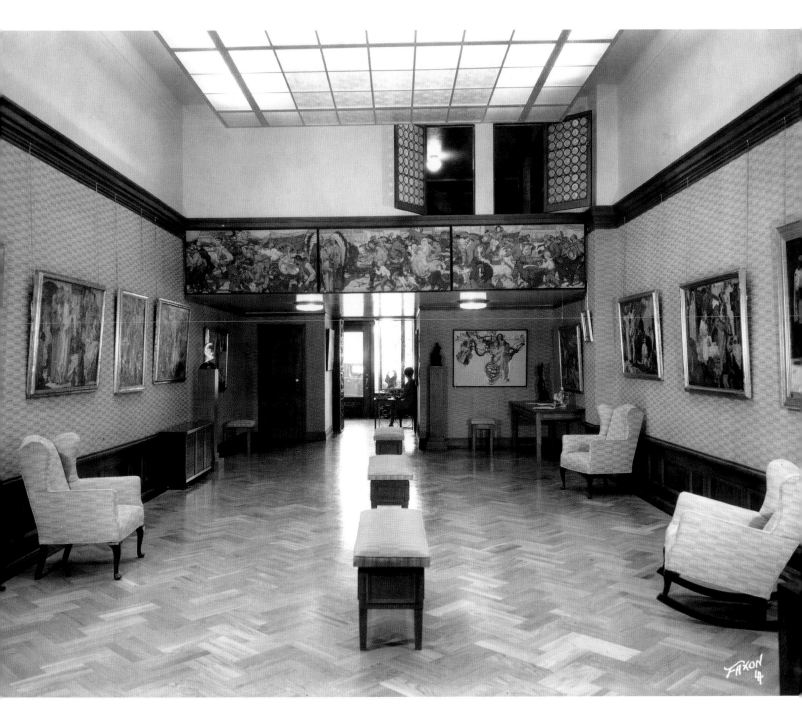

confection and puzzle businesses to help pull him through. Other galleries closed, most within two years, during the decade that Stendahl struggled to stay afloat on Wilshire Boulevard. Adding to the pressure of dealing art in a sunken economy, the Stendahls were developing closer ties with their artists. Earl and Enid felt a responsibility to help keep them housed, clothed, fed, and funded through sales of their work. Stendahl gravitated more toward the European modern artists; he was committed to the likes of Lorser Feitelson, Robert Henri and the other members of the Ashcan School (a group of painters, who advocated capturing social realism in American society), Stanton Macdonald-Wright and Millard Sheets. However, he maintained an interest in some of his favorites from the more representational schools. The dealer had a hand in building each artist's reputation in Southern California. Stendahl was not without his detractors, but in circles that counted for him, he continued to be held up as the apotheosis of fine art entrepreneurship. Otheman Stevens, of the *Los Angeles Examiner,* wrote, "Stendahl Gallery has none of the pouf-pouf of striving and all of the beauty of good taste and bold accuracy." An exhibitionist reviewed by a drama critic.

The Prudence Penny radio interview transcript allows us to imagine Stendahl's voice as he responded on a number of subjects, including the Stendahl Chocolates. Penny suggested that Stendahl's candy sales might be negatively impacted, since cigarette companies were trying to reach dieters with advertising slogans like "Reach for a Lucky, instead of a sweet." But Stendahl had a ready comeback:

> My chocolates contain one-half the amount of sugar found in the usual candies. They're made from the purest ingredients, the finest nuts and most expensive chocolate obtainable. We use pure forty-five percent butterfat cream, and there are no preservatives injected; they are never left on the market for more than two weeks, or they'd turn, just as pure cream will. The coating never leaves a sticky taste; your mouth feels so clean and sweet after eating one, you're quite ready for another.

His insights came in 1931, long before the benefits of natural foods could be applied to candy marketing. To say Stendahl was ahead of his time is understating the obvious: the man saw things, anticipated things, understood things, and took action in ways that others never contemplated.

The idea to combine the packaging of his candies with puzzles came to him when Enid and Al joined

the growing craze over what a jigsaw could do to plywood. In today's fast-paced, technological world, the notion of sitting around a table for hours with family and friends, pushing three hundred to five hundred puzzle pieces together to form a picture seems quaint, if not downright boring. But in the early days of the Depression, at-home activities gained popularity when people could no longer afford restaurants and other outside amusements. Adults looking for cheap entertainment discovered jigsaw puzzles in a big way. In 1933 alone, Americans purchased ten million puzzles a week. It is not surprising that Earl Stendahl would look for a way to mine such a rich vein.

"He thought there was gold to be made…and why not by us? Pictures weren't selling." Al recalled the way his father developed the jigsaw puzzle concept as a money-making scheme. Stendahl-the-Senior wouldn't have called his queries "market research," but that is essentially what he was conducting, when he looked into what appealed so strongly to the people who were emptying store shelves of puzzles. He tried his hand at a few himself with Enid, Al, and ten-year-old Eleanor. There was no denying a certain sense of accomplishment in placing the last puzzle piece. In a society suffering from more than

twenty-five percent unemployment, even a small victory could help ease troubled minds. Stendahl began to understand puzzling's wide popularity and set out to make his mark in the new field.

The Candy Kid (soon to be a Puzzle Prince?) heard that unemployed woodworkers, craftsmen, even architects were starting to cut puzzles and sell them. But the puzzle-subject pickings currently being offered were slim: tired, trite, poorly colored images, that seemed to appeal mostly to children. Quality was always paramount in Stendahl's thinking and in the way he did business. To his mind, here was a niche that could be filled. He could make a better puzzle, a beautiful puzzle.

The gallery had been accumulating stacks of color reproductions of paintings. Earl and Chris pasted some on plywood, then made the cuts with a jigsaw. Masterpiece Picture Puzzles was born. Puzzle enthusiasts would be rewarded at the end of their endeavors with a fine-art picture that had been (or still was) a part of Stendahl's famous collection. California scenes were popular picture subjects, for which Stendahl had many examples from his California Impressionist artists.

Estelle Doheny (Mrs. Edward L.) sent photographs over to Stendahl, asking him to make them into

No. 17.- CALIFORNIA POPPIES PICTURE PUZZLE CHOCOLATES-2 LBS- $3.00
By Granville Redmond *Spanish Art Galleries*
 OVER 100 PIECES $1.00 CALIFORNIA POPPIES CHOC. & PUZZLE $3.00

puzzles for her family. Her social standing and wealth were like gold (or, more aptly, black gold) for stimulating other sales. Stendahl charged Doheny twelve dollars per custom order—an expensive proposition. But customized puzzle Christmas cards were only thirty-five cents apiece. Stendahl publicized the fact that his new factory provided work for unemployed motion-picture-studio artists who helped him develop "figure" puzzle shapes. For western subjects, pieces were cut into cowboys, bucking broncos, and Indians, represented in the completed picture. But Stendahl was just getting started. He added other innovations. The New Deal Picture Puzzles (at twenty-five cents each) touted as "The World's Finest," listed these new features: Your Fortune Told; Wood-Style Back; Double-Faced Puzzles; Non-Skidding; Brilliant Color Process and New-Style Designs.

One of the most inventive ideas was Stendahl's puzzle-within-a-puzzle, in which the solver was challenged not just to complete the picture, but also to recognize a movie star's silhouette. Marlene Dietrich, Ann Harding, Carole Lombard, and others in Hollywood jumped on the bandwagon, adding panache to the puzzle craze. All of this delighted Stendahl. For a man who stated emphatically that the film colony held no special appeal, personally or

professionally, and that, in fact, actors were notoriously slow to pay him, he seemed never to ignore an opportunity to rub elbows with the famous of the film world. Stendahl told a radio interviewer, "Movies are a great stimulant to cultural knowledge." He noted that in the pre-decency-code M-G-M movie,

Paid, starring Joan Crawford, one of the minor characters is a Mr. Stendall (note spelling) who runs a high-end art gallery. The movie itself plays like a sexploitation women-in-prison drama, but that didn't bother Stendahl. "If they had asked me, I might have acted the part of Mr. Stendall myself. Acting is one

1 A print of *California Poppies* by Granville Redmond was jigsawed into a Stendahl puzzle.

2 The manufacturing of Western puzzle scenes.

profession I haven't gone into seriously." We can only imagine.

The New Deal puzzles, which used painting subjects from all over the world, were big sellers. President Roosevelt's New Deal reforms and recovery efforts were a fact of economic life after 1933. Stendahl did not let his personal politics interfere with a good marketing gimmick. He was a Republican and no fan of the Roosevelts or their "bleeding-heart programs," but most of America benefited from the government's relief efforts, so Stendahl was only too happy to spread a little relief of his own, in the form of delicious chocolates and entertaining puzzles. Enid had an unfortunate lifelong aversion to anything that liberal Eleanor Roosevelt might say, do or touch. The first lady's mere existence was, to Enid, an affront. That Enid had named her only daughter "Eleanor" (in 1923) distressed her for years and amused the rest of her less-politically-passionate family.

When Al was about to graduate from the University of California, Berkeley, he wrote his father a letter, requesting a position—no matter how lowly—at Stendahl Galleries. The busy puzzle factory required several more employees. Al had spent summer and Thanksgiving vacations at home, working the jigsaws and, for a time, was the only one cutting from three hundred to five thousand pieces for the most elaborate puzzles. He also boxed, addressed, and shipped for a wage of three dollars an hour.

A few months after Al came to work full-time, Earl put on two shifts a day with five men each at the

jigsaw tables. The Stendahl Chocolates were selling well nearby at Bullocks Wilshire and other places around town where Stendahl's clients and artists talked up the sweets, especially at holiday time. Stendahl told William Wendt in a letter, "My optimism has had several setbacks, and at the present moment I am very low, but if I sell a pound of candy, I am quite sure it will pop up again." He assured Billy he was welcome to every damn pound he wanted, gratis, for his own Christmas-giving. Stendahl set aside three to four three-pound boxes for the Wendts, as his Christmas present to them.

Stendahl's idea of pairing the puzzles with the chocolates was marketing gold. He charged two dollars a pound for the candy and three dollars for the candy-puzzle combo. Years after the candy and puzzle factories stopped production, the Stendahl inventory retained thousands of color prints. Many had been used as puzzle art and on the box covers. Most accumulated from advertisers who would ask Stendahl for permission to use a color reproduction of one of his paintings in their campaigns, then pay back the favor with a photo credit and a stack of color prints. The Union Oil Company used a Stendahl

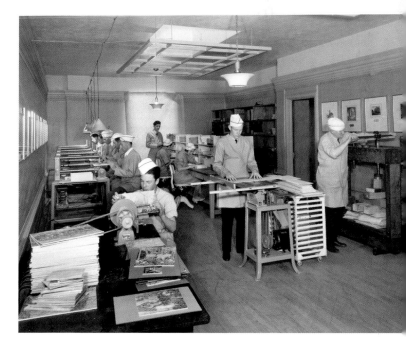

1 The "New Deal" puzzle packaging spoke of the era.

2 The "Masterpiece" combo: an artful mix of chocolates and puzzles.

3 Al, in the foreground, is at work at the jigsaw.

painting image each year for its Christmas card, as did the Robert A. Rowan Real Estate Company, whose Los Angeles history and influence paralleled Stendahl's, to some extent.

To expand his offerings of suitable color prints, Stendahl went to Parisian client Pascal Bonnetti, founder of *Les Amitiés Francaises* (promoting French culture), to aid in the search. Together they investigated the Louvre holdings and checked out publishers and lithographers along the Seine for odd lots that could be gotten for only five or ten francs each. Stendahl impressed Bonnetti with his hot-selling puzzles made from foreign travel posters. Stendahl envisioned the large boards (three by four feet in size) enjoyed on ship decks, patios, beaches, at home, and on country-club lawns. He boasted "the world's largest and the world's smallest puzzles" in his advertising, the smallest being a two-inch square with miniscule cuts. For the travel-poster puzzles, Stendahl's staff pasted foreign suitcase labels on the boxes. The packaging was an important feature, since Stendahl believed "a book should be judged by its cover."

After he ceased making puzzles in the late 1930s, Stendahl hoped to see his large inventory of post-puzzle-business color prints put to some use. He sent Al around to local libraries, offering the prints for lending but had few takers, and no other organization wanted them. The Stendahl color plates were donated to the printer in Pasadena who had done most of the gallery work. Leftover puzzles were sold to the May Company department stores, and the manufacturing equipment that wasn't disposed of ended up in mother-in-law Sophie's garage in Hancock Park.

The lucrative puzzle sideline occupied Stendahl but never at the expense of his primary focus: selling fine art. At the same time that Stendahl was asking Bonnetti's help to sniff out prints of French masters and colorful maps of Paris, he was involved in an enterprise that ballooned into a scandal of international proportions: the van Gogh fakes.

1 Travel poster puzzles.

2 Puzzles on display in Wilshire Boulevard window of Stendahl Galleries.

Through Bonnetti, Stendahl had gotten mixed up with a certain Monsieur Proux, a collector from Asnières, who possessed several dozen "unquestioned" van Goghs. Letters of authenticity and other documentation involving the Mayor of Asnières and other "experts" crisscrossed the Atlantic for months, as Stendahl tried to assess the status of three expensive paintings he had acquired, that were, supposedly, original van Goghs. When he pressed Bonnetti for more proof, Bonnetti responded, "Your common sense will tell you that you can be given no other assurance, van Gogh himself being dead."

Stendahl's van Goghs, along with an embarrassing cache of paintings others had bought or were considering, turned out to be unequivocally *faux*. Stendahl ended a December 1932 letter to Bonnetti, "I understand our friend Proux died, which leaves us sitting high, wide and handsome." Proux's death must have let Stendahl and Bonnetti off a financial hook. One thing is clear: Stendahl never made a dime on his van Gogh investment. It was neither the first nor the last time the dealer would lose big in an attempted art transaction. Stendahl had no illusions about the risks of fine art commerce. They were great. But so were the potential rewards.

The problem of forgeries came up again and again in Stendahl's long career, as it does for any dealer involved with objects of great value. His adventures with questionable paintings that resulted in significant financial losses over the years were eclipsed by the enormous problems of authentication he encountered with Pre-Columbian and other ancient artifacts. Stendahl often said he preferred "dead artists" to the temperamental living ones but had to admit, as Bonnetti had wryly pointed out, that questions of an artwork's source were much easier to validate in the contemporary world.

2

All the years Stendahl was selling art, he made good on every transaction. The return policy was this: clients may bring anything back for trade or full cash refund—no questions asked. The gallery policy stands to this day. The "no questions" part was blurred here and there, depending on the level of Stendahl's disgust. If he knew a piece to be authentic, and a buyer came

back with it, citing someone else's opinion that it was no good, the customer would get a short lecture from the dealer informing him that his source was ignorant and that learning to trust Stendahl's expertise would make for a mutually beneficial relationship. Then, before handing over the money with a smile (and maybe a puff of cigar smoke), Stendahl would show the client something else to consider in place of the returned object. If that was, for the moment, a "no-go," before the client was out the door, Stendahl would be on the phone to another likely buyer for the painting or the Pre-Columbian figure or the jade and gold necklace.

The return policy was no gimmick. It was, in Stendahl's view, a solid business practice to foster trust and keep customers coming back. But Stendahl was not averse to trying something new to boost sales. For a time, Stendahl tried the European plan of catalog admission charge for his exhibitions. That didn't last long. If people wanted to look at art, Stendahl let them in and put the price list in their hands, gratis. He encouraged walk-in traffic from Wilshire Boulevard. Although he wanted a reputation as a sophisticated operation, catering to the

crème de la crème, occasional skim milk was not to be ignored.

Stendahl liked to tell the story of a visit from a cowboy with a diamond-studded belt buckle and a ten-gallon hat, who came in one day, ambling through the gallery before sidling up to the proprietor. Slim told Stendahl he had a big new place that, according to his architect, needed some sixty paintings to cover the walls. "Have you got sixty paintings?" As fast as you could say "Tony the Wonder Horse," Stendahl waved to Mrs. Bateman to bring him a pad of paper. Legal size. Stendahl walked Western film star Tom Mix from room to room, building an instant collection for him, with an emphasis on western subjects. Mix left, happy. His architect would be happy. Stendahl, God knows, had a good day. That night he took Enid to Chasen's.

Enid was happy for the lovely evening and the infusion of cash. But she had an opinion on the big sale to Tom Mix. She observed that rival cowboy actor William S. Hart really knew art and would never approach buying in such a willy-nilly fashion. Enid never hesitated to voice her opinion. She disapproved of Earl paying her young cousin, Robert DiVall, a few dollars to play his trumpet outside the gallery,

hawking Stendahl Chocolates at Christmastime. A kid on a soapbox was so…well, retro and undignified. But the impresario in Stendahl usually prevailed against his wife's—or anyone else's—doubts. (DiVall went on to enjoy a long, distinguished career as first trumpet of the Los Angeles Philharmonic Orchestra.)

Apparently Stendahl had a good ear. But friends, artists, curators, collectors, and art historians extolled his remarkable eye. It has already been established that the Candy Kid appreciated perfect chocolate, fine art, and beautiful women, as well as the visual charms of cities all over the world. He knew quality in a way he didn't try or care to explain. At racetracks in the U.S., Mexico, and Europe, Stendahl would go down to the paddock to study the horses, claiming that some looked hungrier to win than others. He saw what he called "aristocracy" in certain of the equine heads, making those horses, in his opinion, the likely winners. More often than not, Stendahl-the-handicapper was right on the money.

Still, there was no guarantee that recognizing beauty, originality and power in Modernism trends would translate into successful business for Stendahl. Other dealers were proceeding more cautiously in the early 1930s. Stendahl put his reputation and money on the line with shows for Lorser Feitelson, Stanton Macdonald-Wright, Millard Sheets, the Mexican muralists, Robert Henri and George Bellows of the influential Ashcan School, and others, whom less courageous connoisseurs were only talking and writing about. Stendahl entered dangerous territory just when his family and his business needed more, not less, stability. The Sanity in Art movement that lay ahead suggested just how crazy-making the enterprise of appraising, authenticating, buying, selling, and defending art could be.

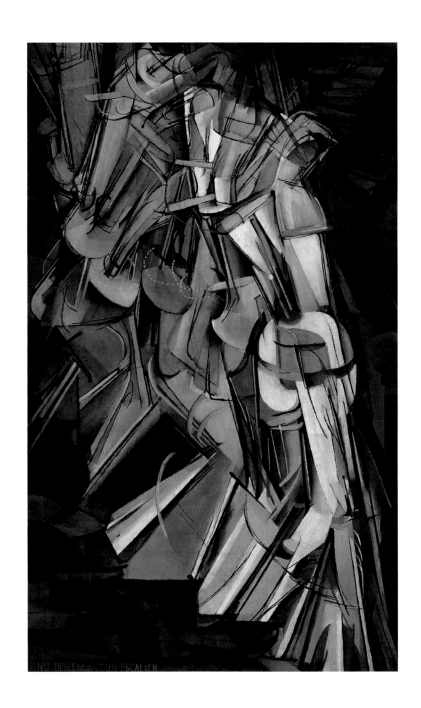

Nude Descending a Staircase, No. 2, Marcel Duchamp, 1912.

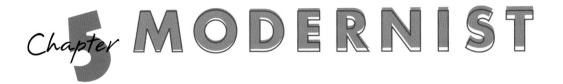

Chapter 5 MODERNIST

In 2005, when art historian

and curator Michael Kan called

writing the rules as he went, sometimes spending lavishly

Earl Stendahl a pioneer, he smiled,

for a whole collection if that is what it took to acquire a

reconsidered, and said,

few sure-sellers. Thoroughly modern, Stendahl thought big,

"Make that a *buccaneer*." Kan

acted hastily, and gave the impression of supreme confi-

remembers an adventurer who

dence, even when he was not at all certain that a particular

played fast and loose,

move was ultimately wise. Over the long haul, his track

record was exceptional. But there was a win-at-any-cost

aspect to his dealings that blurred the lines of correctness.

In the early gallery days, the rules of conduct of selling fine art, particularly from ancient cultures, were not established. In 1935, when Stendahl made his first forays into Mexico and Central America buying up truckloads of Pre-Columbian clay and stone objects and caches of gold and jade, countries were not yet protecting their patrimony. The market for ancient art was wide open for a dealer who didn't mind venturing into jungles or making a cash offer to an official who might raid his own museum to sell a brash *Yanqui* whatever he wanted.

Collector Walter Arensberg and others waited on the other side of the border, salivating over what treasure would come out of Stendahl's crates when he pried them open in the carport for a few special clients to have first dibs. Outlaw Earl was operating in the Wild West, pushing through the swinging doors of every saloon that would have him—and some that would not.

Kan added "prophet" to his description of Stendahl—a visionary who was under-appreciated, especially by the museums. Local collectors grew to depend upon Stendahl's sure eye and no-nonsense business dealings. His ability to predict trends in art put him and his gallery ahead of the buying-and-selling curve. If Stendahl showed a new artist or promoted an entirely new genre, people paid attention. With guru-like charisma, Stendahl led the way. Kan noted that Stendahl never considered himself to be an influence on taste. Stendahl said the art itself held the power.

At the same time that Stendahl was turning his attention increasingly away from the Impressionist and Realist schools toward the wilder and woollier moderns, an entire city was developing a more cosmopolitan profile. Mid-1930s Los Angeles was billed as "The City of Balanced Prosperity" by the *Los Angeles Times*. That optimistic characterization was patently false, then as now, but the sentiment reflected

1 Stendahl at work in Mexico.

2 Unpretentious exhibitionist among ancient friends, Earl works at his basement restoration table. Ron Dammann felt sorry for his grandmother when Enid could not convince Earl to change out of his workshop overalls for a *Saturday Evening Post* photographer, coming over to do a photo spread on Stendahl and his gallery. There he was, the gentleman dealer-to-the-stars, looking more like a farmer from Menomonie.

3 *Xipe Totec*, the flayed god, and receptacle; both carved stucco, ca. 1000 AD.

2

3

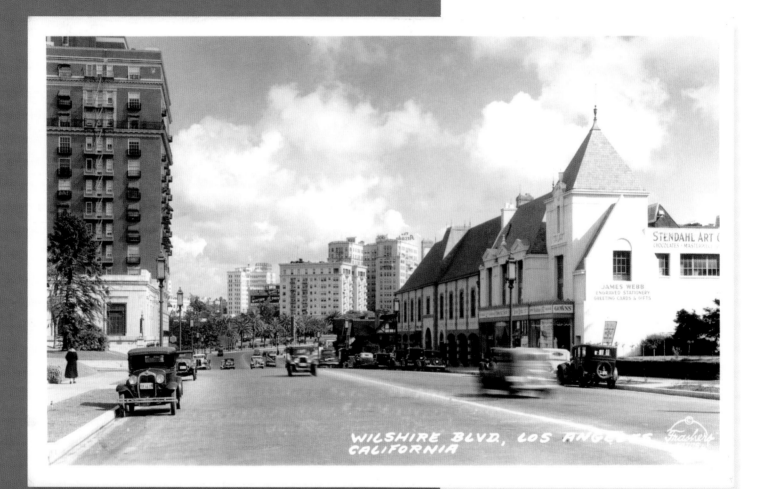

a new trend. Between the World Wars, L.A.'s reputation changed from provincial to regional, driven, to a significant extent, by its artists and architects, as author Victoria Dailey noted in *L.A.'s Early Moderns*. If there was not balanced economic opportunity, there was a discernible momentum toward community, where certain gathering places attracted those who forged their city's growing modern identity: the Stanley Rose Book Shop, or Jake Zeitlin's bookshop and gallery, or Walter and Louise Arensberg's salons or Stendahl's gallery. An artist, writer or musician could exert fierce independence in Los Angeles and, at the same time, celebrate a collective muse with other renegades. Fraternization offered a lifeline for the sometimes-maligned artists of Southern California.

As supportive as Stendahl was on the local scene, it is clear that his influence was felt far and wide. From its inception, Los Angeles has been a place to watch and to emulate. Particularly in its cultural life, the once-young, independent city resisted mellowing or taking on the attributes of older cousins like New York and Chicago. A singular identity calling to mind palm trees, pink houses and hotels, movie palaces, oil fields, surf, open spaces, and visitors who came and never left, continued to evolve on its own terms. Unlike most cities, which are proud of their histories, Los Angeles resisted even having one.

Painter and art teacher Lorser Feitelson (1898-1978) chose Los Angeles because it was unlike New York, Paris, or San Francisco. He moved eight times between 1928 and 1951, always remaining within L.A.'s vast boundary, as he sought new experiences. Feitelson and his wife, artist Helen Lundeberg, and others moved often because they could. Los Angeles was a mobile culture from the very beginning, affording automobile access from beach to snow-capped mountains in half a day. Everything was alluring and much of it transient: the light, the air, the arroyos, the ocean breezes, even healthy-looking skin. If New York was about putting down citified roots, the City of Angels was for celebrating nature in all its mutable beauty. Feitelson and Lundeberg, who founded the Post-Surrealism school of painting, drew long-term inspiration from Los Angeles, as did Stanton Macdonald-Wright and so many other Modernists, whom Stendahl mentored and represented through the years. Stendahl was drawn first to San Diego for its distance from his small Wisconsin world, but Los Angeles called him to spend the rest of his life in a place where one could hide in plain sight or oversee a four-ring circus on busy Wilshire Boulevard.

When institutions in Los Angeles and elsewhere had to cooperate with Stendahl in the acquisition of an artwork or in attracting museum support,

Stendahl Galleries on busy Wilshire Boulevard. Note that the chocolates are promoted on the building as well as the art.

107 MODERNIST

they found themselves in the role of co-conspirator with someone they didn't trust completely. Unlike Stendahl, who answered to no one but himself, the Los Angeles County Museum was beholden to a

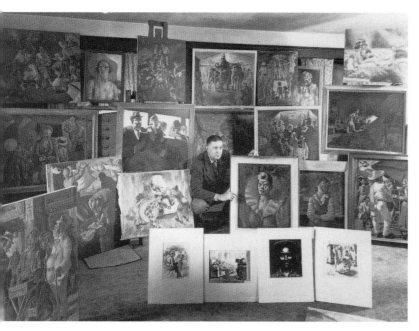

1

board of trustees and the taxpaying public. As late as 1950, local schools and museums still resisted Pablo Picasso or Georges Braque and the other Cubists, Dadaists, and Surrealists who were stirring things up in more cosmopolitan Paris and New York. But Stendahl knew it was only a matter of time before the

modern artists gained a wider acceptance, aesthetically and geographically. He wanted a piece of any action associated with a growing market and had a strong hand in creating markets himself.

Stendahl's confidence about how to show art sometimes bled over into how to make art. His ideas weren't always received as magnanimously as they were by artist Benjamin Newton Messick (1891-1981). Messick was a Los Angeles painter, whose modern depictions of urban Americana caught Stendahl's eye. In preparation for a one-man show at Stendahl's in 1937, Messick brought in his recent paintings. Stendahl looked them over and had the audacity to pronounce the whole group of about twenty canvases not colorful enough. Messick had lately been painting circus subjects and clown studies. Younger and of a more gentle spirit than many of the bigger egos in Stendahl's growing stable, Messick repainted the canvases to suit his dealer, who acted not the least surprised when the vivid paintings sold well on opening night. Stendahl had advanced the career of another celebrated artist whose works would one day command thousands of dollars at auction. What is more, Ben Messick (as he liked to be called) earned a reputation as "the American Daumier."

Stendahl couldn't count on artists bending to his will any more than he could anticipate how a new

customer might alter his future in a profound way. Hadn't the cowboy star ambled into the gallery one day and dropped enough cash to cover two years' rent? And hadn't Louise and Walter Arensberg walked into the gallery one day, too?

The Walter Arensbergs visited Stendahl for the first time, when he was still at the Ambassador Hotel. Instinctively, he was confident that the wealthy transplants from New York would be impressed with his offerings. Knowing that the Arensbergs were beginning to hold salons in their Hollywood Hills home for artists, collectors, critics, musicians, and writers, Stendahl hoped to gain some measure of acceptance. But he could not have foreseen what the Arensbergs' decades-long patronage would mean to him personally and to the future of the art world.

Their relationship began in the early 1920s and continued until Walter's death in 1954. That Earl and Enid lived out their days post-1954 in Arensberg's house is a testament to the symbiosis of an enduring dealer-collector. It is hard to imagine two more contrasting backgrounds and personalities than Earl's and Walter's. But they had one common trait that bound them together like brothers: a passion for art.

In 1910, Arensberg was a Harvard-educated poet living with his young wife in Cambridge,

Massachusetts, in the former home of Henry Wadsworth Longfellow. Arensberg's discovery of the works of Cezanne, Gauguin, Vuillard, and a burgeoning network of European and American modern masters changed his focus entirely. He and Louise, an accomplished pianist, began buying art as a full-time pursuit, accumulating what would become one of the most acclaimed modern art collections of the twentieth century. The Arensbergs amassed close to twenty works of Romanian sculptor Constantin Brancusi (1876-1957) and cornered the market on the output of their close friend, French avant-garde artist Marcel Duchamp. His once-scandalous *Nude Descending a Staircase No. 2* hung on the wall in the Arensberg home all the years that Enid and Earl enjoyed the intellectual soirees there. On those occasions, the Stendahls shared pineapple juice and pound cake with an artistic elite made up of such personalities as ceramist Beatrice Wood (who was also Duchamp's lover), Galka Scheyer, violinist Louis Kaufman and his wife Annette,

photographers Edward and Bret Weston, the Man Rays, writers Henry Miller and Clifford Odets, Mexican Surrealist painter Roberto Montenegro, and the top collectors of the day, including Vincent

1 The accommodating Ben Messick.

2 Louis and Annette Kaufman.

1

2

3

Price, Edward G. Robinson and Austrian émigré film director, Joseph von Sternberg. Montenegro was taken by Eleanor Dammann's beauty. He painted a long-necked portrait of her, which she detested and which languished in the basement stacks until after her death in 2000 at age seventy-six.

Each one of these personalities deserves its own treatise. Painter and high-fashion photographer Man Ray (1890-1976), for example, was central to the development of the Surrealism and Dada movements in America. In 1920, Ray, with lifelong friend Duchamp, and Katherine S. Dreier, founded the Société Anonyme, the first American organization to promote modern art.

Arensberg fit right in with the cast of characters around him. He was as eccentric as he was acquisitive. He spent most of his life trying to prove, through cryptographic clues (anagrams, puns, acrostics), that the seventeenth-century English Lord Chancellor Francis Bacon was the actual author of all of the works attributed to William Shakespeare. Three secretaries showed up for work every day at the Arensberg home, employed as researchers for the Bacon-Shakespeare investigation. The collection of

the non-profit Francis Bacon Foundation—originally funded by Arensberg—now resides at the Huntington Library in San Marino, California.

Arensberg had plenty of money left over from his esoteric literary pursuits to invest in art, and his generosity was legendary. He opened his home to almost anyone—from the humble to the famous—who showed an interest in his and Louise's collection, including clients Stendahl might send over for a dose of collecting enthusiasm and exposure to the best of the new wave. But try as they might, Stendahl and Arensberg couldn't carry Los Angeles toward that challenging frontier without strong museum support.

At the same time that Stendahl and Arensberg were hosting modern artists whom Los Angeles and Pasadena museums were reluctant to endorse, Stendahl and the other smart dealers recognized the necessity of widespread public backing for those institutions. Stendahl called "deplorable" the fact that the wealthiest citizens of Los Angeles were not adequately supporting their Museum of History, Science, and Art, which, as a county-funded institution, could apply contributions and gifts directly to the acquisition of art. Stendahl agreed with radio interviewer Prudence Penny when she suggested that the American public had an inferiority complex regarding art. But Stendahl blamed the Europeans for unfairly plastering the complex upon our shores,

1 Photographic portrait of Walter Arensberg.

2 A Beatrice Wood photograph of Louise and Walter Arensberg with Marcel Duchamp, right; Hollywood, 1936.

3 Portrait of Eleanor Stendahl Dammann by Roberto Montenegro.

adding a special dig at the French: "When France wants the world to think about art, it wants the world to think of French art."

Stendahl saw no place for jingoism in art appreciation. He defended the more inclusive American approach and praised his countrymen for valuing beauty and harmony in all things. "Americans carry that thought into their everyday living, as no other nation does; our smallest bungalows are built for beauty, as well as utility."

Stendahl launched a personal mission for the advancement of arts education with an emphasis on what he (and others, increasingly) called "non-objective art." He looked to the museums to take up the cause and to New York to lead the way. On August 5, 1938, Stendahl wrote to Baroness Hilla Rebay, the young German artist/curator who convinced a much older Solomon R. Guggenheim to begin collecting modern paintings by Kandinsky, Klee, Chagall, and others. Knowing that Rebay had Guggenheim's ear (and, Stendahl conjectured, possibly other parts as well), the dealer made a strong pitch for the Solomon Guggenheim Foundation to build a Guggenheim Modern Museum in Los Angeles. The Foundation's purpose mirrored Stendahl's goals exactly: "for the promotion, encouragement, and education in art and the enlightenment of the public."

Stendahl thanked Rebay "a thousand times" for the wonderful evening he recently had spent with the Guggenheim collection in New York, which was at that time housed in Guggenheim's private apartment at the Plaza Hotel. "I will try to tell you in my humble way why a Guggenheim Modern Museum would do more good by being located here, than any other place." Guggenheim and Stendahl had apparently talked about the possibilities of a Los Angeles site. Stendahl made the bold statement that Southern California lacked an important museum and that a Guggenheim Museum would be the most exciting cultural institution in the West. "It would not have any competition whatsoever." He suggested that the motion picture industry was primed to advance the cause of non-objective art. "I know of several directors that are anxious to do an abstract picture in color, based upon a (Rudolf) Bauer or a Kandinsky painting." One can only wonder at the plot and character development of such a film.

Stendahl also touted Los Angeles as a news center that would promote a modern museum with "unlimited publicity." But that's not all. The supplicant claimed that a Los Angeles building boom of modern architecture made his town ideal for the Guggenheim collection.

Stendahl told the baroness that land had been promised (a questionable assertion on his part) by the city, and that he had lined up collectors who would contribute their own modern paintings. Rebay must have been impressed to hear that Walter Arensberg was on board. "Mr. Arensberg has already put his great collection in a trust foundation for this purpose [also doubtful]. As you know, his collection is second only to Mr. Guggenheim's and has been acquired over the past thirty years. He has most of the 1910 period of the first great Armory exhibition in New York." Indeed, Stendahl envisioned *Nude Descending a Staircase, No. 2* as a cornerstone of the Arensberg material which might grace the halls of a new Los Angeles Modern Museum, if Guggenheim could be lured to California. As important as Guggenheim's holdings were, Arensberg's Cubist and Pre-Columbian artworks hardly deserved secondary status. But, given Stendahl's acute business instincts, it is understandable why Stendahl put Guggenheim front and center. The impresario never lost sight of where the spotlight belonged.

Stendahl's final rationale for a Guggenheim-West was his strongest: Los Angeles was a virtual laboratory for the innovative and the new. Fresh ideas that incubated and developed in Southern California became practical, everyday necessities. Even a casual reading reveals the writer's not-so-hidden agenda: Los Angeles was the perfect town to show modern art, because it was Stendahl's town. If he could convince Rebay and the Guggenheim Foundation to plant their museum in his backyard, potential clients would be exposed to the finest examples of abstract American and European art, without spending their money on buying trips to Paris and New York. An enterprising dealer could ride the coattails of a more informed, turned-on public—right at home.

When Stendahl called the Guggenheim collection "exciting," he wasn't talking only about headless nudes. He was envisioning a new culture of appreciation and acquisition that would surround a world-class museum of modern art. Earl Stendahl wanted the Guggenheim, and he wanted it badly. "I hope you can receive just a small picture of what we have to offer and will do what you can in helping, not only us, but the non-objective art advancement in the most fertile field on earth."

One year later, in 1939, Solomon Guggenheim cultivated a less fertile field, at least in Stendahl's view. The Museum of Non-Objective Painting opened in rented quarters at 24 East 54th Street in Manhattan.

Stendahl lost the battle, but not the war.

He never wrote anyone or any institution off, preferring to keep doors and options open. When

the Frank Lloyd Wright-designed Solomon R. Guggenheim Museum was inaugurated in 1959, Earl and Enid were there to celebrate New York's commitment to a broader scope of modern and contemporary art. Stendahl must have had moments of regret that night in the grand, spiraled building on Fifth Avenue. He couldn't think of anything he might have done differently to achieve his desired outcome. But there were times when the man got in his own way.

For someone who always had one eye on the prize, Stendahl was known to blow a deal if he had to jump through too many hoops to land it. He was known for his wisecracks, often insulting the very people who could help him. Stendahl's son, Al, recalled that after Hilla Rebay failed to influence Guggenheim to establish his museum in Los Angeles, Stendahl suggested the "baroness" was a phony who lacked the sexual prowess to get what she wanted from the old man. The more laughs Stendahl got from Max Ernst, the Crown Prince of Norway, and others around his dinner table, the faster the insults flew. One of Earl's favorite gambits was to tease a potential client with "The price is eight thousand dollars. But to *you*...[pause, while the sucker savored the imminent bargain]...*ten* thousand."

Once when Stendahl was compared to Horatio Alger, the nineteenth-century American dime novelist who became synonymous with rags-to-riches stories, Stendahl questioned the compliment, informing those in attendance that Alger—for all his social idealism and hard-work ethic—was in fact a pederast forced out of the ministry after certain incidents with young boys. Stendahl relished the hush that would fall over a room when he dropped such a bombshell—the more unsavory, the better. He was an equal-opportunity offender, winking at the women present as he blew cigar smoke into the suddenly weighty air.

Stendahl hasn't actually been labeled a *sadist* in print or in anyone's oral history, but there were instances when Al, his sister Eleanor, and their mother squirmed along with one of Stendahl's victims. Ron, who with his brother Rock, was close to Earl, says that their grandfather was so convinced of the enduring value of the pieces he sold that he could afford to alienate some people. Even in the toughest economic times, Stendahl figured there would always be an aesthete to recognize quality and put her money down with a dealer she trusted. She didn't have to like him.

In truth, women liked Earl Stendahl very much. He cultivated female allies in all aspects of his career and recognized early on that wives had a strong influence on their husbands and—of particular interest to him—on their husbands' wallets. Perhaps because his own wife was a small town girl from the Midwest, Stendahl took special notice of women who demonstrated a glamorous or exotic side. In late 1937,

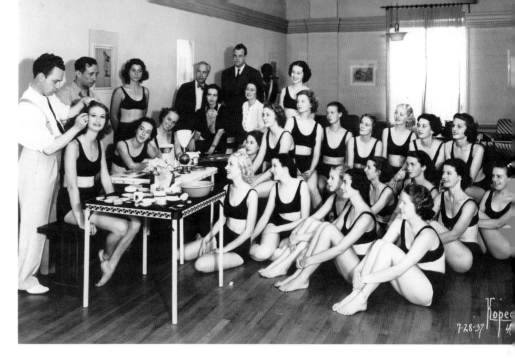

Stendahl wrote a letter to a certain Princess Pignatelli, asking her to come in and experience personally his Four-Ring Circus on Wilshire Boulevard. It isn't known exactly which member of the historic and illustrious Pignatellis of Naples Stendahl was writing to, but her family traced its ancestry back to the ninth century in southern Italy. The Princess Pignatelli (*née* Constance Wilcox) of the late 1930s was apparently a writer, as well as a patroness of modern art and the first and ex-wife of Prince Guido Pignatelli (who divorced the Princess in Reno and married another woman, all in less than twenty-four hours). Stendahl asked the former royal to do a story on his multi-faceted gallery and supplied the following:

"In the front Studio we now have the "Parnassus Book Shop" dealing in rare books and first editions. In the Print Room, the most complete press for Lithography in the West. Life Art classes in the Patio, conducted by Lorser Feitelson. In the Modern Gallery—Sara Mildred Strauss, Studio of the Dance." Most of Stendahl's renters were at least peripherally related to the business of art. But Madame Strauss's long-legged beauties took up residence at 3006 Wilshire Boulevard for the fine wooden floors and well-ventilated rehearsal room which Stendahl provided for fifty dollars a month. Three days a week the *danseuses* arrived for their classes, adding eye candy to go along with Stendahl's chocolates. It is not known if the princess wrote up Stendahl's gallery, but Stendahl had no trouble attracting publicity throughout his career. Sometimes an article reflected a truly good turn on the part of the dealer.

There are still those who remember, firsthand, Stendahl's benevolence when someone needed a break. According to pianist and author Dr. Annette Kaufman (who with her husband, violinist Louis Kaufman, became early clients of the Stendahl

The Strauss Dancers, 1937.

Galleries), if talent was involved, Stendahl went to great lengths to support and promote it. Much was made in the Los Angeles press of Stendahl giving an exhibition for itinerant Yugoslavian taxi-driver and dishwasher B.D.K. Ara. He was an out-of-work, self-taught artist who painted on his wife's kitchen curtains and tablecloths, using window frames as stretchers. Ara's wife called him crazy and damned annoying, but Stendahl saw something in the man's primitive depictions of his native land. He set up Ara with proper paints and canvas and let him rip.

The Ara exhibition of 1932 brought laughter from some, raves from others. The Arensbergs bought three works, including a self-portrait. Stendahl was credited with having discovered a genius, but he, himself, would not claim that Ara was anything more than a flamboyantly original naïf. What the dealer did know was that the immigrant's story was uplifting and that a few new customers might be inspired to help a young man's dishwater hands find their true métier.:

Emma Bellows appreciated Stendahl's personal connection to the up-and-comers, as well as to the important artists of the day. Following the death of her husband George, Emma wrote to Stendahl about his and George's relationship with the legendary artist and teacher Robert Henri (1865-1929).

Emma Bellows had never met Stendahl, but she wrote unguardedly, "When I read that you knew Mr. Henri and appreciated all the fine things he stood and fought for, I had a very warm feeling around the heart. I adored him, and when he and George Bellows passed away, American art lost two champions hard to replace." Emma did not exaggerate. While still young, Bellows (1882-1925) earned acclaim as one of the most influential artists of his generation. Stendahl had shown Bellows's work when at the peak of its (controversial) origins in unrestrained social realism. Bellows studied under Henri at the New York School of Art, becoming one of "The Eight" of the Ashcan School. Stendahl appreciated the way that Bellows, Henri and the others had exposed the American public to a new way of interpreting everyday life. Their actions took courage—something Stendahl found in short supply in his own city.

By 1939, Stendahl was losing patience with what he interpreted as cowardice among the California museums that should have been leading, rather than following. Successful shows from the Museum of Modern Art in New York found no welcome mat at the Los Angeles County Museum which was, for many years, not dedicated solely to art. According to Al, his father sponsored many such exhibitions, his gallery acting, effectively, as a museum. In April

Oil painting by B.D.K. Ara.

of 1941, the San Francisco Museum of Art put on a Paul Klee memorial show. Stendahl couldn't wait to book it. And he did; on May 8 of the same year, the Stendahl Art Galleries opened the Paul Klee Memorial Exhibition with one hundred paintings that drove rationalists mad. Just another day in the trenches for an exhibitionist.

The most dramatic example of Stendahl taking on a museum's role was his presentation of Pablo Picasso's twelve-by-thirty-foot masterpiece, *Guernica* (also known as *Bombing of Guernica*) in Los Angeles for two weeks in August of 1939.

It would be difficult to name another painting which expresses so powerfully the horrors of war. Picasso (a Spanish expatriate) was outraged by the German aerial massacre of the Basque town of Guernica in northern Spain just two years earlier. The terrorist bombing, the first intentional attack against civilians in modern warfare, left the village in ruins. In tones of black, white, and gray, Picasso's surreal depiction of the aftermath is still a shattering reminder of art's ability to stir emotion. Stendahl understood the importance of the work, as well as the controversy that surrounded it. He relished the publicity—and the traffic—that were sure to follow opening night.

Along with the extraordinary mural, the comprehensive paintings and studies were on display. A nationwide tour was launched at Stendahl's gallery, one of only two non-museum venues in the world to show *Guernica*. The exhibition moved on to the San Francisco Museum of Art and to New York for the Museum of Modern Art's Picasso retrospective.

Stendahl's exhibition was sponsored by the Motion Picture Artists' Committee for Spanish Orphans. The local press described a glittering affair, attended by

SPONSORS EXHIBITION

YOU AND YOUR FRIENDS ARE INVITED TO THE

PREMIERE
WEST COAST SHOWING OF

PICASSO'S
MASTERPIECE

GUERNICA
AND 63 RELATED PAINTINGS AND DRAWINGS

FROM

THURSDAY, AUGUST 10th, 1939
TO MONDAY, AUG. 21st, 1939
DAILY FROM 10 a.m. to 10 p.m.

AT THE

STENDAHL ART GALLERIES
3006 WILSHIRE BOULEVARD
LOS ANGELES CALIFORNIA

ENTRANCE FOR PREMIERE
TWO-FIFTY
(plus tax)
General Admission—Aug. 11th to 21st, Inc.
Students 25c 50c (plus tax)
BENEFIT SPANISH ORPHANS

MERCEDES de ACOSTA	FRITZ LANG
GILBERT ADRIAN	ANATOLE LITVAK
MR. & MRS. WALTER ARENSBERG	ERNST LUBITSCH
DOROTHY ARZNER	MRS. LESLIE M. MAITLAND
GEORGE BALANCHINE	BARONESS MANTIKA
MRS. E. BERSSON	DR. and MRS. RUDOLPH MARX
DR. and MRS. REMSEN BIRD	MR. ROLAND J. McKINNEY
ADOLPH BOLM	CAREY McWILLIAMS
MR. LOUIS BROMFIELD	ALFONSO BEST-MAUGARD
INA CLAIRE	LEWIS MILESTONE
MARGUERITE CLARKE	ALEXANDER MARQUEY
HUMPHREY COBB	ONA MUNSON
CONSTANCE COLLIER	RICHARD NEUTRA
PROF. GEORGE J. COX	DUDLEY NICHOLS
GEORGE CUKOR	GOV. CULBERT L. OLSON
J. R. DAVIDSON	MARIANNE OSWALD
BETTE DAVIS	MRS. MORGAN PADELFORD
DOLORES DEL RIO	CHARLES PAGE
WILLIAM DIETERLE	DOROTHY PARKER
MELVYN DOUGLAS	ROSA PONSELLE
PHILIP DUNNE	MR. and MRS. WILLIAM PRICE
MR. and MRS. EDWARD ELISCU	LUISE RAINER
REX EVANS	CAROLYN JANIS RAPORT
FRANCES FARMER	EDWARD G. ROBINSON
JOHN ANSON FORD	MADELEINE RUTHVEN
BERNADINE FRITZ	GALKA E. SCHEYER
HELEN GAHAGAN	CONSUELO SIDES
JANET GAYNOR	SYLVIA SIDNEY
CEDRIC GIBBONS	MRS. MORTIME H. SINGER
PAULETTE GODDARD	GALE SONDERGAARD
HAROLD GOLDMAN	COUNT ALDO ZOLITO De SOLIS
ROBERT E. GROSE	DONALD OGDEN STEWART
JOHNNY GREEN	PRINCE ALEXIS THURN-TAXIS
DASHIELL HAMMETT	ERNEST TOCH
DR. and MRS. EARL P. HEDRICK	MR. and MRS. FRANK TUTTLE
BENJAMIN GAYLORD HAUSER	MR. and MRS. H. P. ULLMAN
MRS. SARTORIS HIRST	MR. and MRS. EDGAR VARESE
MIRIAM HOPKINS	MR. and MRS. BERNARD VORHAUS
HEDDA HOPPER	MRS JACK WARNER
EDITH HUGHES	NATHANAEL WEST
MADAME PAUL M. SRIBE	ANNA MAY WONG
MARTIN KOSLECK	VERA ZORINA

Under Auspices of
MOTION PICTURE ARTISTS' COMMITTEE
Hillside 7361 for Reservations
AND
THE AMERICAN ARTISTS CONGRESS

a throng of celebrities, some of whom had themselves been refugees: Fritz Lang, George Balanchine, Ernst Lubitsch, Luise Rainer, and Ernst Toch among them.

California Governor Culbert Olson was in attendance, along with Bette Davis, Dashiell Hammett, Edward G. Robinson, Dorothy Parker, George Cukor, Richard Neutra, Janet Gaynor, Hedda Hopper, Louise and Walter Arensberg, and dozens of other luminaries.

For the privilege of viewing what is today considered by many to be the greatest artwork of the twentieth century, Stendahl charged his first-nighters two dollars and fifty cents "plus tax." All proceeds benefited the children who had been orphaned in Guernica.

2

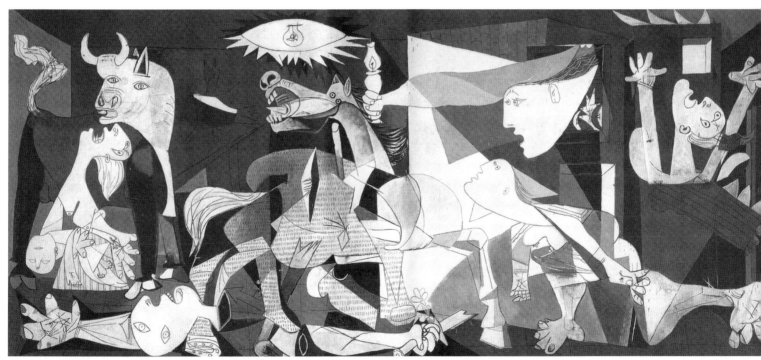

1 Invitation to West Coast premiere of *Guernica* exhibition at Stendahl Galleries, August of 1939.

2 *Guernica*, Pablo Picasso, 1937.

Unfortunately, Stendahl's efforts netted only two hundred forty dollars for the cause. Other showings brought a similar, disappointing response. The public, stirred up by the press, seemed more interested in a conservative backlash to Picasso's "cuckoo art," as it was widely trumpeted, than in being reminded of civil strife in Europe.

The Hearst newspapers were particularly vocal in their attack on Picasso and his ilk. They devoted generous space to a movement called Sanity in Art, which grew in popularity as a revolt against what some called sick and amateurish Modernism. The fact that Hitler was on their side didn't seem to bother the adherents, who included artists of the more traditional schools. Portrait painter Charles Bensco, for one, called Modernists "drunks and madmen who should be locked up for their offenses." Herman Reuter, in a *Hollywood Citizen-News* review of Edward Biberman's paintings at Stendahl's, compared the abstractionist to a kindergartner who throws paint willy-nilly onto a canvas. "What I know about art could, without difficulty, be put in a pea pod with room to spare for possibly a sewing machine," but disclaimer aside, Reuter thought he knew enough to attack Biberman's nonrepresentational slashes of color.

Stendahl did not miss the irony of a depiction of war starting a war of its own: was *Guernica* art or was it insanity? The critics could not agree, but Stendahl was less interested in a meeting of the minds than an opening of pocketbooks. In an effort to represent both sides of the inflammatory issue, he devoted his patio gallery (adjacent to the *Guernica* display) to an exhibition of fine examples of the more conservative academic art that his patrons (and the West Coast) were familiar and comfortable with: William Wendt, Armin Hansen, Maynard Dixon, Orrin White, Alson Clark, and Guy Rose were represented. Astute art critics pointed out that there were California painters in Stendahl's stable who were thoroughly modern in their aesthetic outlook, without pandering to the more radical European influences. But Edgar Payne lowered himself into the fray by claiming that wild-eyed Bolsheviks had taken control of the art world.

Payne had a friend in Josephine Hancock Logan, founder and president of the Society for Sanity in Art, Inc. Logan was the wealthy daughter of Col. John Lane Hancock of the Chicago Hancocks. Her husband, Frank Granger Logan, served fifty years on the board of the Chicago Art Institute and became its honorary president. The influential couple had strong feelings about how they, as art patrons, wanted their Logan Medal awarded. (Hint: not to a work representing any new "ism," whether cubed, dada'd or surrealized.) The Sanity in Art movement grew out of Logan's resolve to preserve soundness, rationalism, and internal logic in fine art. "Sane" was fairly simple to define: a bowl of fruit should look like a bowl of fruit.

In correspondence with Stendahl in August 1939, Logan laid out her strategy for Los Angeles and sent a check to cover a series of artist symposia that Stendahl sponsored for the public at his gallery. The discussion centered on the theme, The Sane Art of our Time.

An opposing voice was that of writer Irving Stone, a longtime friend and customer of Stendahl's gallery. As the author of *Lust for Life,* the story of Vincent van Gogh, Stone was in a position to express his thoughts on Modernism. He saw the world as richer for the works of van Gogh, Cezanne, and other modern artists whose paintings inspired the new, inevitable wave in America. Josephine Logan and her followers, no matter how erudite their connoisseurship, missed the point if they ignored the emotions expressed in an artwork, Stone wrote. Stendahl agreed with Stone. For him *Guernica* almost defied description, so powerful were Picasso's passionate and distorted images. Let the outraged collectors rage on. They would be led out onto Stendahl's patio, where they could feast their eyes on the impressionistic landscapes that never failed to soothe their souls.

Female figure, Jalisco, Mexico.

Chapter 6 ANTIQUARIAN

In early 1935, the Museum of

Modern Art in New York opened

Oceanic art (bronzes and ivory, as early as sixteenth century)

the groundbreaking African Negro

at his East 57th Street gallery. Matisse approached Stendahl,

Art exhibition. Concurrently, New

with whom he had collaborated before, about showing his

York art dealer Pierre Matisse (son

primitive art exhibition in Los Angeles following its summer

of Henri Matisse) was showing

run at the San Francisco Museum of Art. Pieces from the

examples of African and

New York show were also included. Matisse reported to

Stendahl that a great reception in New York had elevated the

reputation of the African sculptures beyond ethnographic curios to fine art. Not everyone agreed.

By September 1935, when Stendahl opened his version of African Negro Art on Wilshire Boulevard, a buzz had built about the objects that were variously called "naïve," "barbaric," "savage," "comic," and "bizarre." But some art critics marveled at masks and statues that they termed "modern masters" and acknowledged them for inspiring artists such as Modigliani and Picasso to echo the "Negro" sculptural forms in their own works.

Stendahl capitalized on the extreme reactions to attract the curious and the connoisseurs into his gallery. He arranged for Mrs. Hilda Byatt of the Royal Academy and longtime resident of the Ivory Coast, to lecture daily on the subject of African Negro sculpture. A folklore expert, Byatt impressed her audiences with an insider's knowledge and with the fact that insurance for the exhibition came to an astounding thirty thousand dollars.

Besides the Matisse material consigned from Mme. Charles Ratton of Paris, Stendahl borrowed pieces from the private collection of celebrated Lithuanian sculptor Boris Lovet-Lorski (1894-1973) who was known for his marble Art Deco female nudes. An impressive array of objects from New Guinea, Easter Island, and New Zealand was included, some

1 African Negro Sculpture, San Francisco Museum of Art, 1935.

2 Stendahl's Lovet-Lorski show with the artist's portrait of Mary Pickford, far right.

3 Boris Lovet-Lorski demonstrates his work, which drew actress Mary Pickford to his studio as his pupil.

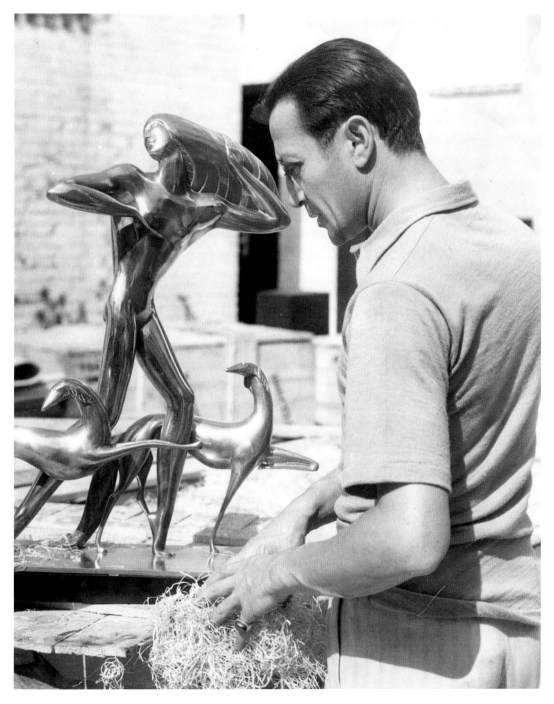

commanding in the present day a thousand times more than what Stendahl was asking.

Exhibit co-sponsor Merle Armitage wrote the catalog introduction. He gave credit to the Parisians for being among the first to recognize the aesthetic value of African art and the consummate skill of the native artisans. *Los Angeles Times* columnist Harry Carr took Armitage to task: "He now informs us that the wild African images worshipped by the Hottentots are high art and grand culture. No, no, this is too much." Buckley Mac-Gurrin complimented Stendahl for staging "the first showing of this sort of thing in Los Angeles."

But political correctness was a distant concept when Mac-Gurrin began his *Script* magazine essay with "Black has always been a fashionable color." In the piece he praised *les Parisiennes* for avoiding the mistakes of their less-sophisticated sisters who ignored black and missed an opportunity for arriving

at *chic*. Mac-Gurrin ended his mostly pro-Negro art critique with:

> Currently black is very much à la mode in the local art world. Please don't conclude that I believe that the future of American art is lurking in the jungles of Africa. This show is extremely valuable, however, as a viewpoint broadener. My only worry is that perhaps the younger enthusiasts may go for it too intensely and subsequently deluge us with phony Negroisms, as when, during a brief-but-painful period, they all became spurious Mexican primitives.

In fact, Pre-Columbian Mexican art opened Stendahl's discerning eyes to the wonder of ancient wood, clay, and stone. From the beginning, Stendahl recognized the commercial possibilities of exposing his clients who collected modern art to the aesthetic forms of the Pre-Columbian tomb offerings. Al described that compatibility in a catalog introduction for a 1952 Stendahl-sponsored exhibit at the Pasadena Art Institute: "The emotional overtones of form and their infinite expressive possibilities are the dynamic elements of our mid-century art, just as they were for the early-American image-maker." He concluded that Pre-Columbian and modern art were beyond the stereotypical ideal of classical sculpture. A certain

1 Oceanic art at the San Francisco Museum of Art, post-1935.

2 Olmec figure, Vera Cruz, Mexico.

1

vitality sets off each work, Al explained, though the styles vary widely.

Hollywood responded enthusiastically to the artifacts from Mexico and Central America. Edward G. Robinson, Vincent Price, John Huston, Charles Laughton, Kirk Douglas, Irving Stone, and many others invested in the exciting "new" genre and helped increase its cachet. If Stendahl disappeared for months at a time in Mexico or the highlands of Guatemala, it would be worth the wait.

Irving Stone's introduction to Pre-Columbian art illustrates the way Stendahl lured a new customer, hooked him, and became a decades-long supplier of the Meso-American figures. "Pay me as you would a utility" has already been described. But Stone became enamored so quickly with the ancient pottery, that it caused problems between him and his wife-editor-business manager Jean Stone. On one impetuous occasion in 1945, Irving dropped almost five thousand dollars (which the Stones could not afford) on Stendahl's latest terra cotta trove. Jean demanded Irving return all but one Aztec stone corn goddess to Stendahl.

But Irving had the bug. He tried for seven years to buy a tall clay ballplayer. Each year the price went up, disappointing Stone, who thought he had saved up the right amount. Stendahl increased his

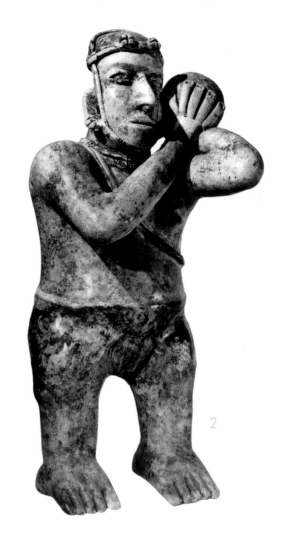

2

prices because he knew, better than anyone else, that the material was exceptional and becoming more valuable. (It might be giving him too much credit to suggest he foresaw what Pre-Columbian art commands today, but he certainly had foreseen its appeal long before anyone else.) Irving and Jean gave up on acquiring the piece they wanted so much—a piece just out of their reach. But Stendahl

1 Huastec Sun God, Vera Cruz, from the Vincent Price collection.

2 An ancient ball player like this one sought a home with Irving and Jean Stone.

was a dealer with a soft spot when it came to clients who were as passionate as he was about the Pre-Columbians.

One night as Stone was about to leave for Italy to research his novel, *The Agony and the Ecstasy*, Stendahl called to say he needed immediate cash to fly to Egypt, to make an offer on a newly discovered cache of gold. A deal was struck: If Stone could supply Stendahl's round-trip ticket to Cairo, the Pre-Columbian ballplayer would belong to Jean and Irving. The price? Exactly what was quoted to the Stones eight years earlier. From then on, Stone called Stendahl "the godfather" of his Pre-Columbian family. Their friendship was cemented when a Mayan vessel Stone pined for, but could not afford, landed on his doorstep as a gift one Christmas morning. Over time, Stone's literary success allowed him and Jean to add dozens of statues to their collection, which, reminiscent of the Arensbergs, took on the importance of adopted children.

Stendahl is the American art dealer most closely associated with Pre-Columbian art and the most influential, especially in the early years. Stendahl's reputation as an expert in the field developed over decades, from the late 1930s through the mid-1960s. One hundred years after the gallery doors first opened, the shingle is still out, and although the gallery is involved in European and American paintings,

the emphasis continues to be Pre-Columbian art. Stendahl was introduced to Pre-Columbian art, all because of a wooden printing press.

In 1935, Señor Guillermo Echaniz, a Mexico City bookseller, came through Los Angeles, on his way to the Grabhorn Press (1920-1965) in San Francisco. Echaniz was looking for a buyer for the first printing press used in the New World, a wooden model from Mexico. He had with him photographs of the machinery and historical documentation. Echaniz heard that Stendahl knew people at the Grabhorn Press and at Los Angeles institutions (museums, schools, historical societies) where there might be interest in purchasing the printing press. Since Echaniz was seeking introductions, Stendahl took the man to see Walter Arensberg, who had good contacts of his own and a few examples of centuries-old pottery from Mexico. Arensberg was proud of his small Pre-Columbian collection, acquired in New York—some pieces as early as 1915. After a quick perusal, Echaniz commented off-handedly to the two men, "Oh, I can get things like that." This got Stendahl's attention. "Well, get some!"

Echaniz and Stendahl, early explorations.

The Mexican government or *The New York Times* eventually bought the printing press, depending on which story is the more reliable. And Echaniz continued to sell antique texts in his bookstore. But after connecting with Earl Stendahl, the aristocratic Mexican discovered that he had bigger *pescado* to fry. Echaniz became wealthy by selling and exporting crates of statuary to Los Angeles, enabling Stendahl to launch a sideline that proved to be seminal in its scope and dominance.

Art historians refer to a pendulum of taste. Stendahl liked the term, because it implied freedom of movement—the back and forth of trends, styles, spending habits. He was comfortable at the extremes that made lesser players nervous. Stendahl saw his client base as a diverse population, novices to pros, who could

be, if not manipulated, encouraged toward certain works of art. Manipulation was, however, always an option. Stendahl's collectors were expected to trust him and to trust their own increasingly educated tastes. The dealer was the teacher, but he had plenty of help. Stendahl never let an opportunity pass to book speakers on Wilshire Boulevard who could enhance the appreciation of whatever exhibit was currently running. It has already been established that the artists who took up residence in his small studios paid their rent, in part, by giving classes to Stendahl's patrons and art students. Entering into an entirely new field of art made it more important than ever to begin educating the public about the exciting finds coming out of the ground in Mexico. It helped that Arensberg was such an early enthusiast and considered his Pre-Columbian holdings to be of equal artistic merit to his masterpieces of twentieth-century sculpture and paintings.

Stendahl particularly prized the jade objects for their exquisite carving and the unmatched green of the New World stone. He dedicated an entire room to jade and gold upstairs on Hillside Avenue when the two Hollywood houses became showrooms, inventory repositories, and workshops of the Stendahl Galleries.

Pre-Columbian gold pieces still come along today, but an industry of fakery has made even the experts skeptical about authenticity and some dealers wary of handling the genre. Any discussion of early dealings in ancient art must include mention of fakes. It was never a question of *if* Stendahl would get burned by buying counterfeit art, but where, when and how often.

The Joseph Brummer Gallery of Paris and New York, known for classical ancient art, was one of the first commercial establishments to sell Pre-Columbian objects. According to Louis Kaufman, the Arensbergs traveled five days by train to New York just to buy a few objects from Brummer. At the time that Stendahl entered into the Pre-Columbian market (the "market" still largely un-established), only the Europeans were already active. In the U.S. in the mid-1930s, most of the interest in indigenous cultures was institutional, emphasizing archaeology and ethnography. The material that museums or universities had acquired was, for the most part, stored in their basements. Stendahl's first trips to Mexico to meet with Echaniz and his suppliers were the beginnings of a long learning curve.

Stendahl's baptism into the buying and selling of Mexican artifacts was instructive. Stendahl landed a group of Zapotecan urns, which, if authentic, could command a lot of attention and good prices. Unfortunately, he sold a number of the urns before it was determined that they were all fake. Stendahl

honored the same long-standing policy that had been applied to his paintings and other works of art: satisfaction guaranteed or your money back. No questions asked. Al recalled his father donating the urns to the Los Angeles County Museum of History, Science, and Art for educational purposes. Years later, the museum wanted to unload the spurious material, so they returned what they had left of the cache. A dealer who had bought an old Cadillac from the Stendahls bought the whole group of urns for just a few dollars apiece. "And then he shot himself," said Al. Unfortunately, true.

Even a slight doubt as to provenance was grounds for canceling a deal. And there were plenty of doubts until Stendahl and others slowly developed an eye, an expertise, and a reputation in the challenging new genre. Of equal importance, Stendahl established close relationships with his sources. He had given shows for Diego Rivera, David Siqueiros, and José Clemente Orozco and was instrumental in luring them to Los Angeles following successful mural commissions, such as Rivera's *California* frescoes at the San Francisco Stock Exchange. "I know you would like Los Angeles and Hollywood, and they would like you," he told Rivera in correspondence in 1936." I firmly believe it would be worth your while." Rivera was the first Pre-Columbian collector of note. His preference was for the west Mexican material that came out of the states of Colima, Nayarit, and Jalisco, the same area that Stendahl chose as his

1

2

Paseo de la Reforma, 104,
Mexico, D. F.

October 29, 1929

Stendhal Art Galleries,
Ambassador Hotel,
Los Angeles, California.

Gentlemen:

I trust you will pardon the delay in answering your kind letter of September fourth, but I have had illness in my family and have not been able to attend to my correspondence.

I should be most happy to send you the canvas you desire at once were it possible, but at present all my time is occupied with the painting of murals in the new building for the offices of our Federal Health Department and the immense wall of our National Palace. Also I have recently had the honor of being named the Director of the Academy of Fine Arts, which I am now in the process of reorganizing.

As time permits, however, I am painting at home and I am always finishing something new. I shall, therefore, keep your request in mind and communicate with you just as soon as I have something which would please your client.

Very sincerely yours,

Diego Rivera.

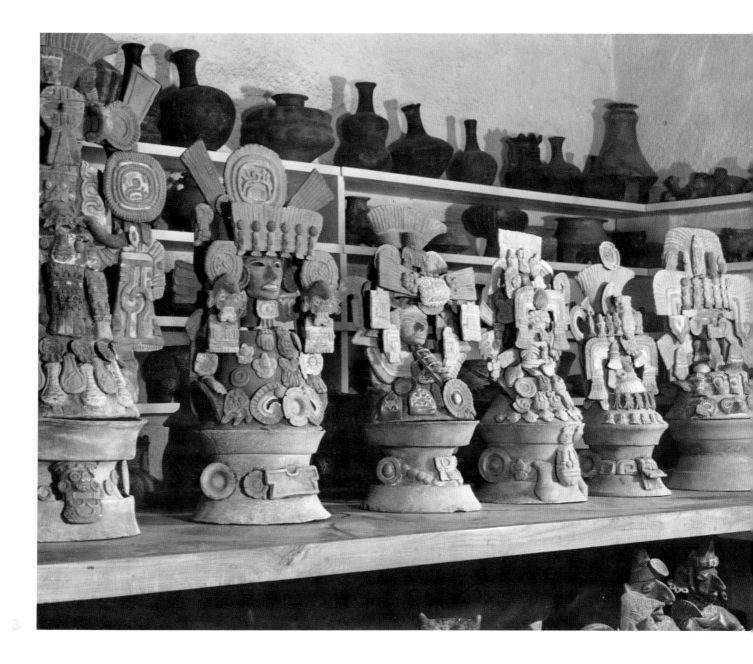

1 Stendahl admires a Diego Rivera painting.

2 From Diego Rivera to Earl Stendahl, 1929.

3 A group of authentic incensarios from Teotihuacan, Mexico, ca. 300-900 AD.

2

1

special emphasis, early on. Stendahl saved Rivera's letters, evidence of their decades-long friendship and dealings with each other.

Rufino Tamayo (1899-1991), the Zapotec Indian artist from Oaxaca, was acclaimed as a modern Mexican master whose work was inspired by Pre-Hispanic art. His sensibility was not socially conscious or political, so he suffered criticism from the radicals around him. The more-spiritual Tamayo remained true to freedom of artistic expression. Stendahl liked him very much and admired his use of Pre-Columbian motifs in his colorful paintings and prints. Tamayo had an extraordinary collection of Pre-Cos (the term used by dealers and collectors) that he donated to his native city of Oaxaca.

Stendahl also promoted the work of Mexican Miguel Covarrubias (1902-1957) who, like Rivera, found success painting murals in San Francisco. His work enhanced the Golden Gate International Exposition of 1939, but Stendahl was more familiar with his popular illustrations (caricatures) in *Vanity Fair* and the *New Yorker.*

Stendahl enjoyed trips to Mexico to visit his "*niños*"—the revolutionary painters and their circle who influenced a generation of politically engaged artists. "*Las niñas*" weren't bad, either. Dolores del Rio, Frida Kahlo, Georgia O'Keeffe, and dancer/ artist Rosa Covarrubias added beauty, brains and passion to the 1940s Mexican cultural scene. Patrons of the arts Miguel and Rosa Covarrubias bring to mind the Arensbergs and similar hosts in Paris's Left Bank or New York's Greenwich Village. These avant-garde thinkers drew together an artistic and intellectual society fed by daring art and ideas. The Stendahls were equally generous with their own open-door policy in Los Angeles and saw first-hand what it meant for the émigré to find a welcoming community.

Stendahl took up residence in Mexico for extended periods. He invested in silver mines there, one called The Enid. But he tapped much richer veins beneath the soil where stone masks and terra cotta vessels were hidden. His trips to oversee the mines, which included aerial surveys, educated him about the land, its people, and its bounty of ancient burial mounds. From those sites—easily located from an

1, 2 Stendahl's gallery displays of Pre-Columbian art.

3 Joe Dammann in the Stendahls' New York apartment.

airplane—Stendahl withdrew treasure. For Stendahl, the material he so freely brought across the U.S.-Mexico border for thirty years was not treasure; it was inventory, the next product to be exploited. Stendahl certainly appreciated the skill of his long-dead artists. He admired tremendously the work of the early Mexican masters. But Stendahl was a businessman. A salesman. Selling is what he did, and he did it well. He never anticipated getting into so esoteric a market as ancient New World art. But there it was, there he was, and there followed a career with far-reaching historical and cultural significance.

Mexico was not a lawless country without protections for its national heritage. The books were clear: It was illegal for a foreigner to own or export the ancient art that was becoming so popular in the U.S. and Europe. But enforcement was iffy: pockets could be filled; rules were ignored over a couple of tequilas. After all, there was so much yet to be unearthed. Remarkably, there still is in the twenty-first century; but fortunately the rules and enforcement thereof are far more rigid.

In the earlier decades of excavation and exploitation, some in the Mexican and Central American governments reasoned that, with such an abundance of riches, it made perfect sense to them that collectors and museums in other parts of the world could proudly display the Pre-Columbian artifacts if they were willing to pay for the privilege. Money that was being spent to protect the burial sites and to tighten the borders could go instead toward building well-maintained museums and providing services for the citizenry. The fact that the objects were stolen (by law, all finds of cultural property should have been turned over to Mexico's National Museum of Anthropology), demonstrates that the "system" failed to send resources where they could do the most good. Earl Stendahl might have been a *contraband-isto* who brought countless works of Meso-American tomb art across the border into the United States, but he paid his small-time dealers and middlemen to show him their discoveries first, and he bought the

1 Reverend James Latimer McLane, an authentic connoisseur, in the rectory of St. Matthias Church, Los Angeles, surrounded by his Pre-Columbian, rococo and modern objects and one frog of dubious origin, 1950.

2 Mayan captive, Jaina Island, Campeche, Mexico, ca. 600-900 AD (late classic period).

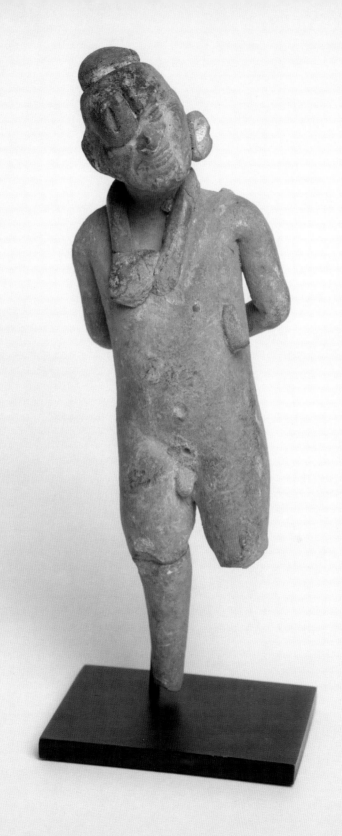

2

pieces he would re-sell. Stendahl believed, from the very beginning, that he and his collectors had a much greater appreciation for the art works than anyone in the Latin governments. A convenient belief, to be sure, but it worked for him.

Stendahl has been compared to "Indiana Jones." There are sequences in *Raiders of the Lost Ark* (1981) that nearly capture Stendahl's early adventures south of the border. In truth, son-in-law Joe Dammann was much closer to the "Indy" character, more than once narrowly escaping with his life and armfuls of Pre-Columbian gold via Central American jungle rivers in the 1950s. Joe was the first to admit that he had learned from the best treasure hunter in the business.

On trips to the Mexican silver mine, Stendahl gained knowledge about more than how to run a shoddy mining operation from the foreman. He observed savvy ways to deal with the Mexican locals. Guns bought protection and opened secret doors, as did supplies of whiskey, cigars, cheesecake photos (Dolores del Rio was a favorite), and, occasionally, a sound horse or ox. Former jockey and art dealer Billy Pearson (1920-2002) bribed his way across the Mexico-Texas border hauling a trailer loaded with Pre-Columbian artifacts, by offering the Mexican guard a case of canned chilies. Pearson

wore his smuggler cap proudly. "To an art collector, any crime, including murder, is fair in protecting a collection of rare junk." He was just kidding about murder. Probably.

Stendahl discovered another enticement for breaking down barriers that others before him had not tried: an appeal to vanity. Perhaps he was inspired by his experience with the Hollywood movie crowd who helped create a market for Pre-Columbian art. Today a pair of sunglasses worn by the starlet-du-jour becomes a coveted item. In 1940, a stone fertility goddess in Charles Laughton's collection said "I am in vogue—coveted by the famous. You can own one like me, and you can get it from Stendahl." But the original source for such objects might be a place that was not friendly to outsiders.

By the mid-1940s, Stendahl was well established as the pre-eminent American dealer in Pre-Columbian art. He had cornered the market on exquisite, finely carved figurines from the island of Jaina, off the Yucatan peninsula in Mexico. Because Mayan kings were buried there, armed soldiers guarded the burial sites and the highly prized tomb contents. How the statuettes continued to make their way out was a mystery. Refer to "canned chilies" above.

In 1957, Stendahl disembarked on Jaina, posing as a movie producer with written permission to shoot a documentary about an archaeological excavation.

He was accompanied by about three dozen diggers with shovels and "crew" members carrying cameras. The commandant in charge seemed skeptical, even though Stendahl offered up impressive (but bogus) paperwork to corroborate his claim. (Would that we could see that letter.) Stendahl played the vanity card, which did the trick: as the "producer" he offered *El Jefe* and his soldiers parts in the movie. They would mill around offering expert opinions on where and how to dig, tidbits on Mexican history, and other colorful commentary. Stendahl's diggers were all Spanish-speaking, as were, of course, the soldiers, but there was no attempt to translate anyone's comments for the presumed English-speaking audience. In hindsight, Stendahl may have produced the first mockumentary ever made. That is, if there had been film in the cameras.

When Stendahl yelled, "Action!" (he was also the director) the soldiers showed off their weapons, shooting the occasional lizard or rabbit to the applause of all gathered. No one clapped louder than Stendahl. Meanwhile, the diggers kept digging. For more than a month cameras rolled on Jaina. Out came object after object, with Stendahl stifling his excitement, as he gazed upon the uniquely

The classic Mayan profile. Note the similarity in the two necklaces.

Mayan blue pigment ornamenting the delicate clay noblemen. Potentially millions of dollars lay before him, lined up in the dirt.

One cannot recount this story without recognizing that Stendahl was plundering the final resting places of ancestral remains. As in Egypt and other cultures, the Mexican tomb offerings were meant to accompany the departed's soul to the afterlife. Who has the right to interrupt such a holy journey or to desecrate a grave? Stendahl found a way to justify his actions. Even though he was called "an old bandit" by Edward G. Robinson and a grave robber or *huacero* by others, Stendahl believed he was rescuing great art from oblivion. On many occasions, he (and others of his ilk) arrived at a site, just hours ahead of bulldozers that were poised to turn over fields for construction. If Stendahl got there too late, he witnessed another kind of plunder: graves filled with Pre-Columbian treasure plowed under in the name of Mexican or Central American progress.

Ron Dammann remembers his first trip to Mexico on a buying trip with his father, Joe. Ron was a teenager in the early 1960s, ready for high adventure. Instead, there were rather low-key business transactions between Joe and the network of Mexican dealers whom the Stendahls and Dammann had cultivated. A small archaeological museum in the western state of Colima was closed on the day Ron and Joe arrived. The director opened up for them, and Ron watched his dad point out pieces in the display cases that interested him. After a short time, money changed hands, and the Dammanns left. Some weeks later a shipment arrived in Los Angeles from Colima. It is astounding that museum directors would sell off valuable objects under their care, supposedly prized by their countrymen and their governments. But "valuable" tells the story. Where there was money to be made, a way was found, even at great legal risk.

Stendahl operated in a world where dealings were fast, loose, and largely unimpeded during the years that the U.S. admitted duty-free antiquities. All that changed when the United States recognized the importance of assisting other countries in protecting their cultural patrimony. In 1972, UNESCO (United Nations Educational Scientific and Cultural Organization) passed a Convention Concerning the Protection of the World Cultural and Natural Heritage. Since that time there has been increased cooperation between countries to stem the flow of smuggled artifacts, so that the Pre-Columbian art market entered a more tightly controlled phase. Questions of provenance immediately took on equal importance to authenticity.

During his presidency in the 1980s, Ronald Reagan appointed Al Stendahl to the first Cultural Property Advisory Committee commissioned to evaluate petitions from foreign countries seeking the return of artworks. Al was among those recognized

as experts in contributing informed opinions about which objects qualified as cultural patrimony. Al's presidential appointment was a kind of *quid pro quo*, acknowledging the contribution that reputable art dealers make to the fair worldwide distribution of art that has been identified with its country of origin. But the Committee had little influence on the problem of illicit trade.

Oscar Wilde once declared, "Morality, like art, means drawing a line someplace." Governments have tried to define the line. Lawyers and moralists have tried. Earnest politicians, anthropologists, writers, artists, educators, students, scientists, poets, and ordinary people all make their choices while straddling the line or committing to a side. Earl Stendahl's early exploits in Latin America put Pre-Columbian art on a world stage. There is no going back to an era of obscure burial mounds that stretched as far as the eye could see.

1 Stendahl in a Panama in Panama.

2 Stendahl at El Tajin, Vera Cruz, Mexico.

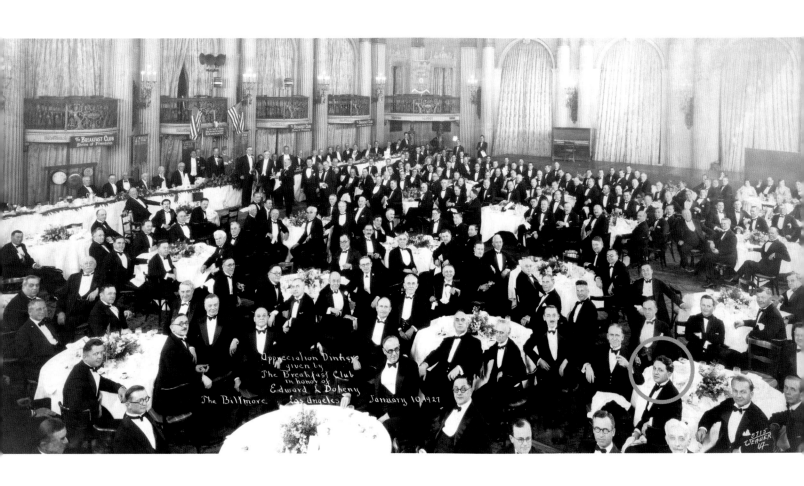

Breakfast Club Appreciation Dinner in honor of Edward L. Doheny, The Biltmore Hotel, 1927.
Earl Stendahl is circled.

Chapter 1 TEAM PLAYER

Growing up in a tight-knit

family of seven siblings taught

one of the brothers would ask another to man the bakery

Earl Stendahl the value of

ovens, with the promise of a payback for the favor.

cooperation. The family business

Well into his seventies, Stendahl still displayed a lifelong

in Menomonie required

impatience with idleness. Ron describes a grandfather who

everyone's industrious

treated work like religion and expected others (particularly

participation. Many a night,

family) to worship at the grindstone altar. Joe made continual

attempts to convince his father-in-law that Ron and Rock

deserved a childhood filled with many carefree, imaginative hours. Like Stendahl, Joe had grown up with four brothers, all hard workers on the family farm in Illinois. He left home early (the only Dammann brother to flee the Midwest) for a bigger, non-agricultural life. Rearing sons in Los Angeles had its challenges, but Joe supported his family well from his Stendahl Gallery income. He and Eleanor saw no need to press Ron and Rock beyond doing their best in school.

Their grandfather had other ideas. If he spotted the boys unoccupied or simply playing, they were usually put to work. Rock recalls that the jobs could be insignificant: pulling weeds with the old man, digging a hole, sweeping the walks, even polishing the leaves of plants. "Do something useful" was heard over and over, as Stendahl tried to instill a work ethic in his grandsons. In hindsight, Rock believes his grandfather was someone whose mind was going a mile-a-minute and didn't understand a gentler approach to life, even for children. The man hummed incessantly, as if his own voice kept him company. He wasn't someone who sought solitude. Stendahl's escapes from the pressures of business took him to racetracks, fishing holes, places to paint, artists' lairs, and cities of the world. But he was rarely alone. Hundreds of letters reveal a fraternal nature and warmth toward his fellow man. Perhaps his memberships in organizations like the Los Angeles Breakfast Club, the Elks,

and others had more to do with pure socializing, not networking for the purpose of selling art.

It isn't entirely clear why Stendahl, who was among the first to open a gallery in Los Angeles, remained in business for fifty years, while other, very fine operations closed their doors in only two or three. Lorser Feitelson had some success promoting Subjective Classicism and Post-Surrealism at Stanley Rose Gallery, the Centaur Gallery, and as the director of the Hollywood Gallery of Modern Art. These enterprises did not last. Actor Vincent Price said in his amusing "visual" autobiography, *I Like What I Know,* "You can never really appreciate or understand the business of art unless you actually run a gallery." His deep respect and admiration for art dealers was born out of his experience opening his own Beverly Hills store in 1943 with actor and partner George Macready. Price kept The Little Gallery going for two years before it folded, and the two art-loving partners returned to their successful film careers.

Later, Price convinced Walter Arensberg that Los Angeles needed a Modern Institute of Art. San Francisco had multiple museums, concert venues, public parks, a great zoo, and an aquarium. Los Angeles had Forest Lawn cemetery and the La Brea Tar Pits, which Price called "a hole in the ground." Money was raised, and the public responded to the Institute's exhibitions of modern art. Some of Hollywood's finest got involved, such as Edward G.

Robinson, Fanny Brice, and Sam and Mildred Jaffe. Even with a strong director (Kenneth Ross), and knowledgeable leadership from Kenneth MacGowan, a film producer who was the first chairman of UCLA's Theater Arts department, the institute folded after just two years. The high Beverly Hills rent was, no doubt, a factor. However, Price summed up the experience this way: "Most of the original founders were bled time and again for additional contributions, but the good, rich people of Los Angeles wouldn't come through, so we closed." Price was disgusted with the lack of support. To his mind, L.A. was a city that needed all the culture it could get.

Jake Zeitlin's bookstore and gallery enjoyed a long run, attracting the same artistic and literary types as Arensberg salons and Stendahl galleries. Dealer John F. Kanst arrived on the scene early and his gallery lasted a long time. But Stendahl survived and thrived in ways that some firsthand observers found remarkable. Vincent Price called Stendahl one of the greatest characters in the art world and one of the most controversially exciting. Labeling him a pioneer and an astute businessman, Price declared that no one had yet put Stendahl into his proper place in the history of great dealers, and that Stendahl, more than anyone else, was responsible for bringing the variety and brilliance of Pre-Columbian art to a receptive world.

Stendahl's strategy for success was multi-faceted, depending heavily on the alliances he forged with other dealers, artists, critics, scholars, museums, and collectors. What appeared to be an act of benevolence—the hiring of two of his brothers and a cousin to work at Stendahl Galleries—allowed the boss to surround himself with trusted family members who were grateful for the work. Mildred Lawrence, Sonia Wolfson, and Delfina Bateman, the bookkeeper, joined the close-knit group for long periods of time and were trained to run the operation during Stendahl's absences. It wasn't all work. Artists and clients enjoyed jovial lunches and suppers upstairs at 3006 Wilshire, where Chris fussed over the food and service like an overly attentive *maitre d'hotel*. No one was more appreciative of a fine dining experience than Stendahl. From a 1940 letter to Schofield: "Enid has cooked a few meals that you certainly would have enjoyed on her new electric stove. Although she doesn't know how to run it, she is still able to turn out a credible meal."

Written on the back of a photo titled *Reflections*, is a dedication to Chris Stendahl: "In appreciation of your swell dinners." Painters & Sculptors Club of Los Angeles, November 1, 1938.

In contrast, the Arensbergs served only nuts and fruit at their place, along with the de rigueur pound cake and pineapple juice. You might beg for an invitation to rub elbows with Marcel Duchamp, Mark Rothko, Henry Miller, or Irving and Jean Stone, but you did not go to the Arensbergs' to eat.

Mr. Earl Stendahl

cordially invites you to a reception in honor of

Mr. Karoly Fulop

and to a pre-view of Mr. Fulop's exhibition
Monday evening, November thirtieth
Eight to eleven o'clock
at the

New Stendahl Art Galleries

Three thousand six Wilshire Boulevard

Los Angeles

Mr. Fulop's Exhibition may be seen
from December 1 to December 19.

EXHIBITION by KAROLY FULOP

PANELS

CARVED AND PAINTED WOOD

1. Baptism	2500	8. Procession	900
2. Fleur de Lys	1000	9. Lullaby	2000
3. Marriage	1500	10. The Gateway	1000
4. Hymn	1800	11. Vision	1400
5. Cloister	1000	12. Salome	600
6. Betrothal	1500	13. Shrine	750
7. Pentacost	2500	14. Even Song	600

NATURAL WOOD

15. Offering	1000	17. Marriage	1000
16. Vision	1000	18. Betrothal	1000

Stendahl and Arensberg cooperated with each other in a loose arrangement, whereby each recommended the other to Los Angeles visitors looking to increase their knowledge of art. Collectors who were exposed to Walter and Louise's magnificent home, with its antique furnishings and growing art collection, were referred to Stendahl's gallery for a deeper immersion into a particular artist's work. Arensberg was taken by the paintings and wood reliefs of Hungarian sculptor and painter Karoly Fulop, who exhibited at Stendahl's. Enid and Earl brought Fulop to Hillside Avenue to meet other émigrés, so he could join the dynamic Los Angeles creative community whose members fed upon each other's ideas.

These mold breakers relied on mutual acceptance, no matter how divergent their artistic or political philosophies. What was once, for Los Angeles, a regional viewpoint, expanded to an increasingly global perspective under the leadership of visionaries like Stendahl, Arensberg, Armitage, architect Lloyd Wright and others. Most of the players probably did not grasp the far-reaching impact of their get-togethers in Southern California homes, bookstores, art clubs, and galleries. But Stendahl, for one, understood there was power in partnerships. Instead of concentrating on building up the Stendahl name, to the exclusion of competing galleries, he entered into cooperative efforts with them. Since World War II, it has been common business practice to form unions and associations for the welfare and advancement of all the participants. A "strength in numbers" mindset, if you will. But before 1950, a more solitary, one-against-the-world position was viewed as

1, 2 Karoly Fulop exhibition, Stendahl Galleries.

3 Karoly Fulop's work is reproduced in *The Wasp-News Letter*.

Courtesy Stendahl Art Galleries
Printed by
Walter S. Braat Press
331 Seventh St., S. F.

YULETIDE MELODY
By Kasper Pissis

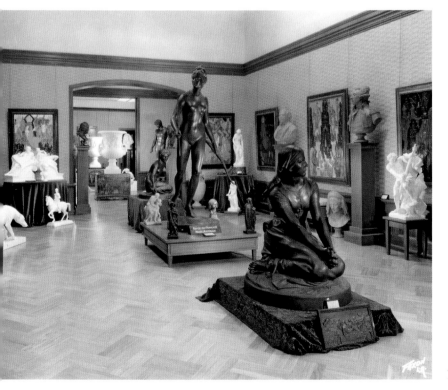

the strong one. In that climate, William Randolph Hearst and Edward Doheny rose to prominence, as had earlier captains of industry, such as J.P. Morgan and Cornelius Vanderbilt. Stendahl's sociability worked to his advantage in planning sales strategies that were ahead of his time. For example, he was not above teaming up with the federal government, when he saw an opportunity to expand his business.

Enid Stendahl might have despised the Roosevelts, but she and Earl could not deny the artistic and economic benefits derived from one of the New Deal's most successful programs: The Federal Works of Art Project. Operating between 1933 and 1943, the project's purpose was to employ out-of-work artists by commissioning works (usually murals) for government buildings, such as libraries, county courthouses, and schools. When artist Millard Sheets was appointed to the Southern California Works Projects Administration (WPA) committee to hire artists, he turned to friend and mentor Stendahl to find local talent. Sheets was not yet thirty years old but already had established a reputation as a first-class painter whose watercolors Merle Armitage considered "head

and shoulders above the rest." Multiple-hat-wearer, cultural maven Armitage was the Southern California regional director of the Public Works of Art. The artist selection committee included Sheets, his dealer Dalzell Hatfield, Arthur Millier, film director Cecil B. DeMille (a Stendahl client), and Stendahl-artist Hugo Ballin, A.N.A. (painter of the famed murals at Griffith Park Observatory and the *Los Angeles Times* building rotunda).

Stendahl's connections paid off after Sheets and company were instructed on a Friday to put a hundred artists to work by Monday night. A harried week later, the huge undertaking was complete, with the committee hand-picking artists who were both needy and capable of meeting the project's high standards.

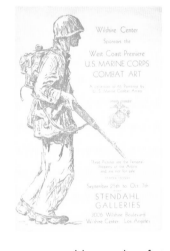

What did Earl Stendahl have to gain from the local Public Works of Art program? A well-fed artist is a happy artist. Over the years, Stendahl expended considerable money and energy tending to the well being of those who were his bread and butter. If Emil Bistram, Lorser Feitelson, Stanton Macdonald-Wright,

and others could pay their rent with the help of a public art commission, Stendahl's job became a little easier. But there were rewards beyond aiding and abetting his artists.

A highly publicized show put meat on Stendahl's table. In the spring 1937 issue of *Rob Wagner's Script,* Art Stuff columnist Buckley Mac-Gurrin called Stendahl's Federal Works of Art Project "astonishing!" Stendahl could not have bought a more enthusiastic and amusing account of how offering his gallery space served the public good:

1 U.S. Marine Corps Combat Art at Stendahl Galleries.

2 The Stendahl Galleries storefront on Wilshire Boulevard advertises combat paintings.

As he did so, his eyes were bright with the happy dew of righteousness, and his fine, Louis Seiziemesque features were suffused with a patriotic carnation, which made one think of …Camille Desmoulins, Garibaldi, Patrick Henry, Molly Pitcher, Leonidas, Jeanne d'Arc, John Paul Jones, Admiral Farragut, Simon Bolivar, Betsy Ross, Abraham, Napolean I [sic], Daniel Webster, the Imperatrice Eugenie, Hannibal, Lord Nelson, and—possibly—David Belasco [a prolific Broadway producer, rumored to be the "casting couch" inventor]. After all, the Stendahl Galleries are extensive and expensive; the Federal art productions are not for sale, since they already belong to the people of the Commonwealth, hence offer no field for commissions. Besides, the American Consul at Los Angeles couldn't step forward and bestow a medal of reconnaissance, as could the French, Lithuanian, or Japanese consuls, under similar circumstances. So it was really a generous gesture, and when we heard it, we cheered Stendahl whole-heartedly and ran briskly aloft to man the yards.

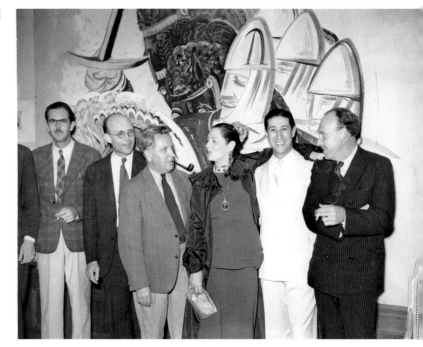

3

4

3 Stendahl (with the pipe), Buckley Mac-Gurrin (in the white suit), and S. Macdonald-Wright (far right), pose with a group in front of Mac-Gurrin's fresco, which is painted on the wall of Stendahl's patio.

4 Buckley Mac-Gurrin Exhibition, 1933. Note the cash discount note.

On the opening night, a man stationed at the door counted twelve hundred visitors before he fainted and had to be replaced. Those who have consistently tongue-in-cheeked the Project shrank, so that the Singer Midgets were busy apologizing for stepping on them. In fact, I think one can safely say that, at this writing, the immense importance of the Federal Art Project has been grasped by the people at large.

One of the reasons Stendahl so identified with the Public Works of Art Project was its emphasis on mural art. He enthusiastically supported the form, which was inspired by the works of the great Mexican muralists Orozco, Rivera, and Siqueiros—all of whom he backed with solo exhibitions in Los Angeles. Painting on the wall of a building suggested permanence. The social ideals espoused by many of the Latin and American artists before World War II could be expressed in a monumental format for future generations to look at and appreciate. But would anyone be surprised to learn that the U.S. government frowned upon anything that might be deemed a tad too avant-garde? "Revolutionary" was not an attribute. The Mexicans were to be admired for their artistry, not for their bloodlust. One of Sheets's frustrations as a young administrator for the Los Angeles region was the strings-attached dictum that the subsidized artists' subjects should stick closely to the American scene. Pretty colors, recognizable places, nationalistic displays. Nothing weird or political, please.

EXHIBITION APRIL 2 TO 21

Macdonald-Wright

THE STENDAHL GALLERIES

3006 WILSHIRE BOULEVARD, LOS ANGELES

1 Stendahl Galleries' Macdonald-Wright show announcement.

2 Macdonald-Wright inventory page from Stendahl's archive. Note the misspelling of the artist's name, plus the price and the sales history of *Conception Synchrony*. Stendahl bought the work for $300, marked it up to $4,000, and sold it to art dealer Paul Kantor in 1960.

Stanton Macdonald-Wright (1890-1973) was an internationally acclaimed Modernist from Santa Monica, California, who, according to Al, spent many hours hanging around Stendahl's gallery. Attesting to Earl's enthusiasm for the artist's work and scholarship, a promotional postcard for a combined Stendahl exhibition with Morgan Russell declared, "Mr. Wright will give a thrilling talk Monday evening." The talk, presumably, incorporated Synchromism, the color harmonies painting theory Macdonald-Wright co-created with Russell, his mentor. Stendahl liked to quote Macdonald-Wright's Zen-like confession, "I paint as I do because that is the way I paint."

Macdonald-Wright was not only one of the earliest abstractionists in California, but a series he painted for the Santa Monica Public Library was the first federally-sponsored mural project in Southern California: *Technical and Imaginative Pursuits of Early Man*. The historic panels were considered outmoded and stored away at the time the library moved in 1965. More than forty years later the restored work returned to public view, gracing the walls of Santa Monica's new main public library—an architectural jewel of contemporary design.

The Stanton Macdonald-Wright/Morgan Russell show exemplified the way Earl Stendahl became a part of virtually every important movement in

4244

STANTON MCDONALD WRIGHT
Conception Synchromy
Abstraction *Syncrony

Oil - fmd.?

24 X 66 1916

c-300

p- ~~2500~~ 3000 4000

rep- Schools of 20th Cent Art - Mod. Inst of Art
 April 1948

reproduced - Art News - April 1950
 Page 50

Am. Fed. of Arts Traveling Show
Mod. Inst. Arts - Bev. Hills
Food Museum of Modern Art 1951
Brooklyn Museum 1951

rep- American Painting from the Armory
Show to the Depression -
Dr Milton W. Brown
Princeton University Press

Sold Paul Kantor
 1960

twentieth-century art. The dealer aligned himself with the women and men who were not only making art, but who were on the cutting edge of defining the way the world looked at art.

It isn't surprising that Stendahl was asked more than once if certain local art critics were, perhaps, a little too close to him and his operation. No one actually accused the dealer of bribery or other dirty tricks where critics were concerned, but his exhibitions were consistently positively reviewed; he employed secretaries who also happened to be excellent writers and art historians with connections in the local press; art reviewers and columnists were frequent dinner guests at his house. Was it all orchestrated? Was Stendahl a fair-weather friend who exploited relationships to his own advantage?

Oral histories, letters, photographs, and family recollections suggest something else. Yes, Stendahl missed few opportunities to turn a situation to his business's advantage. And yes, there are instances where he told certain artists or other gallery owners that they would have to prevaricate along with him, to smooth someone's feathers or close a deal. No

one is attempting to put a halo over the man's head. That would be, all things considered, laughable. What cannot be denied is that Stendahl, the man, was sincerely liked, even by those who might gain from taking him down a notch or two.

Here is a composition by Merle Armitage, written for an unknown occasion, recognizing Stendahl and others for their support of the arts. It is an anthem to Los Angeles in all its superficial glory and to those who tried to bring culture to what Armitage considered a "middlebrow" audience. Stendahl saved the original, typewritten "song," given to him by Armitage.

Because Stendahl had no problem seeing himself as team player, he entered into deals with the top galleries of his time in California, Chicago, Dallas, London, New York, Paris, Portland, and Washington, D.C. This was more than a gesture of cooperation. Stendahl needed to work with his rivals to keep his own doors open. Others felt similarly: "We need the contact with you breezy Westerners to pep us up!" This, from Stephen Bowen of the Marie Harriman Gallery in New York in 1941. Stendahl made a consignment agreement to sell works by Cezanne, Seurat, Gauguin, Matisse, Lautrec, and van Gogh. In the ten years since Stendahl launched his Wilshire Boulevard gallery, values had increased dramatically. The game was being played at higher stakes. To build his profile and add to his inventory, Stendahl acted as the de facto West Coast painting representative for the prestigious art dealer, Wildenstein &

"Walt Whitman's Return," by Merle Armitage.

Why not enlist the aid
Of men who have laid
Arts real foundation?
Of thee I sing.

Where are our sculptors bold
Our painters with their gold
Of Western traditions?

Give us imaginations, free
Strong work by Lovet-Lorski
See Stendahl's Gallery

Give us a chance to show
All that we do, and know
Give us a chance to sow
Some seed for ART.

Of THAT I sing!!

WALT WHITMAN'S RETURN
With apologies to Ogden Nash
and everybody
Blank(very blank) verse
By Merle Armitage

My country, 'tis of thee
Sweet land of debaucheree
Of thee I sing.

Where cemetry's soil is dry and warm
Where receivers overcoat presents were born
Help us in our fright, to fight
Fake "Art" our King!

Land of gimcracks, galloping
Richfield cars, racing
Bathing Beauties, gaudy
Where six legged dancers, bow,
to the Adohr cow.

Democratic "Art" rampant
On a field of subdivisions!

Los Angeles bootleg XXXXXXXX
Wayside sculpture
Of thee I sing!

Land of Chicken-wire and stucco
Gentlemens estates
Building, Loans and
Other fakes
Of thee I sing

We love our ꭓꭓꭓꭓ

Company of New York, Buenos Aires, London, and Paris. Theirs was a fruitful partnership, which helped secure Stendahl's commitment to the painting business for many more years.

Disputes did occur between Stendahl and other dealers, artists, galleries, museums, and collectors over the economics of showing art. Shipping and insurance were expensive; determining the responsible party for a damaged painting or frame was financially significant. There were misunderstandings about agreed-upon exhibition and delivery dates, and sometimes a painting was missing or lost in transit. Terms were negotiated and renegotiated, attempting to broker the cheapest deal possible. Stendahl rarely sponsored a show at his gallery without having to cut corners and count pennies. Everything was scrutinized, from postage to the cost of opening-night crackers. Mrs. Bateman was an invaluable partner in that effort, according to Al. Clearly, however, Stendahl's presentations showed no hanging threads. Like a low-budget movie with a savvy director where all the money ends up on the screen, a visitor to any of Stendahl's galleries was assured a rich experience.

Stendahl liked to quote New York art dealer Nathan Wildenstein's philosophy: be bold in buying and patient in selling. Stendahl was certainly bold in buying. The "patient" part was another matter. From a business standpoint, Stendahl understood the practicalities of waiting for monies to become available, tastes to adjust, spouses to come around, publicity to have its effect, correspondence to cross oceans. But he was always in a hurry. He was known to raid his wife's jewelry box, with the promise of replacement if a client wanted to buy a family bauble. Daughter Eleanor took to hiding her Pre-Columbian gold eagle and frog pendants after the third time Stendahl sold one of her Colombian or Panamanian favorites. Stendahl must have figured that, since he had bestowed the jewelry on his girls in the first place, what was the fuss about, if he could reclaim the items for a quick sale at a good price? There would always be others. More often than not, Stendahl found substitutes of equal or greater value.

Joe also found treasures, with which he loved to adorn his beautiful wife's neck, wrists and ears. He was drawn into disputes between Eleanor and Earl when her pieces would go missing for Earl's good cause (any sale being a good cause). Earl didn't seem to care who had bought or given what to whom. If there was a potential client downstairs with a Scotch in his hand, cash in his wallet, and a yen for Pre-Columbian ornamentation, the old man (he was

Ecclesiastical garb exhibition, upstairs at Stendahl Galleries.

called that from around age forty-five) was likely to send the client home with something in jade or gold, still scented slightly with Enid or Eleanor's perfume.

When Stendahl's trips to Mexico and Central America began overshadowing the time he had to devote to paintings, he turned to an American in Paris to find works for his exhibitions: Theodore Schempp. The private dealer was, by training, a musician and painter of average talent. His true gift, recognized early on by his friend Stendahl, was in cultivating ties with French Modern artists who lived in his Left Bank neighborhood. Georges Braque, Georges Rouault, Nicolas de Staël, and Pablo Picasso were names Stendahl wanted for his clients in California.

From L'Auberge de la Colombe d'Or, Schempp wrote,

Hope to see Picasso in a day or so. In three and a half hours I have an appointment to see Henri Matisse. He is the only one of the big boys I have not met before. Incidentally, I was at Brancusi's studio in Paris a couple of months ago. He must be about eighty. Wanted a million francs for one sculpture, and that's a lot of money.

Thanks to his relationship with Schempp, Stendahl became the dealer credited with introducing Picasso's work to the West Coast. The New York galleries had

Rouault "Biblical Landscape" — 4800. — 5700.

Rouault "Judge" — 3000. — 3500.

Rouault "Père Ubu on horseback" 6500. — 7500. 7000 5800 #1200

Rouault "Wrestlers" — 1600. — 1900.

Rouault "Elégante" — 1500. — 1850.

Rouault "Emigrants" — 3600. — 4400.

Rouault "Men combing hair" — 1500. — 1850.

Picasso "Dora Maar" (blue background) 6000. — 7500.

Picasso "Dora Maar" (cost us 3000) — 3800.

Picasso "Dora Maar" (cost us 3000) — 3800.

Picasso "Portrait

Klee "Dancing F

Jacques Villon

Vuillard - "C

de Staël —

January 26, 1940.

Mr. Earl L. Stendahl,
3006 Wilshire Boulevard,
Los Angeles, Cal.

A painting by Paul Gauguin (1848-1903), representing

"L'Appel" (The Call)

A painting by Gustave Courbet (1819-1877), representing NET $ 65,000.00
 72
"Woman Arranging Flowers"

A painting by Paul Cézanne (1839-1906), representing NET 38,000.00

"La Montagne Ste. Victoire"

A painting by Henri de Toulouse-Lautrec, (1864-1901), NET 32,500.00

"Jane Avril Dansant"

A painting b

not found a way to create active markets in San Francisco and Los Angeles for Picasso's work until well after Stendahl's success in the early 1930s.

Most of the artwork Schempp supplied to Stendahl was sold at astonishingly low prices. But the two dealers were in the game to make profits, not to get rich. The U.S. market for modern art had to be cultivated slowly. A quick sale to Clifford Odets, William Inge, William Randolph Hearst, Frank Lloyd Wright, or Aldous Huxley carried some cachet, to be sure, but collectors proceeded cautiously, even with a trusted dealer who had an impressive track record.

For thirty years, Earl and Enid kept up a colorful correspondence with Schempp and his wife Lucile, enjoying many visits between Los Angeles, Paris and New York, where Schempp also had a residence. It isn't known how Schempp got his hands on Pre-Columbian objects, but he sent pieces from Europe to Los Angeles, along with on-approval paintings by Braque, Degas, Dufy, Klee, Picasso, Renoir, Rodin, Lipschitz, Manet, Matisse, de Staël, Jacques Villon, and Edouard Vuillard, among many others. On a scribbled inventory list Schempp typically kept track of his net profit on Stendahl's prices.

Stendahl enjoyed an intimate, gossipy relationship with his French connection. Schempp's salutation was always, "Dear Stendahl," and Stendahl's, "Dear Ted." In August 1946, Stendahl wrote,

We have two directors in the Museum now. [Wilhelm] Valentiner from Detroit as an advisor and [James H., Jr.] Breastead, a school teacher from UCLA. Looks bad. Just heard that Arthur Millier left home for a little twenty-year-old in N.Y. Roland McKinney, our former director, now with Pepsi Cola, is going to get him a job. Roland also has left his bed and board for an eighteen-year-old, also of N.Y. So has Valentiner for an eighteen-year-old. Watch yourself.

Stendahl was intrigued by Schempp's report of a 1947 visit with Picasso, where Schempp was shown "wonderful pottery," recently made. He exclaimed to Stendahl, "Amazing. Words fail me, but they are really something! Two or three hundred pieces." Schempp was witness to Picasso's first foray into the now-famous Ceramic Editions. "These can be worth *ten times* present prices sometime in the not-too-far-distant future," predicted Schempp. (What would he think of a *thousand* times? A Picasso clay owl sold at auction recently for $150,000.)

Stendahl was aware that museums and private art galleries in San Francisco were courting Schempp for his connections in Europe. Since the late nineteenth century, a rivalry existed on the West Coast between Los Angeles and San Francisco, with the northern city leading the way in the acquisition and exhibition of important art. The 1915 Panama-Pacific Exposition in San Francisco was groundbreaking for its examples of Impressionism, while the Golden

Price list for works from Theodore Schempp.

Gate International Exposition of 1939 cemented San Francisco's authority in Modernism.

Stendahl must have known that the San Francisco Museum of Art was the first museum on the West Coast devoted solely to twentieth-century art. But Stendahl considered the offerings in his gallery on a par (and even superior to) most collections in San Francisco, public or private. Without Schempp's ability to supply him a steady stream of canvasses from Paris, Stendahl probably could not have made such a claim.

One of Stendahl's most satisfying alliances was forged in an unlikely place for fine art acquisition: the Los Angeles Unified School District. Between 1919 and 1956, the graduating classes of Gardena High School purchased California Impressionist paintings and presented them as gifts to their school. Each was carefully selected by the students them-selves after visiting local art galleries and artists' studios. Of the more than ninety works amassed, Stendahl Gallery records show that at least nine were bought from Stendahl, including paintings by Armin Hansen, Edgar Payne, Elmer Schofield, and James Swinnerton. These were no ordinary artworks. They represented California's finest painters of the *plein air* school. But once the gifting program ended, the collection languished in storage.

In 1999, a representative group of restored Gardena High School paintings was exhibited in a gorgeous show called Painted Light: California Impressionist Paintings from the Gardena High School, Los Angeles Unified School District Collection. The cover of the *Painted Light* catalog is a detail from a John Frost painting, *Desert Twilight*, which Stendahl sold to Gardena High School's winter class of 1928.

The Gardena High School Art Association of 1935 is pictured on page twelve of the catalog. There sits Earl Stendahl at a banquet table, looking very much the art dealer. In fact, Stendahl was one of the participating *artists* for that year, having submitted his original work *Yuccas* to the student selection committee. Alas, the summer class of 1935 selected *Head Winds* by Joe Duncan Gleason instead.

Five years later, Walter Arensberg made Stendahl an offer he could not refuse. It involved a different sort of partnership: next-door neighbors. Stendahl's move to Hollywood would enrich the Southern California artistic landscape in ways neither man could have envisioned.

Gardena High School Art Association, 1935. Earl Stendahl is circled.

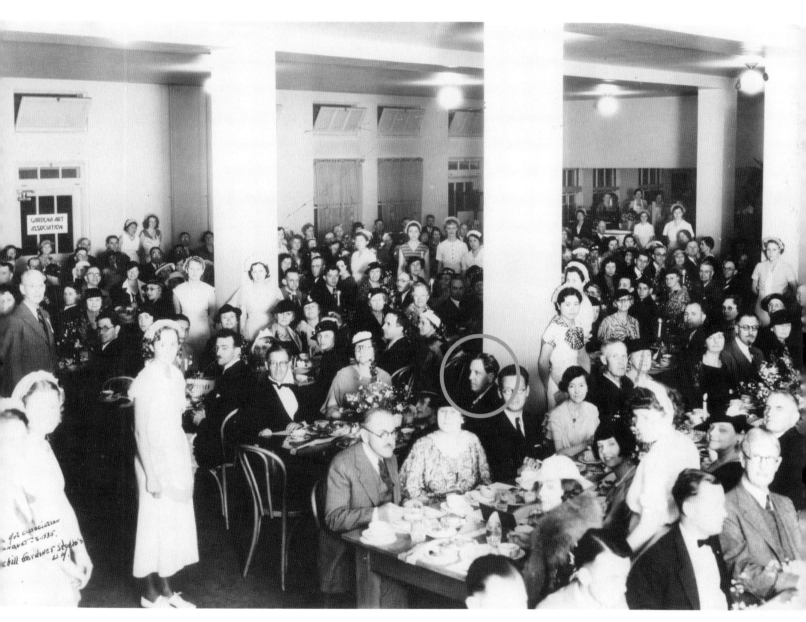

GARDENA ART
ASSOCIATION

Stendahl home on Hillside Avenue, Hollywood.

Chapter 8 HOLLYWOOD DEALER

Former New Yorkers Louise and

Walter Arensberg lived in the

Indian burial grounds and hanging trees in this small corner

Outpost Estates development of the

of the once-wild West, but what appealed to the Arensbergs,

Hollywood Hills. The neighborhood

besides the lush sycamores and eucalyptus, was the enclave

is one of the oldest in Los Angeles

of exclusive properties, all Spanish Colonial Revival-style

and the site of Hollywood's first

houses with red tile roofs, designed for protection against

adobe in 1853. There are tales of

canyon brush fires: then, as now, a threat for hillside dwellers.

In 1940, Arensberg's neighbor to the east decided to sell his house, which meant an apartment building might go up in its place, something Walter and Louise wanted to prevent at all costs. The asking price was a firm ten thousand dollars. Arensberg offered to float a bank loan for Stendahl to buy the Hillside Avenue property and move up to the Outpost. The Bronson Avenue bungalow was feeling small for Enid and Earl. Al had recently returned with a degree from the University of California, Berkeley; Eleanor was a high school senior, contemplating matriculation at the University of Southern California. But her plan was to live at home her freshman year.

Stendahl already knew some of Arensberg's current and former neighbors, having cultivated them as clients: Jesse Lasky, Sid Grauman, John Barrymore, and Dolores del Rio, who lived just around the corner in a large Mexican hacienda she designed to remind her of home. It is easy to picture Outposter Bela Lugosi going for Stendahl's Aztec sacrificial stones with traces of ancient blood, but there is no evidence that Stendahl ever sold to "Dracula."

Once Arensberg made it financially possible, the Stendahls decided to take him up on his offer and move to Hollywood. Stendahl wrote to William Wendt, "Finally made up my mind to get into larger quarters with my family after living in a hat box for twenty years. We will be able to hang up a suit without having it crushed and will be able to find our shoes and won't have to stand in line for the bathroom, which is a blessing, as it is a terrible thing for old folks to get caught short."

There were adjustments. Arensberg exerted some leverage by taking fifteen feet into Stendahl's property, right up to a bedroom. When Earl built an unsightly storage shack on the extension of Arensberg's land there was loud complaining from his neighbor. Arensberg couldn't decide if he wanted to put a gate in the fence that separated his house from Stendahl's. One minute he wanted it, and the next he didn't. He valued his privacy, but guests at one or the other's homes were literally climbing over the fence to see the occupants and their collections. Traffic moved more often from Arensberg's to Stendahl's when guests craved something besides pineapple juice. They knew they could get a stiff drink next door.

Arensberg was not a social person, even though his house was often filled with people socializing

1 "We've moved," 1940-style.

2 , 3 Stendahl home on Hillside Avenue, Hollywood.

2

3

with each other. Walter and Louise didn't go out at night but preferred to stay home or have dinner with Enid and Earl. Arensberg's eccentricities were well known but tolerated, because he was so generous in sharing his artworks. Every foot of wall space, including the backs of doors, were covered with paintings. If Al observed, "There's a little space over there," Arensberg would respond, "Well, find a painting for it." The man had one suit and a very old Cadillac. He spent all his money (most likely Louise's inheritance from textile manufacturing in Massachusetts) on art and on funding the Baconian Society.

At the time of his move to Hillside Avenue, Stendahl didn't anticipate how the proximity to one of his best customers would increase business. The Arensbergs had been regular visitors to the galleries on Wilshire, and Stendahl had spent many hours showing paintings and Pre-Columbian art at their home. But once the two men became neighbors, Arensberg was like a kid waiting for the ice cream truck. When he saw a delivery arrive at Stendahl's driveway, he would hurry next door to inquire about its contents. With great anticipation, Arensberg watched Earl, Al, and Joe unload the crates from Mexico. Money was changing hands as fast as anyone could say Quetzalcoatl. Curator and art critic Katherine Kuh wrote in her book *My Love Affair with Modern Art* that, while she was cataloguing the Arensbergs' entire collection for the Chicago Art Institute (with the

1 The vast Arensberg collection hung throughout the house, including in his office. Clockwise, from lower left: Paul Cezanne's *Still Life with Apples and a Glass of Wine*, 1877-79; Henri Matisse's *Mademoiselle Yvonne Landsberg*, 1914; Pablo Picasso's *Still Life with a Violin and a Guitar*, 1913; Juan Gris's *The Lamp*, 1916; and under the Matisse: Cezanne's *Group of Bathers*, c.1895.

2 Giorgio de Chirico's *The Soothsayer's Recompense*, 1913, is to the left of the door in the Arensberg living room, viewed here through the dining room archway. Note the Pre-Columbian pieces displayed throughout and the tip of a Brancusi polished bronze.

3 In the upstairs bedroom, the Arensbergs displayed Piet Mondrian's *Composition*, 1936, upper left; Wassily Kandinsky's *Improvisation No. 29 (The Swan)*, 1912, over the bed; and Paul Klee's *Little Houses with Gardens*, 1928.

3

2

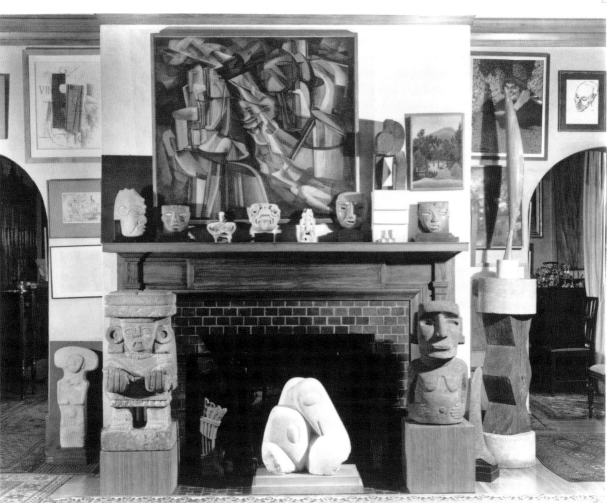

false expectation that the works would be donated there), Walter returned from Stendahl's in a state of high excitement, having just bought two sculptures by Brancusi: *The Fish* and *Torso of a Young Man*. But the Mexican material was competing more and more for Arensberg's attention.

He was not a student of ethnographic art, certainly not compared to the way he understood the modern paintings and sculpture he coveted. But he knew what he liked, and he shared with his dealer a fine eye for craftsmanship and form. Getting first choice was important to him, as was the trust that had developed between the two men. It is generally held that serious collectors are not easily seduced because they are governed by caution based on knowledge. What that axiom fails to take into consideration is that passion knows no restraint. A collector like Arensberg was the kind Stendahl dreamed about and found only rarely.

Arensberg's courtyard and gardens were the perfect setting for the Mexican and Central American stone pieces he acquired from Stendahl.

3

1 The Arensberg sunroom featured Marcel Duchamp's *Glider Containing a Water Mill in Neighboring Metals,* 1913-15, in the window.

2 *Penguins* and *Bird in Space* (right of the fireplace), both by Constantin Brancusi. *The King and Queen Surrounded by Swift Nudes,* by Marcel Duchamp, is over fireplace.

3 A corner of the Arensberg living room rivaled any corner in a Modern museum. Clockwise from upper left: Picasso's *Female Nude,* 1910; Henri Rousseau's *The Merry Jesters,* 1906; Chagall's *Half Past Three (The Poet)* 1911; Duchamp's *The King and Queen Traversed by Swift Nudes at High Speed,* 1912.

Beatrice Wood is said to have especially enjoyed the Pre-Columbians when she and Arensberg's other expert art consultant, Marcel Duchamp, visited Hillside Avenue.

Stendahl wasn't Arensberg's only source for Pre-Columbian art, but Arensberg made sure of a piece's authenticity and value in this way: if someone came to him with an object of interest, Arensberg would direct the fellow next door to try and sell it to Stendahl. If Stendahl bought it, Arensberg would then buy the piece from him. Never mind that Arensberg had to pay Stendahl's mark-up. The extra money was a smart investment. Anything good enough for Stendahl was good enough for Arensberg, and that extended to their friendships with others.

Stendahl liked to tell of an incident early one morning when surrealist painters Max Ernst and Dorothea Tanning rang his bell. It was eight o'clock, and they were drunk. Ernst and Tanning were accompanied by artist Man Ray and his former girlfriend. All four had driven straight from Tijuana, where the two couples had gotten married the night before.

Tanning was Ernst's fourth wife following his marriage to Peggy Guggenheim, but no one was counting that morning. Stendahl broke out the champagne. Then the happy revelers climbed over the fence to Arensberg's, where they were all warmly received by their amused host. The pineapple juice flowed.

Countless colorful characters populated the Hollywood chapter of the Stendahl story. Architects Frank Lloyd Wright and his son, Lloyd, were both clients of Stendahl's but weren't visitors to the Arensbergs' because Walter made no secret of how much he disliked Frank Lloyd Wright's architecture. Stendahl, on the other hand, related well to the senior Wright's Pre-Columbian Revival style with its Mayan temple motifs. Arensberg didn't like Man Ray's work, either. This led to some awkwardness, given that Ray was a close friend of Marcel Duchamp, and Duchamp was not only Arensberg's favorite artist (Arensberg fairly cornered the market on Duchamp's works), but a paid art advisor who spent a great deal of time with Louise and Walter.

The activity on Hillside Avenue led to commissions within the art-loving group. Josef von Sternberg hired Richard Neutra to design his extraordinary residential project in the San Fernando Valley, following a meeting at Arensberg's. In a letter to

Lloyd Wright's plans for the Stendahl's home renovation on Hillside Avenue.

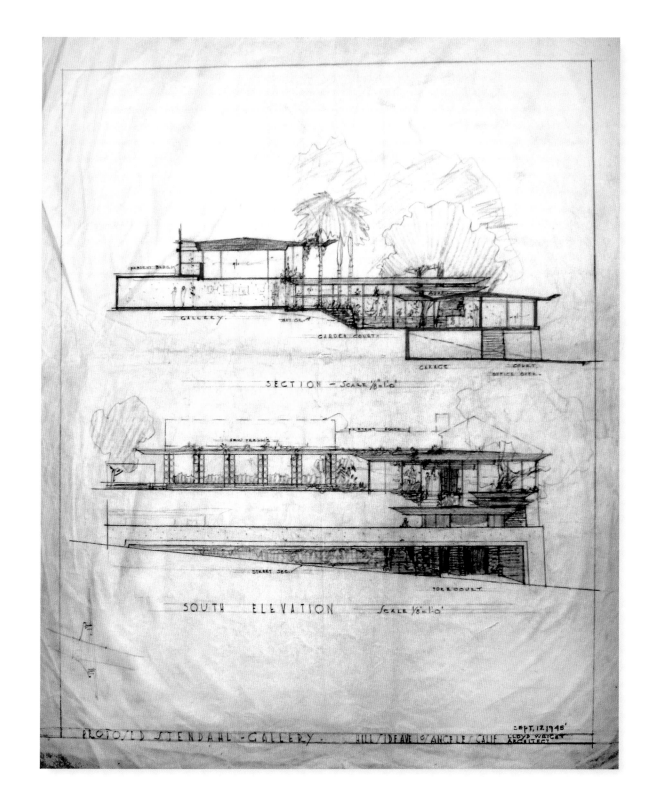

GALLERY.

GARDEN COURT.

GARAGE.

SECTION — SCALE 1/8"=1'0"

SOUTH ELEVATION SCALE 1/8"=1'0"

PROPOSED STENDAHL · GALLERY. HILLSIDE AVE LOS ANGELES CALIF SEPT. 12. 1946 LLOYD WRIGHT ARCHITECT

Diego Rivera in 1936, Stendahl implored the artist to come to Los Angeles, at von Sternberg's request, to paint a mural ("for a special price") on an exterior wall of the film director's estate. (It didn't happen.) Lloyd Wright designed a Westwood home for Louis and Annette Kaufman and was responsible for additions to Stendahl's house, as well. Enid and Earl must have balked at the project's expense, because the architectural drawings called for a more extensive renovation than the one the Stendahls settled on.

Lloyd Wright began as a landscape designer, well versed in the flora of Southern California. It isn't known if he shared his father's hatred of palm trees. It must have been a challenge for the senior Wright to avoid the palms, as ubiquitous as they were in Los Angeles. "Cut these things down. They're not at all artistic," Frank Lloyd Wright exclaimed to Earl, while scoping out Lloyd's plans for the Stendahl house next door to the Arensbergs. As a testament to differing tastes, artist Robert Irwin and landscape architect Paul Comstock have created a "museum of palms" outside the Broad Contemporary Art Museum at Los Angeles County Art Museum, installing the iconic trees as a towering, *artistic* statement.

Whatever their opinions were on art, architecture, or landscaping, all who visited the William L. Woollett-designed Arensberg home admired the 1928 to 1938 additions, downstairs and upstairs, by architects H. Palmer Sabin, Richard Neutra and Gregory Ain. John Lautner (1911-1994), a Frank Lloyd Wright protégé and progressive innovator, designed the carport and sweeping veranda for the Stendahls after they bought Arensberg's place in 1954. Lautner lived nearby in a unique house that incorporated engineering novelties associated with his architecture. Ron remembers revolving exterior walls at the front, as well as the dramatic aftermath of the house's destruction from a fire. Lautner moved to a modest apartment building across the street from the Stendahls. He lived there many years, adding yet another influential vision to the neighborhood.

The Stendahls' move to Hollywood came only a year before the United States was drawn into the

Second World War at the end of 1941. Money was, as always, tight. Stendahl had to put forth great effort to pay for home improvements, Al and Eleanor's college educations, and his and Enid's lifestyle, which required expensive nights on the town and hosting innumerable dinner parties. Whenever possible, Stendahl traded art for services as he had for membership in the Santa Monica Beach Club and in other private clubs. For Eleanor's private school tuition and board costs at Westlake School for Girls, her father paid with two William Wendt pictures. The trick was to find vendors and others (doctor, dentist, piano teacher, tennis instructor) who wanted what he was selling. Most of the non-art world people Stendahl had transactions with were not connoisseurs of modern art, much less of two-thousand-year-old tomb offerings from Meso-America. Stendahl never found a good plumber who appreciated painter Hans Burkhardt or an Aztec fertility god.

But there was a Japanese gardener in the 1960s and 1970s who was, apparently, an aesthete. Long after Enid and Earl died, the Dammann family was still being visited twice a week on Hillside Avenue by an aging gardener and his son who kept the spacious grounds tidy and green. On many occasions, Ron asked them how much was owed, but each time the gentlemanly pair waved him off. One

2

day the gardeners failed to show up. The incredible run was over. The son eventually telephoned to ask the Dammanns if his services were still wanted at the going rate. He explained that Earl had traded his father a Pre-Columbian stone sculpture for gardening services. Some fifteen years later the debt was deemed paid in full, and the father and son moved on.

Always a man on the make, Stendahl proposed to Al at Berkeley that he hit up his fraternity brothers for student Rose Bowl football tickets to sell "for speculation." Earl fronted Al a hundred dollars to buy up

1 Western painter Maynard Dixon at his easel.

2 Dixon's dealer Stendahl at his easel.

1 View from Stendahl Galleries at 3006 Wilshire, as painted in oil by Earl Stendahl.

2 Cultivating a family: Al Stendahl, Joe Dammann with son Ron, and Papa Earl.

3 Joe Dammann and his wife Eleanor Stendahl Dammann with their first child, Ron, 1946.

as many tickets as he could for resale at double the price. Earl pushed the tickets at his gallery for the same markup, notably higher than his usual one-third. Earl Stendahl, proto-scalper.

Stendahl's wheeling-dealing ways seemed to stoke a creativity manifested to best effect in his exhibition spaces. The dealer challenged himself more than ever in the 1940s to maintain his reputation with innovative shows. In They Taught Themselves, Stendahl featured a painting by Anna M. R. Moses. Grandma Moses was self-taught, motivated by her "burning need to communicate in some visual form," according to the catalog introduction. Like Stendahl at his easel, Moses and the other artists on display knew no professional language of art expression and necessarily developed their own visual style.

Stendahl spoke often in correspondence with artists and collectors about his love of painting and his desire to find more time to indulge in it. A *Los Angeles Examiner* writer found "real merit" in Stendahl's canvasses and quoted the dealer-artist as saying "I've discovered that it is much more fun painting your own pictures than handling someone else's work. And I'm just waiting for an artist to tell me that there is something high and mysterious about painting that makes it impossible for me to understand his work." Stendahl found very few things in

1 Village scene with figurines from Nayarit, Mexico.

2 Post-Columbian pet Pepe meets his Pre-Columbian match.

3 Ancient Mexico comes to Hollywood.

life to be either high or mysterious. As a woodworker, confectioner, musician, artist, and businessman, he had figured most things out, much of which involved doing honest labor with one's own hands.

Perhaps Stendahl's painting nostalgic scenes from his youth was a way to honor the past and preserve it. His subjects evolved from Menomonie to still-life studies, landscapes, marine pictures, and one large work painted from the perspective of his Wilshire Boulevard gallery around the time of his move to Hollywood.

Enid and Earl had expanded their horizons by moving to the Arensbergs' upscale neighborhood and into a four-bedroom home. But in just a few years their house was filled to capacity, and then some. Al and Eleanor both married young, "the boys" going off to war in the Pacific Theater: Al with the Army Air Corps and Eleanor's husband Joe Dammann—only twenty-one years old—with the Marines. After the war, everybody moved in with Mother and Papa. When babies came, the "maidless room" (which was the fourth bedroom) turned into a nursery.

To his dismay, Stendahl was running another three-ring circus, this one domestic, not artistic. He had always thrived on the ringmaster role, but wartime pressures coupled with inadequate income began to overwhelm him. Stendahl explored new ways to draw attention to his artifacts. In his carport, he erected an elaborate reproduction of a Pre-Columbian-ritual ball court, the kind that was used in ancient Mexico for a game played to the death. The sporting scene was composed of west

2

3

Mexican figurines from Colima and Nayarit and elaborately painted backdrops of ancient pyramids. The outdoor space was enclosed in canvas and illuminated for nighttime viewing. Stendahl assembled similar groupings for exhibitions throughout Southern California, including for a show at the Pasadena Art Institute where he built a hypothetical village scene with clay figures from Mexico. But such enterprises were more creative than profitable.

In the spring of 1945, Stendahl's Wilshire Boulevard rent tripled, a stunning blow. The income Stendahl derived from renting some of his gallery spaces to local artists for twenty-five dollars a week seemed almost negligible, in the face of such an immense monthly overhead. Al believed the family should have done whatever was necessary to buy the building. Barring that move, Stendahl felt forced into a decision he thought was still a long way off.

STENDAHL ART GALLERIES DUE TO END CAREER

The headline must have shocked Arthur Millier's *Los Angeles Times* readers in July 1945:

> If this reviewer had a shred of sentimentality left in these tragic times he would weep a few genuine tears over the news that the Stendahl Galleries are closing. Inflated rentals, it is reported, have forced this historic art gallery's demise. Earl Stendahl has operated an art gallery continuously since 1913, when he opened in Pasadena. [Correction: the year of Stendahl's debut as an art dealer was 1911, and his Pasadena annex opened in the early 1920s.] At the Ambassador, besides bringing out such artists as William Wendt and Paul Lauritz, he played host to many a visiting and local artist of importance.
>
> There were periods when the Stendahl Galleries showed a three-ring circus of contemporary art. And there was never a time when this enterprising gallery did not present some aspect of the art of our time. Besides presenting some of the best Southern California artists, Stendahl showed works by French Moderns at a time when they were far from popular. And many a local artist had his first exhibition between these hospitable walls.
>
> As the galleries at 3006 Wilshire Boulevard prepare to close, Stendahl has crowded their walls with paintings which he has acquired through the years. These are offered at reduced prices. What will become of his large stock of Pre-Columbian sculpture and pottery is a mystery he refuses to solve.

The rumors of the demise of Stendahl Galleries were greatly exaggerated.

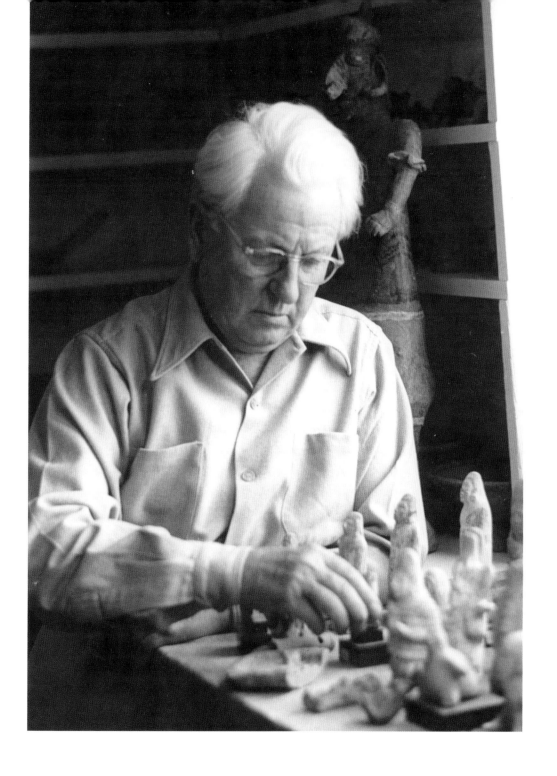

Stendahl contemplates his next move.

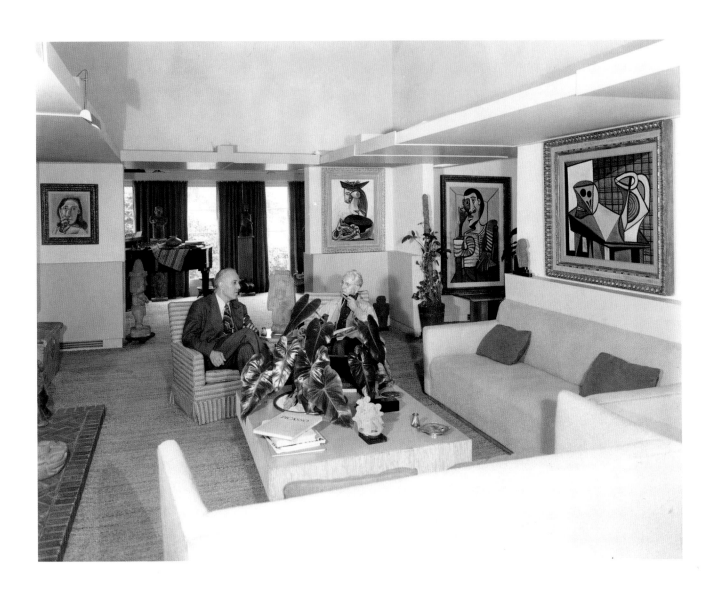

Stendahl's Picasso show interests a New York dealer.

Chapter 9 SURVIVOR

Why did Stendahl's great friend

and admirer Arthur Millier display

World War I, the Great Depression, the Second World

so little faith in the longtime

War, and the vicissitudes of a sometimes fickle, often-

dealer? Did Millier really think a

resistant public's tastes in art. All this in a town that

financial setback would be the end

smelled more of orange blossoms than oil paint.

of a man so remarkably resilient?

Stendahl created business where there was no business.

Stendahl's gallery survived

He turned skeptics into believers. He found ways to fill

(and pay for) ten thousand square feet of gallery space on

Wilshire Boulevard, month after month for fifteen years, as he had done in smaller quarters at the Ambassador and other hotels for the twenty consecutive years prior. And yet, Millier published his lament declaring Stendahl's career over?

Enid and Earl had been in residence on Hillside Avenue for five years before the decision to close 3006 Wilshire. What didn't go for bargain prices during the closeout sale, Stendahl brought home to display in his three front rooms. The recessed lighting behind Lloyd Wright's floating panels in the living room created a modern, even futuristic backdrop to the paintings and Pre-Columbian sculptures. Couldn't this new arrangement work?

By mid-1945, when Arthur Millier saw "tragic times," Stendahl saw early signs of post-war prosperity. *Back to Bataan* (1945) starring John Wayne and other World War II pictures were being released, reminding relieved audiences that the war was finally a part of history. Stendahl had shown patriotic zeal as an air raid warden, dutifully attending weekly meetings with fellow Civil Air Patrolman Walter Arensberg. Eleanor described the two men going off together in their helmets, clutching their notebooks, as if America's future rested on their shoulders. Eleanor missed hearing "*Semper vigilans!*" echo across the garden on Hillside Avenue once wartime blackouts were over, and her father could leave the national security to others. It wouldn't be fair to compare Stendahl and Arensberg to Laurel and Hardy in the 1943 comedy *Air Raid Wardens,* but it is tempting. The movie plot involved two bumbling business failures who uncovered a Nazi plot to blow up a magnesium plant. The movie poster said it all: "Seventy minutes of happiness and hi-jinks!" *Semper vigilans*!

Al recalled that business started to pick up for Alexander Cowie's Biltmore Hotel gallery and for Dalzell Hatfield, among others. But by the time Al returned from Japan, he could no longer afford the little Kandinsky watercolor he expected to buy his wife Ursula for close to the pre-war price of $350. "Things were, quite suddenly, out of reach." None of this escaped his father's notice. Stendahl determined to exploit a growing Los Angeles upper class, made up principally of movie people and those getting rich in real estate. First, however, he had to overcome any ill-effects from Millier's newspaper account of his gallery's closing, which read like a tear-stained obituary. Nothing frightens Hollywood more than failure, and Stendahl could not allow even the suggestion that he had failed in moving his operation to his home.

Impresario Earl was going uptown with no apology and plenty of *chutzpah*. A notice he sent to his clients read: "Welcome to Stendahl Galleries, Hollywood, and to a triumvirate of knowledgeable dealers, at your service: Stendahl, Stendahl, and Dammann."

Touting his son-in-law as "knowledgeable" was bold. But Earl always recognized potential and promoted it early.

At first, Joe Dammann was a fish out of water. He lived with a domineering father-in-law, whom he barely knew; he was a farm boy from Hillsboro, Illinois, without a trade or an education. Joe had dropped out of high school at fifteen, following the death of his mother, who was killed by a train when her car got stuck on railroad tracks close to the family farm. Joe couldn't deal with his hurt or with his father's second wife. He left Hillsboro for a destination as far west as he could go, as Stendahl had done, at a similarly tender age.

Joe was tough and smart. A marine. And he loved Eleanor desperately. With few options and a strong motivation to succeed at something, he began to learn the art business alongside his brother-in-law and Stendahl. There was never a formal agreement for Joe coming into the business, but Stendahl

was willing to teach him a few things and send him to Mexico to look for Pre-Columbian art. Ron says Al had some resentment early on about Eleanor's husband being foisted on them. But it didn't take long for Joe to prove himself. In time, he became the expert in Pre-Columbian art that Stendahl had predicted.

Earl, Al, and Joe had a loose arrangement based on common sense and trust. You take that piece, I'll take this. Al called Rockefeller, Joe called

In vogue: living with the old and new.

Isherwood. Earl headed down to Guadalajara, Al met contacts in Costa Rica. Clients and sales were divvied up to everyone's satisfaction, with Stendahl and Al concentrating their efforts on paintings, as well as the Pre-Columbian material. The wives were busy defining their supporting roles, but there are no stories of turf wars or jealousies (that doesn't mean that they didn't exist). Privacy went out the picture window, as friends, artists, collectors, journalists, and curators showed up not only for dinner (invited or not), but to view what Stendahl had on the walls and pedestals of his home/gallery. "I work from home" sounded so promising, at first. For sixty-five years family members have been adjusting to living above the store.

The Arensbergs were witness to most of the goings-on next door by virtue of their proximity— and because anything Stendahl and his boys were involved in might turn into an exciting new acquisition for Louise and Walter. But it worked both ways. Stendahl kept track of the Arensbergs' activities as one measure of the health of Los Angeles's cultural life. Stendahl thus became a player in a sad story of lost opportunity for his city.

With Stendahl's help, the Arensbergs had begun to investigate a permanent home for their collection as early as 1940. Louise was sixty-one, Walter sixty-two years old—one year apart, like Enid and Earl, but ten years older. Everyone in the art world appreciated the importance of the works the couple had accumulated and the wisdom of considering their future disposition. There was great anticipation about which Los Angeles institution would capture so rich a prize.

Walter's eccentricities were well known by that time, but no one could have foreseen how difficult

it would be to satisfy his requirements for taking on the collection. In 1944, after a long and complicated negotiation, the Arensbergs agreed to deed everything to the University of California, Los Angeles. Stendahl was pleased with the decision. But three years later the deal fell apart. Years later Al summed up the disappointment: Arensberg was a sensitive person and could be childish, insisting on terms that were unrealistic. The Metropolitan Museum of Art was eager to acquire Arensberg's Pre-Columbian pieces, in particular, and made a strong case for the entire collection. But those in charge failed to satisfy all of Arensberg's conditions, as did many other institutions: Los Angeles County Art Museum, Berkeley, Honolulu Academy of Arts, Art Institute of Chicago, Denver, Harvard, the Instituto Nacional de Bellas Artes of Mexico, the National Gallery, San Francisco, Stanford, and the University of Minnesota. An impressive list of failed suitors.

Stendahl hated to see the Met lose out on the Pre-Columbians. He tried to convince Arensberg to soften his stance on a museum promising to fund the Francis Bacon Foundation and on the length of time the Cubist holdings would be kept intact and on display. But there were many small things that killed the deal, time after time. Shabby walls at one place, stuffy trustees at another, a malaprop uttered somewhere else. There were slights, misunderstandings, and stand-offs. Stendahl watched it all, bemused but frustrated for his friend who was getting in his own way. Finally, Fiske Kimball, director of the Philadelphia Museum of Art, came to Los Angeles with an offer. Walter had been born in Pittsburgh, and he and Louise had established their first homes in the East. But geography probably had little to do with the ultimate decision.

Al quoted Kimball as declaring, "I'm not leaving until I get it." Get it, he did. In December of 1950, the Arensbergs presented more than a thousand pieces to Philadelphia. Al was paid five thousand dollars to pack everything up and, for two dollars an hour, to catalog the houseful of art. The transfer of ownership invites the question, why would Louise and Walter—such passionate collectors—send a lifetime of accumulation three thousand miles away during their lifetime? Annette Kaufman remembers the period well and believes that Arensberg had developed a serious distrust of institutions and their directors during the decade he was trying to find a repository. He wanted to see the deal signed, sealed, and *delivered* before he and Louise died. Another factor was Arensberg's commitment to the Francis Bacon

project. It was consuming more of his interest, time, and money. With the change in focus, Arensberg was ready to see his artworks go.

Art historians bemoan Los Angeles's loss of such an important art collection, but Stendahl witnessed more than a few others lured away as well. The tradition continues; recently, one of the finest African American art collections in California was auctioned off (and broken up) in New York to the highest bidders by a South Los Angeles life insurance firm in need of cash. "Keep it intact and in town" goes unheeded by those to whom cultural legacy is less important than a quick buck. Stendahl remained a harsh critic of such practices, but he sympathized with the necessities of keeping a business afloat.

He understood the concept only too well. In late 1946, Stendahl launched into a project that surprised those who had watched him put the Depression years behind him. Everyone assumed that chocolates had been a necessary-but-temporary sideline for the art dealer. But Stendahl seemed to have butterfat and sugar in his blood. He amped up the candy business and bought a warehouse in Burbank for that purpose, building a candy factory for Christmas sales. Al and Joe were assigned most of the work. Stendahl declared the chocolates better than ever and decided to continue production into 1947, as

they had sold out with little effort over the New Year.

What induced the successful art dealer to fall back on candy making? Did he worry that the art business was heading for trouble? Was chocolate a kind of insurance to hang onto for survivor Stendahl? Gary Cooper and Huntington Hartford (one of the world's wealthiest men) paid visits to Hillside Avenue while Stendahl was in Panama digging for gold. They bought chocolate, not art, Al reported to his father: "Money must be tight."

Stendahl continued to make chocolates at holiday time well into the 1950s. For twenty-five years, artists, customers, other dealers, critics, and curators acknowledged gifts of Stendahl candy, anticipated as enthusiastically as a visit from Santa. Stendahl *was* their Santa. The one they waited up for, the plump visitor from the North (well, *West*) whose sources were mysterious and who pulled thrilling things out of his bag.

One Christmas, Stendahl was caught napping. A thief walked into the house and swiped Pre-Columbian gold from display pedestals, while Stendahl slept in the adjacent sunroom. Joe fielded the telephone call offering to sell the cache back to his embarrassed father-in-law. The exchange took place at an obscure intersection in the San Fernando Valley, not far from the Burbank candy factory. The

price was low in comparison to actual market value of the pieces, but it pained Joe mightily to fork over the extorted cash.

In mid-1946, Ron, the first of Stendahl's five grandsons was born, and the number of occupants in Stendahl's house grew to eight before Al and Ursula bought a place of their own in the nearby hills of Studio City. Al built his new home with fifteen thousand dollars he made on the sale of a collection of Chumash (the Southern California coastal Indian tribe) artifacts to society collector Ruth Maitland. Arensberg, a close friend of the wealthy Maitlands of Beverly Hills, had influenced the sale, since he possessed Chumash material and considered it highly prized. But the Los Angeles County Art Museum ruined the party. When Ruth Maitland offered to donate the entire collection, it was declared to be inauthentic, top to bottom. Arensberg and the Maitlands were indignant. Stendahl, less so. He had made his sale, Al got his house, and Stendahl had the satisfaction of being not just the putative expert, but absolutely sure the pieces were good, whether or not some wet-nosed curator at the museum doubted them. Stendahl didn't get involved in fracases between the museum's director, Dr. William R. Valentiner, and disgruntled collectors or dealers. Relations might cool for a time between the various entities, until the next splashy acquisition or non-controversial donation brought back their collective smiles.

Stendahl observed that questions of fakery provoked the Hollywood set more passionately than other constituencies. In the words of Michael Kan, "Earl acquired extravagantly and sold to extravagant people." Perhaps authenticity took on greater importance against the backdrop of Hollywood's extravagant phoniness. Earl's experience with actress Elsa Lanchester, following her husband Charles Laughton's death, was not an isolated case—indeed, it was practically typical. The Laughtons had been regulars at the Arensbergs' and the Stendahls' for many years. They lived just a few blocks away. Laughton amassed an important Pre-Columbian art collection from Stendahl, which his wife put up for auction at Sotheby's. Sotheby's refused to include two clay warrior figures from Mexico in the sale, calling them fakes. Lanchester accepted the pronouncement. Knowing the pieces to be the real thing, Stendahl offered Lanchester a thousand dollars for the pair—exactly what Laughton had

paid for them. Lanchester was offended, insisting they had surely increased in value!

Stendahl was always concerned about what he called "the state of art." He considered it his job to bring clients along, as they defined and honed their personal artistic preferences and learned to commit to building a collection of importance. He was a patient teacher who understood the rewards ahead for someone with the means to collect and the enthusiasm to do so. Of course, Stendahl was the collector's co-conspirator: Finding three exquisite Jean Charlot paintings for William Wyler rewarded them both. It was more than good business to feed the William Wrigley family's taste for Charles Russell's work or George Gershwin's for Guy Rose and Armin Hansen. Stendahl saw himself fostering a healthier state of art for Southern California with this message: give generously to museums and art schools, support the local artists, buy only the best, trust your dealer.

To an outsider, Stendahl's confidence must have appeared out of proportion to the man: short, stout, no formal art education, humble midwestern roots, erratic income. But Stendahl's faith in his product, not his own credentials, was key to his survival. How did he learn? His resume would seem woefully lacking by today's art history or business majors. Stendahl's

society—so different from our own—valued refinement and culture. He sought out wise mentors. He moved in circles where he could look at and appreciate fine art. At a young age, Stendahl picked up a brush and began to paint, which helped him relate to the women and men he would one day represent. Al spoke of his father's "eye." But seeing was not enough. Earl was an innovator. He continually searched for ways to bring his own discoveries to a bigger audience.

In a piece Stendahl wrote for the *Stendahl Quarterly Review* called "A Policy for Art," he declared that galleries must stand or fall on showing "the entire output" of the best of Southern California's artists. By mounting a show of eighty examples of one artist, as he had been able to do on Wilshire Boulevard, Stendahl immersed his public in a "consistent exploitation," which he was convinced benefited both artist and viewer. He asserted that his major goal was to bring to the local culture an ever-widening circle of respect and admiration. He encouraged his artists "to arrive at full fruition" by providing opportunities for them to have uninterrupted time to work, followed by the rewards of large exhibitions.

The Hillside Avenue house, for all its Spanish hacienda charm and pristine interior walls, lacked

the room for artist studios or big shows. Stendahl's "four-ring circus" paradigm necessarily shifted to about one-and-a-half rings, overnight. The impact was as seismic to our impresario's "policy for art" as a real earthquake.

If only we could know the substance of pillow conversations between Enid and Earl, as they contemplated ways to keep the circus going. The big top was gone. But it is not difficult to imagine Stendahl contemplating a P.T. Barnum sideshow approach: *Enter HERE for the true delights. In this smaller, more rarified tent you will be exposed to WONDERS of art from MASTERS of American and European painting. FEAST your eyes on ancient, mysterious tomb offerings, NEVER BEFORE SEEN outside of the jungles of Mexico.*

Life changed drastically on Hillside Avenue on November 25, 1953, when Louise Arensberg died of cancer. Walter was bereft. Ron, only seven years old at the time, remembers Arensberg's blank stare and the way he appeared to be lost in the weeks following his wife's death. In January, the maid found Arensberg slumped over the bathtub, heart-broken, gone. He was seventy-six years old. The couple missed the opening of their collection at the Philadelphia Museum of Art, celebrated on October 16, 1954.

Stendahl had lost two close friends in two months. Walter's death came as a shock, reverberating

through the Los Angeles art community and far beyond. It is difficult to measure the significance of the Stendahl-Arensberg relationship, personally and professionally. In Arensberg's circle, Stendahl was part of an artistic dialectic that was defining a new age and attracting young talents like Walter Hopps, Jackson Pollock, and Philip Guston. With Louise and Walter, he experienced—first hand—the brain and heart of Los Angeles's early Modernist movement. As a dealer, he helped fuel that movement, breathing life and commerce into it.

When the Arensbergs died, Enid and Earl were determined to do everything in their power to buy their home. But how to finance such a large purchase? They had not anticipated the opportunity opening up so soon. And so suddenly. With all the planning involved in disposing of Arensberg's art collection, no mention had ever been made of what would become of their house. Stendahl had to act fast to prepare for the closed-bid auction on the Hillside Avenue property. He was *not* going to lose it. But there was serious competition. The Arensbergs' additions by Richard Neutra and Gregory Ain had added value to the home. Thousands of people visited

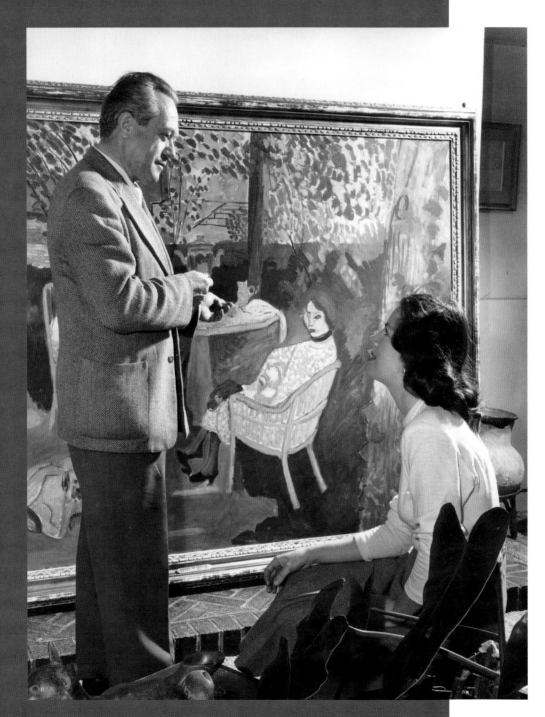

over the years. The place was about as public as a private residence can be. And the Outpost Estates neighborhood was more desirable than ever.

Stendahl got busy. One small page from a Stendahl inventory/sales notebook tells the story.

Tea (*Le thé dans le jardin*), 1919, by Henri Matisse was purchased in 1948 by Stendahl for fifteen thousand dollars from Sarah (Mrs. Michael) Stein, wife of the nephew of Gertrude Stein. The Stein family members were renowned collectors of the modern masters, particularly while living in Paris. Another page from the Stendahl inventory ledgers chronicles the first Matisse brought to this country, originally purchased by the Steins in 1905. Stendahl sold *Faith—the Model* for thirty-five hundred dollars in 1951.

But now he was pressed to make big money on a big canvas. *Tea* measured six feet eleven inches by four feet seven inches. Stendahl had offered it to museums in Cleveland, Minneapolis, and Philadelphia. Though the painting would have been a stellar acquisition for any museum, for various reasons, they passed. Lorser Feitelson exhibited the

4353

HENRI MATISSE

The Tea - Afternoon Tea

Oil on canvas - fmd.

6'11"x55"

~~1921 or earlier 1918~~ *1919 Nice*

c-15000 S ein

p-40000 (signed Lower Left Henri Matisse)

photo - Reagh

reproduced
Henri Matisse by Roger Fry Plate 35
Einstein - Diekunst des 20 Jarhunderts
"Propylaen Kunst-Geschichte age 193
Cat. M. of Mod. Art -
Matisse Exhibition 1952 Pg 26
"Matisse" Lisent & His Publica .
Mus. Mod. Art - Alfred H. Barr Jr. 1951
Pg. 426
"Masters of Art" Cat. L A County Fair
from 1790-1950 1950

Nov 1954
Sld- David Loew 20,000

2

1 Lorser Feitelson explains *Tea* by Matisse to Eleanor Stendahl Dammann in her family's home, 1949.
 Tea now hangs in the Los Angeles County Museum of Art's permanent collection, a gift from David Loew.
 It was valued at $1 million in 1975 when it was donated. Now it's worth tens of millions.

2 Stendahl's inventory of Henri Matisse pieces, 1954

191

SURVIVOR

work one Sunday in February of 1949, at the Los Angeles Art Center School Gallery where publicity photos were taken with Eleanor, Al, and others.

Stendahl's asking price was forty thousand dollars. But when he determined that the winning bid on the Arensberg estate would require around thirty-five thousand dollars, he dropped the *Tea* price ten thousand dollars, hoping the bargain would attract someone quickly. "Business in paintings seems to have taken a beating, from what I hear," Stendahl wrote Schempp.

David L. Loew, son of M-G-M founder and movie pioneer Marcus Loew of Loew's Theatres, came through. With the thirty thousand dollars Stendahl made on the Matisse and five thousand dollars more, he successfully bought his late friend's house and began making plans to move in.

Stendahl's circus re-claimed rings by adding some 2,500 square feet of display space in his new four-thousand-plus square-foot house. The family retained the house next door, where Eleanor, Joe, Ron, and Rock could have the place to themselves. Ron remembers a line of people awaiting entry early on a Saturday morning for the chance to claim items at the Arensberg estate sale. Enid and Earl acquired Persian rugs, the mahogany dining set, and four *Louis Quinze* chairs. Louise and Walter's Steinway grand piano went to Ursula and Al.

Earl, Al, and Joe put on painting and sculpture shows at both houses throughout the 1950s and 1960s. Earl became more relaxed in his larger quarters, feeling that he finally had space to carry out his policy for art. He was strictly hands-on and seemed happiest in his overalls in the basement workshop surrounded by his family of Pre-Columbians. Michael Kan spent many hours visiting the Stendahl basement during his student days at Berkeley. "I had an open invitation to go downstairs and rummage."

It wasn't enough for Stendahl to open his door to the young and the curious. He put forth a great deal of energy to attract a big-spending Hollywood clientele. If his gallery was to survive and thrive, the current crop of movie people needed to be directed toward a higher level of art appreciation and acquisition. Stendahl was confident that if he could bring them in, they would be impressed with what they saw.

The Duke of Earl with his loyal subjects.

Stendahl's flair for display derived in part from his representation of some of Hollywood's top set designers and effects masters who turned to modernistic painting in the 1930s. Stendahl had given Warren Newcombe a show on Wilshire, highlighting the Oscar winner's new direction into bold, California landscapes in oil. Stendahl was not star-struck. He considered those blessed with fame, fortune, and a yen for fine art to represent a good market. And Stendahl was a man on a mission. He counted on connections and referrals within the movie industry, such as Newcombe sending German virtuoso movie director Ernst Lubitsch over.

For a show of artist Henry A. Botkin's (1896-1983) watercolors, Stendahl compiled a telegram list, inviting the elite of the film industry and Los Angeles high society (groups that were still distinct from each other) to attend the opening night party. Most of the names are known to be Stendahl clients from the early days, and many are stars he cultivated throughout his career. Stendahl solicited the support of Botkin's cousins, George and Ira Gershwin, to help him get the word out. The guest list included Harold Arlen, Motion Picture Relief Fund humanitarian Jean Hersholt, Lionel Barrymore, Marjorie Driscoll, producer Gregory Ratoff, William Wyler, Jesse Lasky, Billie Burke Ziegfeld, Fred Bixby, cartoonist Peter Arno, Edward G. Robinson, Howard Hughes's uncle, Rupert Hughes, Clifford Odets, composer Max Steiner, writer-director Albert Lewin, Harold Lloyd, Charles Chaplin, David O. Selznick, Kenneth MacGowan, and the Princess Pignatelli, without whom a party would be incomplete.

The Metropolitan Museum had purchased a painting of Botkin's one week before the telegram campaign, adding heft to the event and to the artist's appeal. Sales receipts indicate that Stendahl did good business with the glamorous guests who came to view Botkin's watercolors. But the dealer never lingered on past success. Work was always about the next deal. Without the foot traffic he had enjoyed on Wilshire, Stendahl pushed harder than ever to attract customers.

Thanks to his partnership with dealer Ted Schempp, Stendahl was able to put his hands on highly coveted paintings on short notice. Well into the 1950s and 1960s, Schempp could be counted on for a steady supply of material from the great European painters.

One of the most heralded mathematicians of the twentieth century, Parisian-born Andre Weil (1906-1998), brother of philosopher Simone Weil, sold

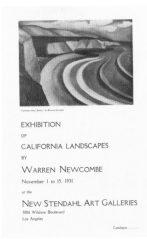

2

1

1 Stendahl sells to actor John Gavin at the gallery on Hillside Avenue.

2 Warren Newcombe show of California Landscapes, 1931.

3 Actress Joan Marsh with Warren Newcombe's *Gas Plant at Venice*

4 *Santa Barbara Mission* by Warren Newcombe.

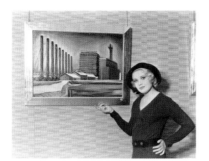

3

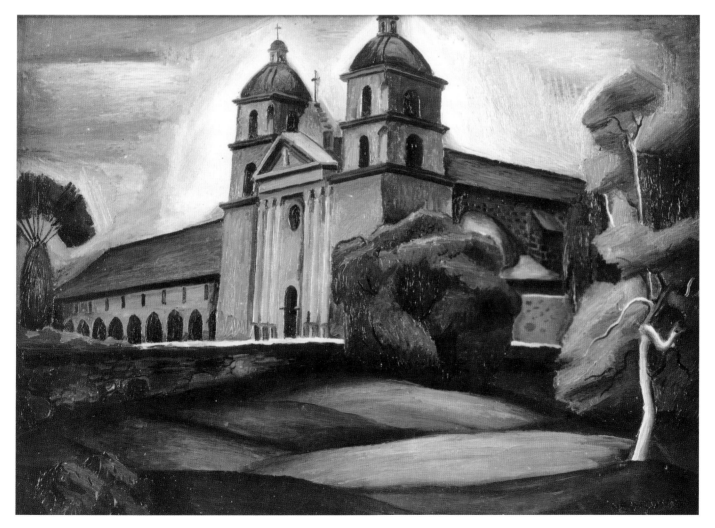

4

4360

Edgar DEGAS *signed lower right Degas*

Woman in Bath

Oil - fmd.

28x35

c-~~45,000~~ 75,000

p-~~$85,000~~ 55,000

Owner - ~~Katzenellenbogen~~

purchased from Leonie Kelln
3-2-2-50
Kat bought from Gold or Vollard
in Paris in 1923

Reproduced in Degas Sales Catalogue
Vente Degas (1918) #73 Femme au bain
Vol I toile 79x90 cm

Sold Bliss

back in stock - B wants 40,000

published in ~~7/~~ "Degas et son Oeuvre" par
P. A. Lemoisne Paris 1946 Vol.lll
#1119 ---col Atellier Degas - in sale
No. 73 -- coll. Oumaelius (Vente, Galerie
G. Petit , Paris 8 juin 1922 No 6 - reprod.
--Coll Willems, Paris

CLAUDE MONET

"Waterlilies"

oil on canvas

1908

$39\frac{1}{2}$X$39\frac{1}{2}$

c-Durbin - wants to trade

p-5000

Sold to Potter and Honore Palmer
of Chicago by Durand Ruel then
through Schemppand us to ~~Diana~~
Universal Studios as present for
Diana Durbin

rt 8 June 1953

Water Lilies by Claude Monet to Schempp, who then sold the painting to Stendahl for $2,995.00 in 1945. The provenance, accurately documented, travels with an artwork and tells a tale of its own. Stendahl's Monet had begun its journey as one of the famed *Water Lilies* series (*Les Nympheas*) in Giverny where it was acquired by French art dealer Paul Durand-Ruel, who is credited with establishing a worldwide market for Impressionism and was largely responsible for bringing Monet to the attention of the American public. Stendahl's *Water Lilies* had also belonged to Potter Palmer of Chicago's famed Palmer House Hotel, before it found its way to Hollywood. The work's subsequent disposition is not known, perhaps because the *Nympheas cycle* included many paintings.

From Paris, Schempp wrote, "How are all the movie stars? Do you sell them much these days, or are they still looking for pictures at half prices? Who had the good judgment to buy the Picasso?" Schempp and Stendahl commiserated often about customers haggling over prices. It couldn't be avoided in a business built upon something as fluid as a fluctuating art market. The two were not selling paperclips or tractors. Theirs was a product of both extrinsic and intrinsic value that could vary wildly in its appeal. It was supplied by temperamental right-brainers, who chafed at the necessity of putting prices on their *oeuvres*. Add to the equation a population of prima donna collectors used to getting what they wanted and trying to outdo the competition. Somehow values were determined; psyches were soothed; money changed hands.

Along the way, there were small scandals involving unpaid bills and Hollywood divorces, but Stendahl preferred a day at Santa Anita racetrack to being caught in the middle of his business's disputes. Where collecting money for a loyal artist was concerned, Stendahl had no choice but to play the heavy. *Shadows* by Armin Hansen was sold through Stendahl to screenwriter Houston Branch in the mid-1930s. Branch, who wrote dozens of pictures, mostly at Warner Bros., promised repeatedly to pay the long-overdue balance of three hundred dollars. "He is absolutely good—is a writer. His check has been slow in coming through from his studio," Stendahl wrote to Hansen in Monterey, California. Stendahl knew Hansen needed the cash and told him he was

From the pages related to dealer Ted Schempp in Stendahl's ledger: Universal Studios bought a Monet from Stendahl for actress Deanna Durbin. Note the misspelling of her name.

doing everything possible to get it to him. Eight months later, still no payment from Branch.

Stendahl wrote again to Hansen, "This is about the lousiest deal I have ever had from this movie bunch. Lionel Barrymore was bad enough, but I didn't expect that type of treatment from Branch." He signed off "with kind regards from the poorest art dealer on earth, Earl" A lawsuit was threatened, unless Branch returned the picture, which he did not do. A year later, Stendahl drove to Playa del Rey to confront the writer. Outside of what Stendahl described as a beautiful home on the beach in a very fine location, he was bitten on the hand by Branch's dog. A Japanese houseboy responded to the commotion. Branch wasn't home. A Band-Aid was offered.

Stendahl counseled Hansen, now ill and needing to pay his doctor's bills, to hire a high-powered attorney, such as Henry O'Melveny or Gurney E. Newlin, friends of Stendahl's and owners of Hansen paintings. Despite a bleeding hand and all the aggravation, Stendahl told Hansen that he liked Branch personally very much and that he had heard from friends that Branch hadn't sold any stories recently.

"I have cut down my own expenses to the raw by retaining only my bookkeeper."

Popular illustrator McClelland Barclay (1891-1943) was a flamboyant and talented illustrator and sculptor, who had his work on the top magazine covers, usually featuring beautiful women. In fact, he married one of his models, "the Fisher Body girl," and the original "Lucky Strike Girl," Helene Marie Haskin. Stendahl gave Barclay his first public art exhibition and sponsored his first public lectures in Southern California. Unfortunately, Stendahl got embroiled in Barclay's highly publicized divorce while the couple was in Los Angeles. As his dealer, Stendahl felt called to the role of hand-holder after the comely Mrs. Barclay-the-Second, a New York socialite, obtained a default divorce on the grounds of cruelty. Cruel, indeed: how else to label a quarrel over a backgammon game on Christmas Eve, which led to the husband's refusal to look at the Christmas tree his wife had decorated for him? She told it to the judge, and the judge's gavel came down on a second alimony for Barclay.

A few years later Stendahl got a letter from "Mac," asking his dealer to line up portrait commissions for him (understandable, since with all that alimony he needed more income.) Barclay called himself a brother-in-the-jigsaw and bragged that he

In 1925, $10,000 changes hands between Stendahl and Charles Russell.

had just painted the great-granddaughter of the first man to sign the Articles of Secession. If Miss Virginia Moore of South Carolina had a figure anything like the Fisher Body girl's, she was a candidate for Mrs. McClelland-the-Third. Moore called herself his fiancée, but they were never married. In 1943, Barclay was reported missing in action aboard a Navy landing ship tank (LST) also known as a large slow target, which was torpedoed in 1943.

As much as Earl Stendahl preferred to distance himself from imbroglios that took his attention away from selling art, he always recognized the advantages of publicity involving large amounts of cash. Shortly before he moved to Hillside Avenue, Stendahl had to admit that a splashy news item about his selling a Charles Russell painting for ten thousand dollars to the Prince of Wales was merely a publicity stunt to increase Russell's profile. But the blatantly untrue Prince story worked: wealthy Kansas City collector Howard M. Vanderslice, a longtime Stendahl client, felt compelled to spend almost as much as the Prince did on his own "keep it in America" purchase of Russell's works and induced Denver oilman Sid Keoughan to do the same. Somehow Mary Pickford,

Gary Cooper, and a couple of Pittsburgh capitalists jumped on the Russell bandwagon, giving Stendahl receipts amounting to twice what the Prince had supposedly paid.

"Six Landscapes Sold in Los Angeles in One Week for $20,000 Sets New Art Record" made for an eye-catching headline in the Los Angeles Times. Was it all based on an elaborate lie? Yes. Did Stendahl deliberately mislead trusted clients in the ruse? Yes. Did he lose any sleep over the whole affair? Doubtful. The royal cachet brought in a few bona fide big-money boys, including Alfred Hitchcock, and moved some good paintings by a very fine artist. Just another week's work.

English art dealer Sir Joseph Duveen, who was a rival of Stendahl's for the money of American millionaires, believed it was better to have no object of art in a home, than not to have the best. Both men sold to William Randolph Hearst, Henry Huntington, Robert Woods Bliss, and John D. Rockefeller. Stendahl respected Duveen's business dealings, but he was not going to buy into any principle that restricted his options. He would sell "the best" to Hearst and something of lesser value to young Millard Sheets

who could not yet afford to play at the top of his collecting game. Sheets and others got there, eventually, because Stendahl brought his customers along at a pace that suited them both.

Stendahl was one of the first dealers (probably *the* first) to encourage "trading up," whereby a painting or sculpture could come back for something more important. The collector got a work she liked better; Stendahl walked away with a check and a piece which he could re-sell at a higher price than the first time around. Everybody won. Annette and Louis Kaufman are but one couple who built a world-class collection of paintings and ancient art through the Stendahl upgrade policy. The policy still stands.

In early 1959, Al and Ursula's third son, Lynden, was born with Down syndrome. Now there were five grandsons for Stendahl, with one needing special care. Into his seventies, survivor Stendahl was still operating on all cylinders despite, at various times, dealing with illness or accidents. Everyone but Stendahl considered it a tragic event when he severed half of his left thumb in a table saw accident at home. Unfortunately, Stendahl's doctor failed to embed the exposed nerve deeply enough under the thumb's skin, so that Stendahl had painful sensitivity for the rest of his life. At age seventy-two, he shrugged off the bloody mishap and got a kick out of the way people recoiled when he showed off the stump, thereafter.

In certain circles, however, Stendahl was on his best behavior. He knew when to cast off the insouciance of "What, me worry?" and get serious about marketing art to collectors who, with a signature on a check, could make his year.

Nelson Rockefeller shares the love with his friend and dealer.

Chapter 10 VISIONARY

If Stendahl's celebrity clients

helped him establish a presence in

walking through the door, who could change his life. On rare

Hollywood after the war, there was

but memorable occasions, someone did come along whose

another category of collectors even

investment in art through the Stendahl Galleries was the stuff

more significant. On any given day,

of dreams. Earl Stendahl was not a superstitious man. He left

especially on a bad day, a busi-

little to chance and saw his life as an example of reaping what

nessman might envision someone

you sow. For a man who believed he got exactly what he

deserved, the "dream client" represented a gift from the Gods.

No matter how hard Stendahl worked on publicity, display, pre-production of exhibitions, client follow-up, bill-collecting, plans for buying trips, relationships south of the border or communication with his artists, nothing justified, to his thinking, the great good luck of Nelson Rockefeller ringing him up on Hillside Avenue, Baron de Rothschild falling for a Persian gold cup, or Morton "Buster" May deciding to sell a thousand Pre-Columbian objects in his May Company stores.

To inhabit Stendahl's fantasies, a person required a great deal of money and the authority to spend it at will. Add a hunger for the very best, plus a competitive spirit bent on outdoing everyone else's acquisitions…and you can wake Earl in the morning. Chocolates and puzzles were the difference in Stendahl's survival during the Depression years, yes, but in subsequent decades, a few wealthy men and women with an art addiction carried him through frightening doldrums, which could have been his un-doing.

"Vincent Price was in, but broke. Liked the Picassos, but not enthusiastic about the Americans. Bought a one hundred and eighty dollar stone for one fifty that was priced in the book at one hundred. Also phallic white idol." Earl read Al's note and probably cringed at "broke."

Stendahl knew his friend Price was a knowledgeable collector who invested in his own artistic passions, as well as in the health of L.A.'s art scene, by co-founding and supporting the Modern Institute of Art (1947-49). Price was an ambassador of both modern paintings and ancient art. But he was not the kind of client one dreams about (see "broke," above).

```
        4368
HOMER, WINSLOW
Two Children seated in Field
Watercolor drawing
8½x6½
from Copley Gallery Boston
Signed and dated lower left
    Homer 1878 or 9
c-600        p in Sept 53
p- 2500

            Rockefeller

                    1000?

    10/8/54
```

In Stendahl's view, the dream client was worth some extra effort. There were drawbacks to working with the egos of such individuals. The biggest spenders expected special treatment and were, likely as not, the fiercest bargainers.

Nelson Rockefeller was an exception. He was an avid art collector who trusted his dealer and didn't question Stendahl's prices. Rockefeller visited the Stendahls in Los Angeles with the director of the Rockefeller Archaeological Museum of Jerusalem in 1949. As Joe barbecued chateaubriand on Hillside Avenue, Rocky told him "Don't tell anyone I'm here." Other guests that night were composer Igor Stravinsky, Frank Lloyd Wright, and Charles Laughton. Rockefeller dropped eighty thousand dollars with Stendahl before cocktails. Earlier that day Rockefeller had a tour of other galleries and private collections with chauffeur Al. One wonders how the special guest thought his rather public visit could be kept quiet, but paparazzi weren't invented yet, and in Hollywood, Rockefeller wasn't everybody's idea of a celebrity.

When the subject turned to French painting, Earl showed off the medal he had been awarded in 1936 by Les Musées Nationaux de France. Responding

2

to the enthusiasm of the small crowd, Enid put her hands on a 1933 certificate honoring Earl Leopold Stendahl of Los Angeles for expanding French language and art. Stendahl told the story of being taken to dinner by the poet laureate of France, which the dealer considered a great honor, until Monsieur sold him two *faux* van Goghs. *Sacre bleu!*

After the steaks that night, Wright decided to pay Stendahl with a check he designed on the spot on Taliesin West stationery. ("This won't go through!"

1 Nelson Rockefeller buys a Winslow Homer from Stendahl in 1954 for $2,500 marked up from $600.

2 The French honor Stendahl for his contribution to arts and letters, 1933.

exclaimed his host.) Like Rockefeller, Wright asked the Stendahls to keep his visit quiet. He was designing Manhattan's Guggenheim Museum (a fifteen-year process) and he considered his trips to Los Angeles an escape from East Coast pressures. The Hillside house and garden afforded a welcoming retreat, even though bustling Hollywood Boulevard was but two short blocks away. There was no shingle to announce the gallery's presence in the residential neighborhood (nor is there today).

In 1947, artist Miguel Covarrubias lamented to Stendahl that a small museum in Skagway, Alaska, was in such dire financial straits, it might be forced to sell off its important artworks in piecemeal fashion. Stendahl smelled a deal. He had experience in Mexico and Central America with insolvent museums eager to unload important objects for an infusion of cash—and usually for a bargain price. Stendahl flew north for a true treasure hunt.

In tiny Skagway, a Klondike River Gold Rush town, he was shown the Axel Rasmussen collection: an extraordinary group of Native American artifacts, displayed in a nineteenth-century wood building Stendahl described as "a wind tunnel." One good fire could rapidly wipe out everything. So taken with the Pacific Northwest material he couldn't resist making an offer for it, Stendahl bought out the Skagway Museum for ten thousand dollars. Whether altruism or art preservation were motivating factors, a staggering five thousand pieces were involved. Since some of the collection had been sold off previously, Stendahl undertook reassembling the entire collection and is revered for its preservation.

Over the course of several weeks, Stendahl single-handedly packed up twenty-five crates to ship south for exhibition at the Los Angeles County Museum of History, Science, and Art. Annette Kaufman remembers how she and Louis marveled at the pieces they saw. Arensberg, Laughton, Price, and others made offers to buy examples from the Rasmussen material. But Stendahl had promised to keep it all intact. He got a disturbing phone call from Annette, shortly after the crates arrived in Los Angeles. She and Louis were horrified to discover hundreds of pieces lying about outdoors in back of the museum, seemingly uncatalogued, untended, and exposed to the elements. Earl and Al drove downtown immediately to straighten things out. According to Annette, the museum staff had no appreciation for the significance and value of the Rasmussen artworks. "Nobody did," she claims. The show went next to the de Young Museum in San Francisco and to the Portland Museum of Art, where it generated enormous excitement.

Los Angeles could have acquired the trove of Alaskan Indian and Eskimo material for about twenty-seven thousand dollars, but the price was deemed too high and the interest was not strong enough for the museum's board to try to raise the funds. The loss of the Rasmussen collection was one more in a sorry pattern of Los Angeles shortsightedness and forfeit.

The Portland Art Museum was the only institution to recognize the historical importance of the artifacts for which Stendahl was seeking a permanent home. Axel Rasmussen, who died in 1945, had been an Alaskan superintendent of schools and friend to Native Americans. He amassed the huge collection of indigenous material from the Northwest Coast and Arctic regions in the 1920s and 1930s, thus preserving a unique representation of nineteenth-century Native American culture. Perhaps Portland's proximity to the great Northwest contributed to its appreciation of the totem poles, potlatch vessels, beadwork, ivory carvings, clothing, textiles, masks, rattles, tools, and other masterpieces.

Like the prospectors of old, Stendahl had struck gold. He sold the entire treasure to Portland in 1948, tripling his investment and accomplishing his goal of keeping the Rasmussen collection together. A dream client could be an institution, as well as a person. The value of the five thousand pieces is almost inestimable. Without exaggeration, it was a trove that would be worth many millions today. Even in 1948, the collection should have commanded much more than Stendahl asked. As important as Rasmussen was to the original acquisition, various publications, such as the Stanford Art Series book, *Native Arts of*

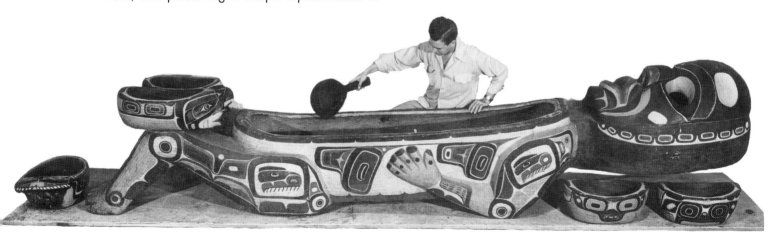

Joe Dammann demonstrates serving from a ceremonial Kwakiutl Indian potlatch figure-container.

Spirit of Dead Man, Yewwood mask, Tlingit Indians.

the *Pacific Northwest* (1949), credit Stendahl with bringing the works to the world's attention. He initiated the plan to publish *Native Arts* and supplied the photographs.

Portland disappointed many U.S. students of Native American art and others when it split up the Rasmussen material. Some forty percent of the pieces were sold off, to be scattered among American and European institutions and private collections. But that decision was prompted by the exigencies of the time. Today, the Portland Art Museum is proud of its Center for Native American Art and considers the remaining Rasmussen objects (of which more than eight hundred are part of the museum's permanent collection) to be among its most valued possessions.

Stendahl's northern adventure posed its challenges, but they were nothing new to the peripatetic dealer. He understood the necessity of striking hot irons. Stendahl could not bear a missed opportunity to acquire a work of art (or five thousand) he knew he could sell. Skagway represented his first serious foray into Native

American artifacts, and the genre remained of great interest to him the rest of his life. There was something about the aesthetic of indigenous culture that never ceased to fascinate the aficionado.

In the decades Stendahl was buying Pre-Columbian art from his sources, objects could be had relatively inexpensively ("dirt cheap" would be too crass), particularly when Stendahl made offers on whole collections and pallets of crated artifacts, as he did in Costa Rica and Panama. But a connection south of the border was only as good as his ability to get the goods safely into the United States. Stendahl Gallery has U.S. consulate invoices dating back to 1938. Until the 1970s, there was a "don't ask, don't tell" understanding, whereby a slim piece of paper signed by an agent in a U.S. consulate was all that was necessary to allow entry of any size shipment.

The days of low prices and open borders are long gone. In the current market of New World ancient art, the diggers, middlemen, museum officials, customs agents, self-styled experts, and runners who bring the Pre-Columbian pieces over the border to sell to their U.S. contacts, have become a sophisticated, economically savvy bunch, as eager as the dealers to make a killing. The situation is not unlike many other countries in the world where ancient art is a highly valued commodity. Al Stendahl's conclusion: "There will always be a way. As long as there's five cents in it, people will dig under a machine gun to get it." But he also spoke with authority on the subject of the value of a worldwide art market, whereby countries preserve fine examples while letting go of others.

Reputable dealers of Pre-Columbian art, committed to working within the import laws, must rely now on finding material that has been in the U.S. since before certain governmental treaties were enacted. Objects from private collections, museums, and other institutions come on the market seeking new homes, but large profit margins are no longer a certainty. It will take a new generation of collectors as enterprising and visionary as Earl Stendahl once was to drive future markets. Dreamers attract dream clients.

Stendahl enjoyed sharing his interest in ancient art with Marcel Duchamp. As Arensberg's favored avant-garde artist, Duchamp was an important part of the Hillside Avenue gang. Stendahl and Duchamp were kindred spirits, directing lowbrow humor at the most pretentious people they encountered. They took turns correcting any Arensberg visitor who deigned to label Pre-Columbian stone pieces in Arensberg's gardens as "primitive" or "unrefined." Career U.S. diplomat Robert Woods Bliss needed no such tutoring. He was a frequent visitor to the

Arensbergs—a refined man, who appreciated the quality of art displayed there. Luckily for Stendahl, Bliss and his wife, heiress Mildred Barnes Bliss, put their money where their appreciation was. In 1940, the wealthy couple donated the Dumbarton Oaks estate in Washington, D.C., to Harvard University and later funded a gallery for Bliss's world-class collection of Pre-Columbian Art supplied, largely, by Stendahl. A visit to Dumbarton Oaks is still an immersion into an oasis of culture and beauty.

By virtue of his passion and his spending, Bliss became a dream client. Unlike Arensberg who preferred more rugged examples, Bliss collected gold, delicate carvings, and highly-polished stone pieces, exquisite jades among them. On a trip south, Stendahl came upon a group of important Aztec masks of inlaid turquoise and jade. He wired Arensberg with news of the find and the big price attached. Arensberg called Bliss. Earl got the next call: "OK, here's the money. Go get them." Arensberg and Bliss divided up the treasure when it arrived, but Al couldn't remember what method they used for first-dibs. "Flip of a coin, probably."

Earl worked hard to cultivate institutions. He researched a museum's holdings, then made offers to curators, knowing which objects would fill out their collections. In that way, Stendahl Galleries made clients of the art museums in Brooklyn, Chicago, Denver, Seattle, Minneapolis, Portland, Pasadena, San Francisco, San Diego, Worcester, Cleveland, St. Louis, New Orleans, Tulsa, Dallas, Ft. Worth, Houston, and at the Metropolitan Museum of Art, the Louvre, and museums throughout western Europe.

Stendahl knew early on that art collecting is a highly personal matter, and totally subjective, even when the client is an important museum curator. When his expert recommendations were rebuffed, he never took it personally. The unpredictability of the game appealed to him, but not where finances were concerned. On the money front, Stendahl wanted no surprises. He needed the money. (He and Enid established separate bedrooms in their mid-sixties. Ron says the story was that Enid couldn't tolerate his grandfather's snoring problem, but it was more likely that Earl was restless and troubled on many nights when a deal had gone sour or when expected payments were not forthcoming.) He had children and grandchildren, and every one depended upon the income generated by Stendahl Galleries.

Once a year, Earl Stendahl slept very well. Thomas Gilcrease paid annual visits to Stendahl's, throughout the 1940s and 1950s. He was a Creek Indian and Honorary Chief of the Sioux Tribe, a

humble man (eldest of fourteen children) who made a fortune in oil in Tulsa, Oklahoma. His philosophy was "Every man must leave a track, and it might as well be a good one."

Gilcrease's track covered the entire American West. The Thomas Gilcrease Institute of American History and Art is unsurpassed as a repository of Native American culture, western paintings, Pre-Columbian artifacts and books. Stendahl was a trusted friend to Gilcrease and one of his main suppliers. He sent historical manuscripts as gifts that became a part of Gilcrease's holdings to share with the public. Reminiscent of Rasmussen, Arensberg, Bliss, and other dedicated collectors, Gilcrease added immeasurably to Stendahl's experience as an art dealer. And not merely financially. Gilcrease bought Pre-Columbian and Native American art literally by the truckload. On the long drives to Tulsa for exhibition delivery, Earl and Al or Joe had a chance to ponder the impact on future generations of Gilcrease's remarkable museum. And the part they played in the saga. Since the Rasmussen deal, Earl had begun seeking out Northwest Coast artifacts to sell. When Gilcrease came along, the dealer knew right where to offer them.

Stendahl and Gilcrease negotiated the price of a totem pole. They settled on Stendahl's formula: one hundred dollars a foot. At 12.5 feet, what a steal. At this writing, such carvings can bring a hundred thousand dollars and more. Gilcrease spent that much on one visit with the Stendahls in Hollywood. It was his habit to drop large amounts of money on Stendahl's Pre-Columbian gold and other artifacts. He wrote Enid from Tulsa, saying, "You are the princess of all cooks, and if I visited very long at a time in your home, I would just about equal the weight of that calendar stone on your terrace. I hear Mr. Stendahl is arriving in this wild western town this afternoon. We will be glad to see him." On that trip an Indian hand called "The Chief" playfully hid Stendahl's leather satchel that had been left on a truck's fender next to Gilcrease's private plane. Stendahl panicked. The Chief thought better of the prank and handed the satchel over. Inside: thirty thousand dollars worth of Pre-Columbian gold, destined for the Institute.

Gilcrease called himself "a fat Indian" more than once. Photographs belie the nickname. He was lean, serious, single-minded. Unfortunately, over-spending (by millions) and a crippling divorce almost brought him down. But in a special municipal referendum, the people of Tulsa funded the Gilcrease Institute of American History and Art, which Gilcrease deeded to the city.

According to Gilcrease's biographer, David R. Milsten, Stendahl encouraged Gilcrease in his mission to preserve the evolution of frontier America. Stendahl said of his friend, "I know of no man who was more devoted to the ideal with which he was imbued." That Gilcrease's ideal drove him to Stendahl's door, time and time again, increased both men's joy and turned their commerce into an art form.

Thomas Gilcrease began as a poor boy from Oklahoma; in contrast, Jerome Orell Eddy was the rich son of Arthur Jerome Eddy, author of *Cubists and Post-Impressionism* (1919). Arensberg loaned the groundbreaking book to Stendahl who heard that the son, Jerome, was actively collecting in Chicago. Eddy Senior had made bold painting purchases at the 1913 Armory Show of Modern Art in New York. So important were his acquisitions that the Art Institute of Chicago

dedicated a wing to the Arthur Jerome Eddy Memorial Collection following his death.

Once Stendahl established contact with Jerome Eddy, he was offered two paintings by French Fauvist Auguste Chabaud (1882-1955) to try to sell for the scion. These two beautiful works from Chabaud's blue period had been purchased by A.J. Eddy from the Armory Show when it traveled to Chicago. Stendahl found no buyer, so the paintings still grace the walls of the Stendahl Gallery in Hollywood.

Jerome and Effie Eddy were serious collectors, happy to discover in Earl Stendahl a West Coast dealer with ties to the best modern work of the day coming out of the East and Europe. Stendahl bought and sold works for them for many years, particularly Kandinskys and the other Blue Four artists. The Eddys are assigned dream-client status because they not only spent a lot of money with Stendahl, but their ranch near Prescott, Arizona, became a southwest retreat for all the Stendahls over many summers. Eleanor had an especially close relationship with Effie and enjoyed Skull Valley cowgirl memories all her life.

When the Eddys decided to sell the large spread for a smaller place, they put an important group of paintings on the market with Stendahl. A partial inventory listing reveals the quality of material the Eddys owned.

1 Young Eleanor Stendahl on a Grand Canyon trail (third from bottom) with, in ascending order from her, Enid, Effie Eddy and Jerome, second from top.

2 *Arcades* by Auguste Chabaud.

Sometimes dreams came in bottles of booze. Millions of magazine readers were exposed to Pre-Columbian statuary through ubiquitous Kahlua coffee liqueur ads between the 1960s and 1980s. Stendahl provided the figurines for much of the campaign. In payment, all that was asked was a case of Kahlua now and then. Another art source might have demanded much more, but the Stendahls were happy to see their clay friends on billboards as they drove through town or across the country.

One of Stendahl's foremost dream clients was a man, like Stendahl, who had "impresario" written all over him. Someone who understood starting at the bottom in the family business as Stendahl had done in Wisconsin, and who developed a craving for Pre-Columbian art (as well as German Expressionism and other ethnic art) with the means to indulge his desires.

Morton D. May was the grandson of a prominent St. Louis retailer. He had a privileged childhood and a Dartmouth education before discovering that he wanted to own and display art. He did both with great flair. An heir to the May Department Stores fortune, his first job in the store was in the complaints department. Stendahl found that, somehow, apt.

1 An inventory page detailing the Eddy collection.

2 A Kandinsky painting from the Arthur Jerome Eddy collection on display (on the rear wall) with a Marion Gross show.

2

1

2

From the ground up, May learned merchandising, eventually taking over the company and retiring as director emeritus in 1982.

Buster (as he was called by friends and family) developed a passion for Pre-Columbian and other ethnographic art, following World War II. Other department stores exhibited and sold fine art over the years, such as Macy's, Gimbels, Bloomingdale's, Sears, Roebuck and Co., and Bullock's Pasadena. Stendahl clients Vincent Price and Millard Sheets were involved in organizing some of those shows. But May's efforts achieved a grander scale. He built important collections that grew very large and traveled from store to store, representing Oceanic, Melanesian, Northwest Coast, and Pre-Columbian cultures.

The May Company and Los Angeles County Art Museum were neighbors on Wilshire Boulevard and, to some extent, strange bedfellows. May—obviously a friend to art and artists—allowed the museum to use his store's parking lot at no cost, not just for visitors' cars, but for special "garage sales." Yet the museum wanted nothing to do with the May Company selling fine art, right next door. Al claimed the art museum passed up some fine bargains, such as the Northwest Coast totem poles the Stendahls were only too happy to buy.

The Stendahl Galleries had supplied much of May's ancient Meso-American material. Reciprocally, May turned to the Stendahls when he was ready to sell his entire Northwest Coast collection of Indian art. Al found a buyer in an eccentric man from Maine, who had given up serious stamp-collecting overnight to pursue the ethnographic arts. The man bought everything in sight and begged for more. Earl Stendahl loved the grand gesture, whether his own or someone else's. Why tiptoe around picking this or that, when, with a larger leap, you can have the whole thing? Dream clients thought big, acted hastily, and were often in trouble with their spouses. They brought a smile to Stendahl's face, and he saw their faces in his sleep. But they never blurred his vision or his eye.

1 Crystal and gold Prince Albert goblet from a set of fourteen.

2 An Earl Stendahl original oil painting, featuring one of the Prince Albert goblets.

Stendahl is dwarfed by stone idols at Tula, Central Mexico.

EXHIBITIONIST

"God speaks," declared Enid to

the dinner guest on her right or

left, following some pronounce-

ment by her husband at the head

of the table. Stendahl was far from

divine, but he was an authority on

the subjects that appealed to his

constituency. Stendahl's ability to identify with people from all

walks of life and economic strata, thereby gaining their trust,

significantly expanded his outreach. He mollified an insecure

artist in the morning, gave pointers on the perfect chocolate

truffle at the Fairfax district's Farmer's Market at noon, and

sold an ancient Iranian ram figurine to William Randolph

Hearst over cigars at the Biltmore Hotel before dinner.

For all his loyalty to the customers on whom his fortunes rose or fell, it was to Enid that Earl gave his first allegiance. Shouldn't a wife expect such devotion? Yes. But Earl's business life was so consuming that he could easily have become a work-first, family-second man. And in the era of their marriage, Enid would probably have accepted such a fate.

The Stendahls were married for fifty-seven years. They often walked apart, as Earl traveled the world, but sometimes it was Enid who stayed in Mexico for months at a time, or at the Eddys' Arizona ranch while Earl flew back and forth. In a letter from New York, where Earl was on an extended stay, he wrote to Eleanor, "The place seems empty without Mother."

Enid and Earl established a pied-a-terre at 68th and Madison in Manhattan. The place was small—only a bedroom, kitchenette, and main room set up for the display of art for Stendahl's eastern clients. Stendahl worked from morning to night on the trips east, leaving Enid to entertain herself at museums, galleries, stores, and Broadway musicals. Her grandson Rock called her a trouper for all the time she spent on her own. Stendahl had nothing against

the things tourists like to see and do in Manhattan—the place never failed to invigorate him. But the fun of a night at Lüchow's or a stroll in Greenwich Village couldn't compete with the rewards of a successful business transaction. Some of Stendahl's favorite customers lived on the East Coast and expanding their collections of Pre-Columbian art became his passion.

Obstacles were inevitable. When a question of authenticity brought things to a quick halt, Stendahl turned to the men whose opinion could make or break a deal. There were few acknowledged experts in the field of Pre-Columbian art in the days when Stendahl was establishing himself in the genre. In New York, he consulted with Gordon Eckholm (department of anthropology) and Junius Bird (curator of South American archaeology) at the Natural History Museum to get their stamp of approval on questionable pieces. But Earl, Al, and Joe gradually earned their own reputations as experts. Stendahl's became the place to go to sell, buy, appraise, or authenticate Pre-Columbian art. Controversies over which objects were "good" or "bad" could get ugly. Big money was involved. Big egos. But Stendahl stood behind his pieces and his opinions, sometimes painfully.

While preparing in 1957 for the most ambitious series of exhibitions his gallery had ever embarked upon, Stendahl was contacted by a dealer in

An ancient Amlash culture bull reproduction that fooled Stendahl.

Lebanon. The man had a trove of ancient pottery from the Amlash culture west of the Caspian Sea in Iran. Magnificent clay bulls and other figures dated to the ninth century B.C. Even by Stendahl's standard of "ancient," these were old. And exquisitely formed. Stendahl became fascinated with classical antiquities while in Europe, as he traveled from city to city, following the progress of his Pre-Columbian Exhibitions 1958-1960.

There are indications that Stendahl was beginning to make poor decisions, spending lavishly on dubious pieces. Al and Joe resisted what they suspected and did not question the boss when he paid many thousands for a large group of the Amlash material. In

Los Angeles, Stendahl showed the figures to his top Pre-Columbian customers, figuring they were a good target for another ancient culture.

The whole batch was found to be fake. Stendahl had never before had to call in so many sold objects—

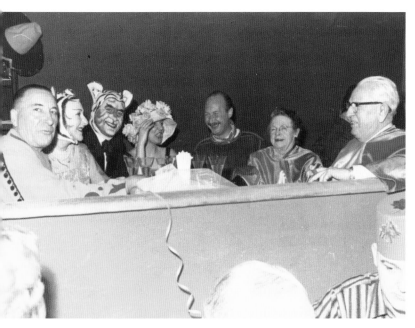

a sad and sobering experience. Surprisingly, more than a few of the people who bought the Amlash figures wanted to keep them, even knowing they were only reproductions. But Stendahl insisted that

every one be returned for a full refund. He could not allow known fakes floating around in the art world that came from Stendahl Galleries.

While in Panama City on a buying trip, Stendahl instructed Joe to bring cashier's checks totaling $42,500 to pay for a San Jose collection Stendahl called "tops." He compared pieces to ones in the Brooklyn Museum and told Joe that the group included the finest clay polychromes and gold he had ever seen. Stendahl was sure they could double their money. The gold pieces represented most of the money Stendahl had spent. They were fake. Another disaster. Again "the boys" helped clean up after Stendahl.

Even after some unsettling catastrophes, Stendahl could still surprise with an astute move at just the right time. He and Enid enjoyed taking the family to visit California's historic missions. Time after time Stendahl noticed a paucity of art on the walls, even though the early Spanish Colonial tradition had brought a wealth of religious objects and artifacts to the New World. Stendahl bought up whole collections of such material at low prices. He contracted with the State of California to sell his best examples for display in twenty-one missions, up and down the coast. It was a remarkable deal with benefits for Stendahl Galleries and for the public's expanded exposure to California history.

Costumed merry-makers in Munich: Haus der Kunst museum director Peter A. Ade, next to Enid and Earl.

The traveling European Pre-Columbian Exhibitions co-sponsored with Munich's Haus der Kunst museum brought the Stendahl Galleries to the world's attention. More important from Stendahl's point of view, Pre-Columbian art took center stage in museum shows of premier quality for an international audience.

Beginning in October 1958, and continuing through 1961, sixty-one clay sculptures and thirteen works in stone traveled to Munich, Zurich, Paris, The Hague, West Berlin, Vienna, Frankfurt, and Rome. Stendahl was paid a sum of thirty thousand dollars plus travel expenses for him and Al. Enid, Ursula, Eleanor, and Joe spent months at a time with Earl and Al, throughout the three-year European adventure. Stendahl ingeniously had fiberglass casts made of large stone ceremonial blocks, which were too heavy to ship. These lightweight, hollow "stones" still grace the Hillside Avenue gardens and fool most observers.

Ron described an assembly-line operation in the courtyard in front of his grandparents' house, as Joe, Al, and Earl prepared the shipment to Germany. They built the packing crates themselves, then each artifact was cataloged, photographed, color-coded, and numbered, to make sure that German, French, Dutch, and Italian curators could keep everything straight. At Galerie Charpentier in Paris, none other than Charles de Gaulle's newly-appointed Minister of Cultural Affairs, Andre Malraux, co-sponsored Stendahl's show.

By all reports, the European exhibitions between 1958 and 1962 brought a great sense of accomplishment to the Stendahls and Dammanns. Significantly, the Mexican government joined in, adding pieces in The Hague and Berlin and continuing their own shows in Russia, Czechoslovakia, Yugoslavia, London, and Los Angeles.

Stendahl organized another important exhibition in his later years, this one at Otis Art Institute of Los Angeles County. Etruscan Art opened in 1963 to an enthusiastic response. It inspired a show at the Art Gallery of the University of California, Santa Barbara in 1967, featuring Etruscan art from West Coast collections. What makes both exhibits particularly interesting is that Stendahl acquired his historic Italian objects as the result of an exchange of Etruscan art for Pre-Columbian art with the Luigi Pigorini National Museum of Prehistory and Ethnography in Rome. Who but Stendahl would make such an audacious proposal? "I want a hundred of your museum's finest objects from ancient burials which

1

PRE COLUMBIAN EXHIBITIONS
1958-1960

Organized and selected by Earl L. Stendahl from the Stendahl

Collection, Private Collections and Museums

Exhibition and dates:

Haus der Kunst Museum,
Munchen, West Germany ... October 15th, 1958

Kunsthaus Museum,
Zurich, Switzerland ... January 24th, 1959

Galerie Charpentier,
Paris, France .. April 15th, 1959

Haags Gemeente Museum,
The Haag, Holland .. June 26th, 1959

Akademie der Kunste Museum,
West Berlin, Germany .. October 3rd, 1959

Museum Fur Volkerkunde,
Wien, Austria ... December 22nd, 1959

Historisches Museum,
Frankfurt, West Germany ... September 1st, 1960

Palasso delle Esposizioni,
Rome, Italy ... November 15th, 1960

STENDAHL ART GALLERIES

7055-7065 Hillside Avenue

Hollywood 28, California

represent the very origins of your country's prehistory, in exchange for a hundred tomb artifacts from sites in the ancient New World." Fair enough? Try to pull something like that off in the present day. No board of trustees or directors weighed in, no "experts" wrung their hands over letting a trove of Italian cultural patrimony escape. There was no one-upmanship comparing the value of the two civilizations. With a handshake Stendahl and the director of Rome's national museum of prehistoric ethnography cut a deal.

The swap brought Etruscan art to Southern California's attention, where few had ever seen the Pre-Roman material. Exhibitionist Stendahl was only too happy to usher his audience into a new tent. "Marvels await you!" Marvelous, they were.

In 1965, Earl and Enid made plans for an ambitious buying trip that would base them in Paris, while they branched out to the Middle East and Africa. Earl was seventy-eight years old. He never came home. On Monday, May 17, 1966, Stendahl fell ill in Rabat, Morocco. A cardiac specialist declared him a victim of coronary thrombosis. Stendahl was hospitalized and treated for four days, complaining constantly about the curtailment of his itinerary and insisting he was well enough to carry on.

But from the beginning Enid was told that Earl's condition was serious. She called Al, who was at that time in Ghent, Belgium, planning to meet up with his folks later in Paris. Earl couldn't think of "one damn reason" why Al should make a detour to North Africa. The next time Enid phoned Al, Earl had died. At age ninety-two, Al still spoke emotionally of hearing of his father's death. He quoted verses from Robert Browning's poem, "How They Brought the Good News from Ghent to Aix," followed by, "I had *bad* news in Ghent."

Enid's letters home described a confused scene in the aftermath. Al arrived, via Casablanca. A female consul allowed Al to turn the wrench on the bolts of Earl's coffin. With a heavy shovel and a heavier heart, he buried his father. Enid did not want to be present for that ritual. After, she focused on comforting Al and a wailing U.S. Embassy official who was beside himself with grief for the family. Joe fielded the official's transatlantic call to Hollywood, but the man's sobs drowned out most of the information Joe was trying to gather.

1 Kneeling female, clay from the protoclassic period, Jalisco, Mexico, ca. 200 BC-200 AD.

2 Stendahl's European Pre-Columbian Exhibitions itinerary.

Al discovered a trunk full of the treasures Earl had amassed so far on the trip. Some sixty thousand dollars had been spent. Earl was hoping he would unload some of the things on his and Enid's visit to the Rothschilds in southern France. So much was left undone. He wasn't supposed to die.

Al counseled Enid to stay on in Paris for a time. She was comfortable with the idea. She had two rooms at the Orly Hilton. Family and friends could join her there until she was ready to return home. From France, Enid went on to New York, where she stayed for several months in the Manhattan apartment.

In February 1970, Enid, eighty years old, who had returned to Hollywood, died in her sleep. A late-night fire, limited to a small area in her upstairs bedroom, took her life.

And, with Earl, what a life it was.

1 A photograph by George Hurrell of a Gordon Coutts oil painting evokes Earl Stendahl's last adventure and his passing. The Moroccan street scene hung in Stendahl's gallery and reminded Al Stendahl that he was in Ghent, Belgium, when he heard the news of his father's death: "I made my way to Morocco to handle the formalities. With a borrowed shovel, I buried my father where he fell. I thought that he would not be unpleased to go this way, chasing treasures in exotic places."

2 Earl and Enid at home, early 1960s. On the back of this photo of Earl and Enid were scribbled the words "Two movie stars whom we met on board. Everyone said it was Mary and Doug, incog."

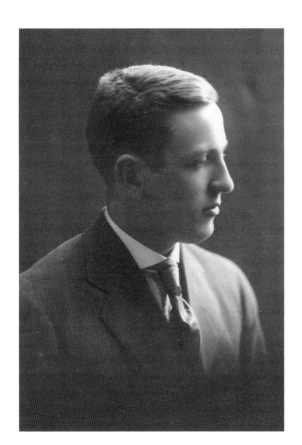

1 A young Earl Stendahl.

2 Earl Stendahl in his later years.

Epilogue

And so a chapter closed. But a legacy of family loyalty, art appreciation, and lives fully lived carried on. At the time of his death, Stendahl had been compiling material for a milestone book to be published by Abrams: *Pre-Columbian Art of Mexico and Central America.* The book's concept, originated by Stendahl, was born out of his monumental European exhibition. His idea was to show pieces not previously published, instead of the usual suspects appearing again and again. Al took over the project, but Earl lived to see Al's photographs and preliminary design layouts. The book, with text by Hasso von Winning, came out in 1968.

It was dedicated to the memory of Earl Stendahl, "who by his zest for adventure, both in the pursuit of knowledge and the object of art itself, gave so much impetus to the appreciation of this American art."

A few days after his death, *Los Angeles Times* art critic Henry J. Seldis was inspired to write the following:

Anyone who knew Earl Stendahl even slightly will always remember his exuberant joy of life. News of his death last week in Morocco came as a blow to all those who had come to look upon Stendahl as a paternal figure to the burgeoning Los Angeles art community...

All the great names of modern French artists and a great many of the revolutionary Americans were introduced to Los Angeles by Mr. Stendahl...

More than anyone else, Mr. Stendahl was responsible for the rising market in Pre-Columbian objects. A shrewd businessman, he also became an unpedantic educator who made sure, by doing them himself, that the installations of his shows were dramatic and memorable.

And the day will come when Mr. Stendahl's central role in the development of interest in the fine arts in Southern California will be accurately (and one hopes, warmly) chronicled.

Stendahl inspired so many people. Perhaps it was because Stendahl—who some detractors might have written off as a cigar-smoking, sometimes-rude salesman whose only appreciation of art was for the money it generated—was a connoisseur, an arbiter and, indeed, an artist himself. He was, in the true sense of the word, a visionary who saw the potential for art to change the world. As early as 1931 he predicted that television would one day popularize and raise the standard of art appreciation. Keep in mind, TV was brand new. It was just emerging from mechanical to electronic scanning; Stendahl could not have contemplated digital imaging. And yet, a direct quote from Stendahl:

> The time will come when homes will be built with special recesses whereon the great masterpieces of all time will be flashed, a different one each week or day or hour, and so the vast public who cannot travel to see them will become familiar with these great art works. This will not, contrary to general opinion, detract from the sale of original paintings, rather it will increase the desire for them.

Decades later, Bill Gates famously digitized the world's fine art to display in his home, and in the process of licensing artwork, formed a company that evolved into licensing giant Corbis Corporation.

Shortly thereafter it became commonplace to see digital photos (paperless works of art) downloaded from a camera and flashed upon an LCD screen. Ten thousand photos in one frame. No computer link necessary. Systems store and play music for a slide show with soundtrack. "The possibilities are endless," says the advertising for one such offering. Yes. Such possibilities were predicted early in the twentieth century by a man with a vision for making art instantly accessible to everyone.

Always interested in new media, Stendahl organized A Showing of Professional Abstract Movie Shorts Synchronized with Music while still on Wilshire Boulevard. The movie producer was Oskar Fischinger (1900-1967), controversial animator, filmmaker, and abstract painter. Once again, Stendahl entered into an unexplored artistic realm, again a pioneer (remember the artful jigsaw puzzles and candy boxes?). Stendahl reached for, not only the highest ideals, but for the money, the sensations, *and* the ways to please the masses. He wanted it all.

His insight that Pre-Columbian art was more than just naïve clay and stonework came from an eye that was always attuned to the modern. Turning this new ancient genre into a sought-after collectible, honored for its keen design, exemplified his ability to blend inspiration and adventure. He inspired his son-in-law to turn art dealing into further grand adventure

in Mexico. How many businessmen have heard these words from a soothsayer? "You are going to find the treasure of the queen, tomorrow." The very next day, Joe Dammann uncovered a fortune in ancient gold ornaments. And Joe's son, Ron, Earl's first grandson, has continued the adventure, heading the Stendahl Gallery operation now.

Stendahl's 1938 policy for art included this elaboration of his gallery's influence on the Los Angeles art scene:

> To a cosmic observer, gazing through his telescope at far distant worlds, seventeen years may be a scarcely perceptible fragment of time; but to a human being watching the headlong development of a Southern California community, it can seem an epoch. Looking backward to that day (1911), when the Stendahl Galleries opened their doors to the public, inviting Southern California to see the works of the best of their own artists, the story of growth and change in the interval does indeed seem that of an epoch in local affairs. The consistent aim of the Stendahl Galleries from their inception has been to seek out the best among our artists and, by constantly exhibiting their works and interpreting their aims, aid not only our own citizens, but the countless visitors from every corner of the nation and every country to realize that we have a real art here and artists of first quality.

Such was Stendahl's mission. He never wavered from it in fifty-five consecutive years of promoting art. Even when his interest expanded from the local artists to European Modernists and the ancient practitioners his message was unchanged. Show the best. Promote growth. Find new audiences. Take risks. Celebrate change.

Earl has been gone since 1966. We can't know how he would have looked upon the rest of the twentieth century and beyond. With pride, perhaps. With humor, dismay, delight, criticism, surprise, most certainly. And probably with visions of art on other planets, or maybe in other universes.

The year 2011 marks Stendahl Gallery's centennial year of continuous operation. But its long story goes on. The story Earl began.

Acknowledgments

From the time of my earliest intimations that I might be the one to chronicle the Stendahl story, I have been the fortunate recipient of generous assistance. I am grateful for support for my research from Hedgebrook, the Historical Society of Southern California/Haynes Foundation, and Ragdale. Because so few people are left who have first-hand recollections of Earl Stendahl, I was privileged to talk to James Byrnes, Stephen J. Cannell, Michael Kan, Annette Kaufman, Ann M. Liebig, Charles Rozaire, and Milford Zornes. Before they died, Earl's daughter and son, Eleanor and Alfred, shared invaluable stories, many of them included in these pages.

Stendahl's personal history cannot be separated from Los Angeles art history, making the contributions of many Los Angeles institutions crucial to this tale. I am deeply indebted to George Abdo, Jacqueline Dugas, Elizabeth Clingerman and Johnny, the microfilm printer repairman, at the Huntington Library Art Collections, where I spent long hours immersed in the Archives of American Art. Karen Wise and Beth Werling welcomed me at the Natural History Museum Pre-Columbian Hall, and I am grateful for the contributions of Kathy Zimmerer at California State University, Dominguez Hills. The staffs of the Mr. and Mrs. Allan C. Balch Research Library at the Los Angeles County Museum of Art, the Academy of Motion Picture Arts and Sciences Margaret Herrick Library, the Getty Research Institute Special Collections, and the Charles E. Young Research Library Department of Special Collections at UCLA all caught my vision and responded to my requests. I appreciate their help, as well as that of Teresa Barnett at the UCLA Center for Oral History Research. I must also acknowledge colleagues and institutions farther from home: Stephanie D'Alessandro at the Art Institute of Chicago, Stacy Goodman at Sotheby's New York, Holly Frisbee of the Philadelphia Museum of Art, and Kate Weikert of the Portland Art Museum.

I could not have accomplished such an ambitious project without an outpouring of erudition from those wiser and further along the path than I. Thank you to Charles J. Fisher, Rebekah Gibson, George M. Goodwin, Madeira James, James R. Lafferty, Sr., Lattice Network, Nancy Moure, Patricia Trenton, and Mark Vieira. Many offered professional expertise

The author on her wedding day to Ron Dammann, flanked by his great-aunt Myra Banes and grandmother Enid Stendahl.

and generous help when most needed: Christine Anderson and Ali Sivak at Creative Partners West PR, Jeffrey Burbank, Pamela Forbes, Hartnett and Associates, Scott Haskins, literary agent/attorney Paul S. Levine, Julie Hopkins, Clifford Niederer, Joan Quinn, and Stephen Wyle.

The story of *Exhibitionist* opened my eyes to the passions shared by art dealers at the top of their game. Here are those dear to my heart, who made this book better: Jerome Adamson, Ron Dammann, Don Endemann, Herb Palmer, and George Stern.

At Angel City Press, I found a warm and welcoming home, and the day I introduced myself to publishers Paddy Calistro and Scott McAuley at the Los Angeles Times Festival of Books is one I cherish. Lynn Relfe's eagle eye, Amy Inouye's beautiful cover design, and Jamison Spittler's marvelous book design enhanced *Exhibitionist* to a degree I did not imagine.

Finally, I owe so much to my family, whose support never waivered: Ron; Sarah, Mitchell, Madeleine and Zoe Thomas; Joe Dammann; Rock Dammann; and Ruth and Dick Sowby. Each has lived the Stendahl story with me from the beginning. I treasure our shared history and am thankful for their love.

—A.D.

A Bibliographic Account

There are authors cited here who have had a decades-long relationship with members of the Stendahl and Dammann families. For that reason, research for *Exhibitionist* was not merely an exercise in gathering information and corroborating anecdotal accounts, but an enormously satisfying experience of reconnecting with writers who have long recognized Earl Stendahl's place in the art history of Los Angeles.

Stendahl Art Galleries records, donated to the Archives of American Art by Al Stendahl in 1976, are available through the Smithsonian Institution. For other examples of the high-stakes business of selling art, see Malcolm Goldstein's *Landscape with Figures, A History of Art Dealing in the United States* (Oxford: Oxford University Press, 2000); Mark Nelson and Sarah Hudson Bayliss, *Exquisite Corpse, Surrealism and the Black Dahlia Murder* (New York: Bulfinch Press, 2006); Billy Pearson and Stephen Longstreet, *Never Look Back, An Autobiography of a Jockey* (New York: Simon and Schuster, 1958); and Ambroise Vollard, *Recollections of a Picture Dealer* (Boston: Little, Brown and Co., 1936).

Passionate art collecting is explored by Louis Kaufman with Annette Kaufman in *A Fiddler's Tale* (Madison: The University of Wisconsin Press, 2003) and by Vincent Price in *I Like What I Know, A Visual Autobiography* (Garden City: Doubleday & Co., Inc., 1959).

Biographies that illuminate important players in the Stendahl story are: *Los Angeles Art Community: Group Portrait, Alfred Stendahl*, by George M. Goodwin, interviewer, Oral History Program, UCLA (Los Angeles: The Regents of the University of California, 1977); *William Wendt and His Work* by Antony Anderson, Fred S. Hogue, Alma May Cook and Arthur Millier (Los Angeles: Stendahl Art Galleries, 1926); *Nicolai Fechin* by Mary N. Balcomb, (Flagstaff: Northland Press, 1975); *Thomas Gilcrease* by David Randolph Milsten (San Antonio: The Naylor Company, 1969).

Architectural history associated with the Stendahls and Arensbergs is covered by Richard Neutra in *Richard Neutra on Building Mystery and Realities of the Site* (Scarsdale: Morgan & Morgan, 1951) and

by Nicholas Olsberg, editor, in *Between Earth and Heaven: the Architecture of John Lautner* (New York: Rizzoli International Publications, 2008).

The years of Stendahl's greatest activity in paintings are treated by: Patricia Trenton and William Gerdts in *California Light 1900-1930* (Laguna Beach: Laguna Art Museum, 1990); Nancy Dustin Wall Moure in *Dictionary of Art and Artists in Southern California Before 1930* (Los Angeles: privately printed, 1975); Peggy Guggenheim in *Art of This Century* (New York: Peggy Guggenheim, 1942); Ruth Lilly Westphal in *Plein Air Painters of California* (Irvine: Westphal Publishing, 1982); and Victoria Dailey, Natalie Shivers, and Michael Dawson in *L.A.'s Early Moderns* (Los Angeles: Balcony Press, 2003). The definitive account of the Stendahl-Rasmussen story is explored by Edward M. Farmer, editor, in collaboration with Earl Stendahl in *Native Arts of the Pacific Northwest from the Rasmussen Collection of the Portland Art Museum* (Palo Alto: Stanford University Press, 1949).

Finally, two books stand out for their subjects and artwork: *Picasso Peintures 1939-1946* by Robert Desnos (Paris: Les Editions du Chene, 1949); and *Henri Matisse, A Retrospective* by John Elderfield (New York: The Museum of Modern Art, 1993).

—April Dammann

Earl (at bottom) and fellow track team members in Menomonie.

Image Credits

The photographs, documents, ephemera, and other images in *Exhibitionist* are from the collections of Stendahl Galleries and the author, except as noted below. Parentheses following page numbers refer to the image numbers on the page. The author and publisher are grateful to those individuals, archives, and institutions listed for permission to reproduce imagery. Extensive research was done to identify photographers; any oversights are unintentional and upon notification to the publisher will be corrected in the next edition.

Images on pages 19, 34(1), 44(2), 64, 66(2): courtesy Smithsonian Institution: Stendahl Art Galleries records [ca. 1920-1964], Archives of American Art.

Guernica by Pablo Picasso on page 119: © 2008 Estate of Pablo Picasso / Artists Rights Society (ARS), New York.

Lillian Gish as Romala (© 2006) and *Tonita* (© 2007) by Nicolai Fechin on pages 74 and 75: © Christie's Images Limited, courtesy Christie's Images Limited.

Photograph of Louise and Walter Arensberg with Marcel Duchamp on page 110: courtesy Philadelphia Museum of Art; Gift of Jacqueline, Paul and Peter Matisse in memory of their mother, Alexina Duchamp.

James Abresch, N.Y.C., courtesy of Dr. Annette Kaufman: 109

Adamson-Duvannes Galleries: 67(3)

Camera Creations photograph: 5, 59, 70, 110(3), 117, 139, 174, 216(1), 221

Mary Culley: 68(2)

Floyd Faxon: 45, 65, 84, 88, 89(2), 96, 97, 98, 124(2), 136, 149(2)

Field Newspictures, Ambassador Hotel: 42(3)

Used by permission of Pamela Forbes (photographer unknown): 138

Florence Homolka: 10, 179, 184, 192

Image Experts: 31, 41, 105(2), 144, 194

Keystone Photo Service: 37(1), 67(4), 68(1), 69, 70(2), 71, 89(1), 199

Albert J. Kopec / Kopec Photo Co.: 89(1), 115, 157

Kug-Art: 50

Lawrence: 175(3)

Gardena High School / Los Angeles Unified School District Collection: 161

J. Eric Lynxwiler: 106

McCutcheon & Reagh: 208

Chet Peck: 147

Pellison & Field, Ambassador Hotel: 26, 28(2), 29, 138

Philadelphia Museum of Art; Arensberg Archive: 102, 110(1), 132, 166, 167, 168, 169

Vincent Price Collection: 128

William Reagh: 190

Walter Frederick Seely: 77, 83

George Stern Fine Arts: 34(2), 47, 60, 63, 70

Weaver: 30, 40

"Dick" Whittington Studio: 80

Los Angeles Bureau / Wide World Photos: 95, 125

J.R. Willis: 37(2)

Index

WILLIAM WENDT
And His Work

With Articles by:

ANTONY ANDERSON
Art Critic of the West

FRED S. HOGUE
Chief Editorial Writer L. A. Times

ALMA MAY COOK
Art Writer L. A. Evening Express

ARTHUR MILLIER
Art Critic Los Angeles Times

STENDAHL ART GALLERIES
The Ambassador Hotel
Los Angeles, California
1926

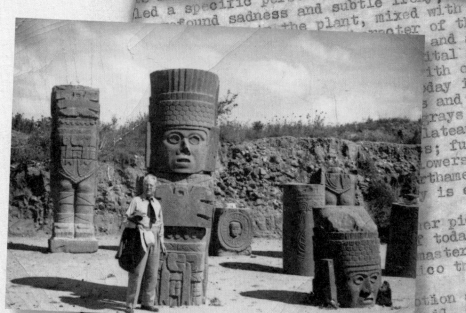

me th...
the ...
had ...
exce...

ton...
Mex...

a ...
he ...

...Mexi...
...ne was Emmy Lou Packard,
...thirteen years old.
...character, the sensitivness of
...ve truth of the paintings of
...child had done.
...y little girl, with
...e reliefs of Chartre...
...e border of Mexico.
...she had all the cha...
...first fruits of her...
...birthplace of the o...
...Hugonot, brought her...
...d years of acclimat...
...eep roots in the so...
...owing up in Mexico,
...is, the men and wo...
...Canada to the tip...
...painting has born...
...teen years ago the...
...s no doubt but that Mexican...
...ed a specific personality. A ...
...rofound sadness and subtle irony, ...
...the plant, mixed with the...
...character of the...
...and ancient.
...ital pro-
...ith our mar-
...oday is the same
...s and moves
...grays from
...lateaus of the
...s; fugues of
...lowers of
...orthamerican and
...y is expressed

...her pictorial
...today, who
...masterly draw-
...ico thirteen

...otion and apprecia-
...soil, will
...the emotion and love
...fruits of a plant which we have grown
...uries of sweat, labor and blood,
...a marvelous heritage that is just
...living reality.

Diego Rivera

1932

INDI...